ART NOUVEAU

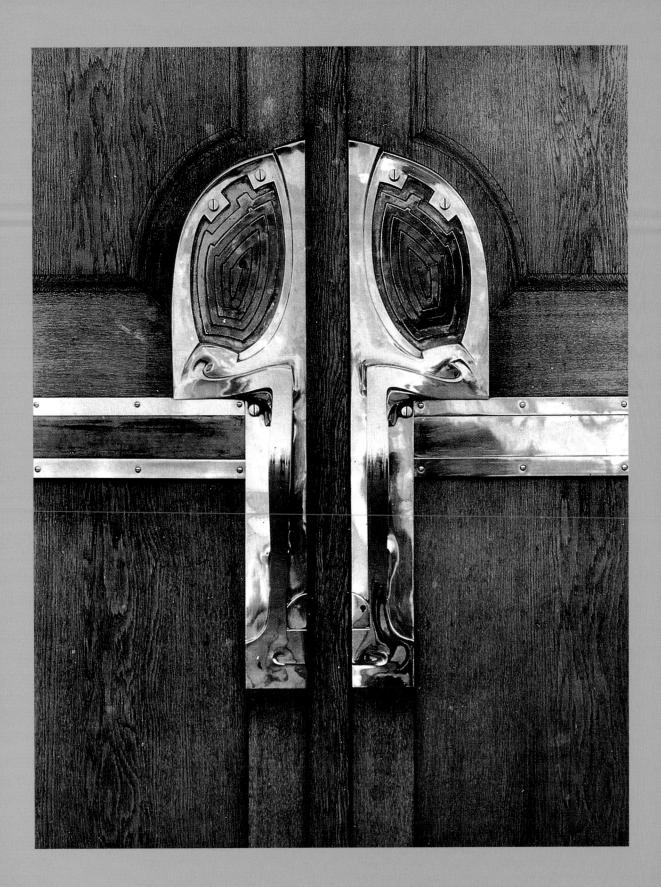

Klaus-Jürgen Sembach

ART NOUVEAU

Utopia: Reconciling the Irreconcilable

Front cover: Louis Comfort Tiffany: Vase, iridescent glass, New York, c. 1900, 45 cm high Bayerisches Nationalmuseum, Munich Photo: © Claus Hansmann

Back cover: Charles Rennie Mackintosh: The entrance hall, Hill House, Helensburgh, 1903 Photo: © Anthony Oliver, London

Illustration page 2: Henry van de Velde: Door handles, Nietzsche Archive, Weimar, 1903

© 2002 TASCHEN GmbH Hohenzollernring 53, D–50672 Köln www.taschen.com

Original edition: © 1991 Benedikt Taschen Verlag GmbH © for the illustrations, unless by the artists: VG Bild-Kunst, Bonn 2002: Behrens, Heine, Loos, Riemerschmid English translation: Charity Scott Stokes, London Cover design: Angelika Taschen, Cologne Illustrations: Klaus-Jürgen Sembach

Printed in Italy ISBN 3-8228-2022-9

CONTENS

6 MOVEMENT

The Modern Style's first steps

- 32 UNREST
 - Uprisings in the provinces
- 40 Brussels
- 64 Nancy
- 72 Barcelone
- 80 Munich
- 120 Weimar
- 140 Darmstadt
- 170 Glasgow
- 186 Helsinki
- 194 Chicago

204 EQUILIBRIUM

Vienne: the Modern Style arrives

- 238 Bibliography
- 239 Index of names
- 240 List of illustrationes

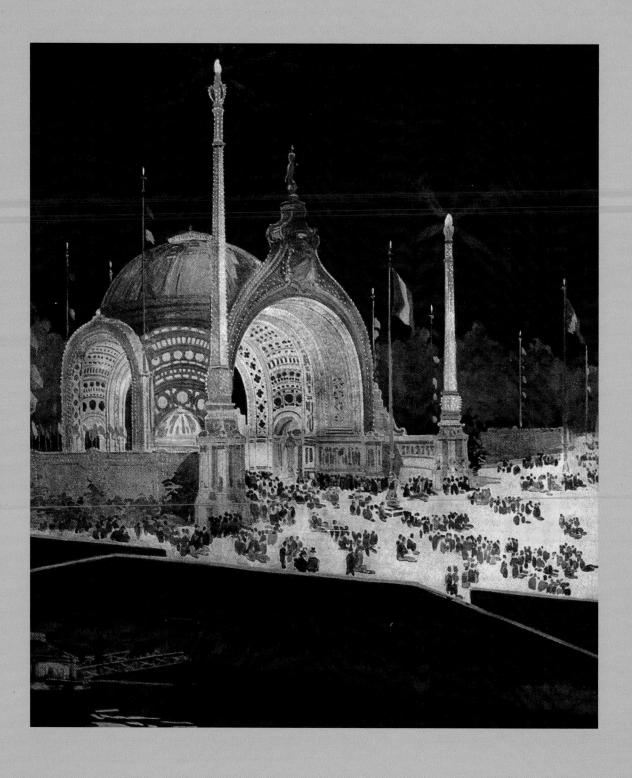

MOVEMENT THE MODERN STYLE'S FIRST STEPS

The 1890s gave the world two innovations: cinema and Art Nouveau. The two are not unconnected, since they started from the same premisses, their aims were comparable and they shared similar yearnings. Motion pictures and stylistic animation both resulted in one way or another from the industrial age – directly, as one of its inventions, or indirectly, as a search for greater refinement. They felt the need for silent, but nevertheless expressive communication, with film thereby somewhat sensationalist, at least in its early days, and style aesthetic to naïve, sometimes frankly vulgar. Both wanted to be popular; here the cinema had more immediate success, but Art Nouveau's success was more long-lasting.

It is not possible to provide evidence of direct links between the two; by the time the cinema revealed its aesthetic ambitions, the Art Nouveau era was almost at an end. We do not know whether Henry van de Velde drew support for his dynamic style from the suggestive powers of moving pictures in the cinema, nor whether Frank Lloyd Wright's remarkably elegant picture palace design really dates from as far back as 1905. Georges Méliès' early screen phantasmagoria were inspired by Jules Verne and created a highly individual visual world, but do not seem to owe anything to the Paris style of Art Nouveau. Yet their almost simultaneous emergence – cinema in 1895 and Art Nouveau a few years earlier – suggests the great relevance of these two phenomena to one another.

If they shared a generating factor, then this was the fascination of movement – every area of life seemed to have been set in motion. The increasing pace of transportation, of mechanical efficiency and human achievement, was affecting everyone. The cinema's first endeavour was to reflect this dynamism, while Art Nouveau strove for its aesthetic sublimation. Although there may have been other contributory factors, it is undoubtedly the case that for some time artists had been concerned to come to terms, in their own way, with the technological progress that was

Title page: Main entrance to the Paris World Exhibition by night, watercolour by M.F. Bellenger, from: Le Livre d'Or de L'Exposition de 1900, Paris 1900.

<u>Henri de Toulouse-Lautrec,</u> Loie Fuller, Paris, 1893, lithograph (detail).

<u>Thomas Theodor Heine,</u> Loie Fuller, Munich, c. 1900.

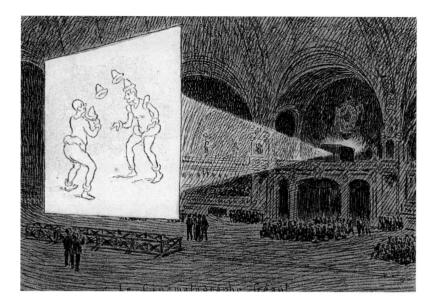

changing the world from one day to the next. The Impressionists had been the first to find an aesthetically satisfying form for the transient, for what could not be contained within firm contours. There was a recognition that impressions did not have to be registered in stasis – they too could shift.

Leaving aside the aesthetic impotence of historicism, such ephemeral contacts as there had been before this time between art and technology had been determined more by a spirit of rejection than by any desire for symbiosis. Art Nouveau must be given credit for attempting to alter this situation, for striving to bring about a reconciliation between traditional expectations of art and the modern face of technology. There may have been suspicion that the two were irreconcilable, but it was Art Nouveau that provided the painful evidence; the lasting popularity of the style must be ascribed to the irrational desire to repeatedly defer the moment of truth. Although Art Nouveau was short-lived, it seems to have gained eternal life as a metaphor of Utopian hope.

The fact that cinema and Art Nouveau came together at the World Exhibition in Paris in 1900 is an indication of their closeness in contemporary eyes. From the beginning these great exhibitions had presented the latest innovations of the day. Art Nouveau featured in many of the national pavilions, and its reputation was secure from that time on, but it is also of especial significance that the enormous auditorium, constructed at great expense but with little taste in what had been the "Galerie des Machines" of 1889, should have been chosen for the showing of films. Certainly it was in the french interest to present the invention of the moving picture as their own; no-one in Germany had given such public acclaim to the Berlin film pioneer Max Skladanowski, whose work was undertaken independently of the brothers Auguste and Louis Jean Lumière, and not much later. But the expense must have been considerable. <u>M. E. Vavaseur</u>, contemporary illustration showing the projection of a film in the auditorium at the Paris World Exhibition. No less than 1.5 million visitors watched the showings on the screen, which measured 18 × 21 metres, from: Le Livre d'Or de L'Exposition de 1900, Paris 1900.

<u>Abel Truchet</u>, poster, France 1895, illustrating the contemporary fascination with the moving image: the tracks extend into the auditorium. Musée de la Publicité, Paris

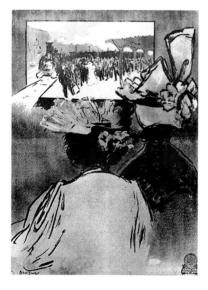

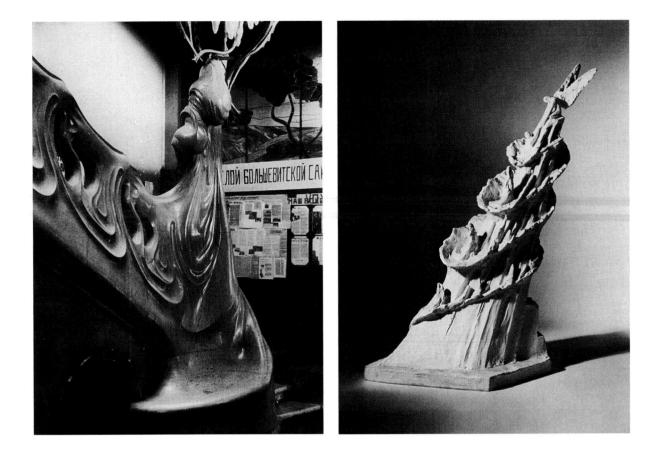

Unknown architect, stairwell in Moscow, c. 1900.

<u>Hermann Obrist,</u> design for a memorial,Munich, c. 1895, plaster, 88 cm high. Kunstgewerbemuseum, Zurich Film projection was a convincing alternative to a different means of telling stories by means of moving pictures: in the Russian pavilion a journey through Siberia was dramatically presented by means of panoramic pictures painted on the windows of jacked-up trucks rolling past, a mechanical means of suggesting movement familiar from the theatre. A special feature of the Paris exhibition was a pedestrian roller conveyor which circulated right round the show – this, too, a departure from earlier types of vehicle and moving platform. The continuous movement of the pedestrian conveyor gave an entirely different view from that gained by moving straight from one point to another, and back again. The same year, 1900, saw a further appearance by Loie Fuller in Paris. Her serpentine dancing, in a shimmer of coloured light, was such an inspiration to Art Nouveau artists that it is impossible to enumerate all the resulting illustrations and pieces of sculpture. They all represent an attempt to fix on a surface or in space something fundamentally intangible, but betray impotence rather than success. Nor could it be otherwise, for this was movement for its own sake, with few concessions to tangible gestures or mood. The most successful pieces are therefore those which reproduce no more than the swirling of robes, head and limbs subsumed within them. The personal element is abandoned in favour of pure movement.

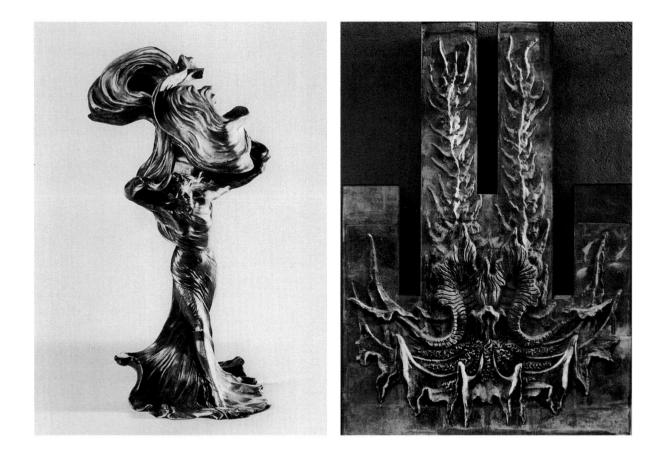

Loie Fuller was a phenomenon in more ways than one: like a piece of abstract sculpture she made movement an absolute, comparable perhaps to the beauty of a ship's propeller in water, except that the latter created propulsion, Loie Fuller only herself. When not in motion she must have broken the illusion; photographs which show her dancing in a meadow reveal the lack of sophistication in the twirling canes which she used to create her effects. She relied on the distancing artificiality of the stage to make her instruments invisible and create pure effect. The spell she cast could wreak havoc.

Immune to artifice and narcissistic excesses were those who could convey the magnificence of a mood or a gesture, like Hermann Obrist and August Endell in Munich, or who could convey compellingly the constructive nature of their thinking, like Victor Horta and Henry van de Velde in Brussels, Hector Guimar in Paris and Richard Riemerschmid in Munich. They were the torch-bearers, setting standards and justifying the identification, in the new experiments being made, of a new style. One feature common to all these artists is that their works seem mobile rather than static – shapes glide and leap backwards and forwards, up and down, interlocking and cleaving. In furniture, utensils and houses, too, an inner dynamism becomes visible. There is also a high degree of abstraction in these works which is distinctive and which distances from them the

<u>Raoul François Larche,</u> the dancer Loie Fuller, Paris c. 1900, bronze gilt, 46 cm high. Bayerisches Nationalmuseum, Munich

<u>August Endell,</u> relief, 1898, 425 cm high, formerly part of a sanatorium on the island of Föhr. Kunsthalle, Kiel

<u>Hermann Obrist</u>, embroidered "Whiplash" wall hanging, Munich, c. 1895, wool with silk, 120 × 185 cm. Münchner Stadtmuseum, Munich products of those artists who favoured the caprices of flowing hair, swans in flight and entwining mermaids.

In the light of these remarks it will come as no surprise that this book does not draw on paintings for its illustrations. The link between painting and Art Nouveau has always been controversial. To ascribe entirely, or in part, the work of Henri de Toulouse-Lautrec, Jan Toorop, Edvard Munch, Gustav Klimt and others, to Art Nouveau involves narrowing a concept which is too complex to be reduced to simple handling of line. There were often symbolist features in the subject matter of a painting which happened to be expressed in a form similar to Art Nouveau. The movement of a line is a less reliable criterion than the motivation behind it. This motivation is bound to be different when applied to an ornament, a chair or a house when relating to pictorial composition. The following pages will hopefully show that Art Nouveau did indeed manifest itself only in the applied arts, and that the term can therefore only be applied to objects, furniture and buildings. One of its paramount aims was to give useful things a useful, though enhanced, form, and it is by its own criteria and tenets that Art Nouveau must be judged. To bring in "art" in the form of painting simply confuses the picture and impinges on the avowed claim of the spokesmen for Art Nouveau, namely to proceed in the manner of artists, but not to create art.

So much has now been written on the subject that there is little point in embracing, generously but indecisively, the weighty and the fragmentary, the sublime and the trivial. The times in which these works were created are remote from ours, and a wealth of catalogues have provided detailed information on many matters. Important today is no longer the material in itself, but our attitude towards it, the view it offers us, and the insight it can bring. Critical appreciation may be distressing at times, but it is more appropriate than sentimental partisanship which applauds everything it sees and is unjust in its failure to differentiate.

It might be argued that there was inherent in Art Nouveau a tendency towards contradiction, ambivalence and indecision. Great claims were made, but far less was achieved – a reproach heard often, then as now. And why attempt to tie down a phenomenon so intent on freedom? It is an enigma, difficult to resolve. Yet there is in Art Nouveau's most successful products something deeply serious which can and must be pursued.

The ambivalence of Art Nouveau, and the protean shapes it took, were not generated by waywardness but by the situation which gave rise to it. Put in the simplest terms, this ambivalence resulted from the dissonance between art and technological progress which had been growing increasingly apparent throughout the nineteenth century and which now demanded urgent resolution. By 1900 the moment had come. Tension was released in an explosive burst of creative energy whose impact was felt far and wide. It explains, perhaps, why so much was produced in such a short space of time; but it suggests, too, that the situation was not one in which things could mature. Frenzy often propelled events, and something of the artificiality which characterized the climax – the 1900 World

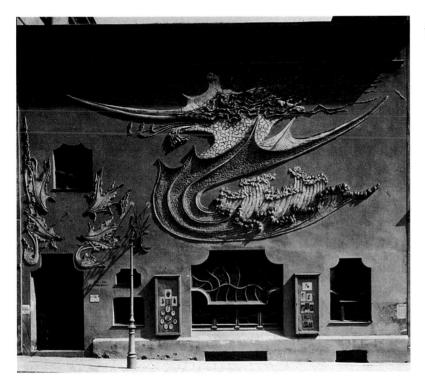

"Out of the unruffled spirit of the last twenty years of the nineteenth century a fever of enthusiasm suddenly arose throughout Europe. No one knew exactly what was developing, no one could say whether it was to be a new art, a new man, a new morality or perhaps a regrouping of society."

Robert Musil, Der Mann ohne Eigenschaften, 1930

<u>August Endell,</u> the Elvira studio in Von-der-Tann-Strasse in Munich, 1896/97.

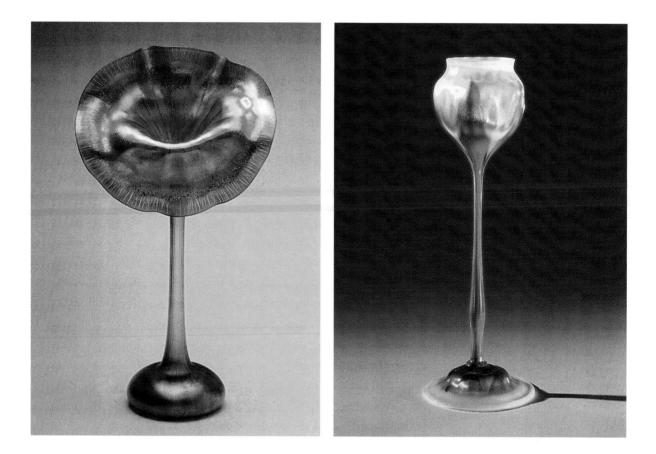

Louis Comfort Tiffany, vase, iridescent glass, New York, c. 1900, 45 cm high. Bayerisches Nationalmuseum, Munich

Louis Comfort Tiffany, decorative tulip glass, New York, c. 1900. Favrile glass, 34 cm high. Bayerisches Nationalmuseum, Munich Exhibition in Paris – was immanent in Art Nouveau. From the beginning it was in the public eye, which served to advance it, but also made it disastrously dependent on people's whims and fancies.

The dissonance to which Art Nouveau owed its existence – inasmuch as it is possible to discern a cause – had arisen because technological progress, as a new, now extensively autonomous phenomenon, indisputably provided increased comfort and efficiency, but was not considered to have any aesthetic value. Moreover technology was frightening in many ways, and it was commonly felt that its manifestations should be hidden behind art, or what passed for art. There were the familiar historicist attempts to adorn bridges, railway stations, exhibition halls and water towers with architectural frippery in accordance with accepted styles. The frontier between the traditional urban settlement and the open spaces of technical expansion – as represented by canals, rail links and industrial areas - was felt to be particularly in need of embellishment. Whatever was beyond the pale enjoyed a high degree of freedom, could no longer be held back, and was swiftly and surely taking on a shape of its own. Thus locomotives, gasworks, pit heads, steam hammers, rotary presses and, above all, the great architectural constructions in iron were among the most satisfying aesthetic achievements of the late nineteenth century. Unquestioning functionality produced beautifully uncluttered

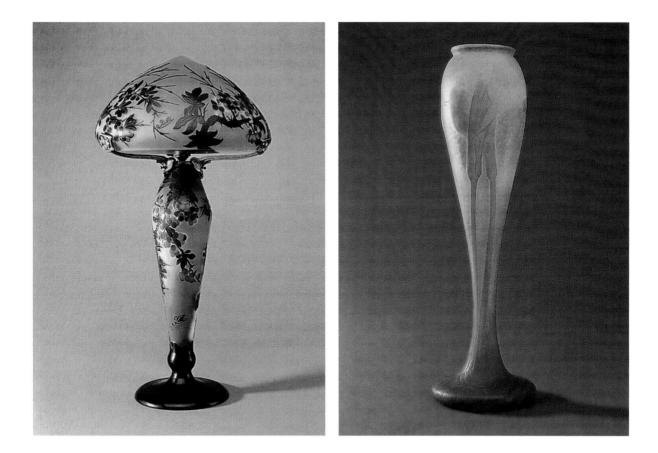

and boldly elegant forms, as could be seen repeatedly at the Paris exhibitions of 1867, 1878, 1889 and 1900. But the very impossibility of checking this autonomy led to the increased defence of the opposite camp. There was an unbridled proliferation of at times grotesque embellishments, ironically reduced in cost by new industrial means of production.

The aesthetic correction measures designed to counteract technology in fact were purely restorative. This is evident in the attempts made during the second half of the nineteenth century to pit industrial products against those made by hand. The catchword was handicrafts – that unfortunate no man's land between industry and art. In spite of Ruskin's quixotic endeavour to support skilled craftsmen in the face of industrial methods of production, it was only in the area of expensive luxury goods that opposition to factory methods could be sustained. Confrontation was senseless; traditional crafts could survive as an alternative option, but not in direct competition to mass production. Seen as the last defence of individual craftsmanship against the soulless world of technology, hand-icrafts became sentimentally escapist in style. The turn of the century saw a renewed upsurge of nostalgia.

This development is surprising in that the debate for and against the new methods of production had already been conducted in the nineteenth Emile Gallé, lamp with blackthorn pattern, Nancy, c. 1895, flashed glass with bronze mounting, 76 cm high. Katharina Büttiker Gallery, Zurich

<u>Antonin Daum</u>, vase with Calla blossoms, flashed glass, Nancy, c. 1895, 51cm high. Katharina Büttiker Gallery, Zurich

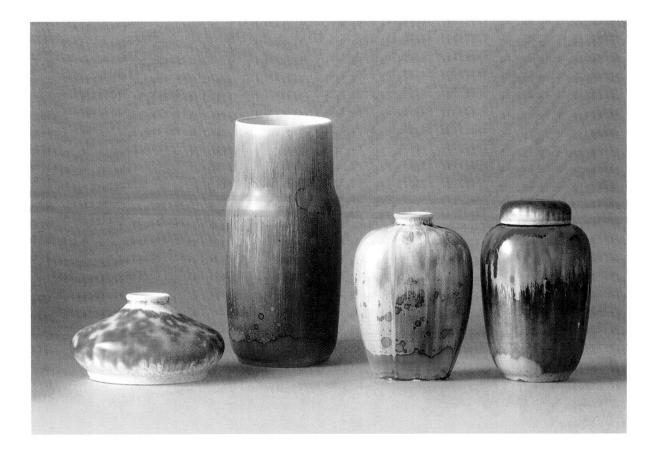

<u>Christian Valdemar Engelhardt,</u> three porcelain vases and a jar, Copenhagen, between 1895 and 1910, 14 to 24 cm high. Private collection, Munich century. William Morris had been the most forceful spokesman for arts and crafts, but he had also been the first to acknowledge its futility as a means of reforming society. Under Ruskin's influence Morris – irish and originally an author - turned to architecture, and later to the design, production and marketing of handmade goods. As an artist he belonged to the Pre-Raphaelites, but he rapidly moved away from their thinking. His ideas continued to be powerfully influenced by Ruskin, who led a passionate crusade against the progress of technology during the second half of the nineteenth century, exhorting people to return to traditional crafts in order to withstand the threat of disenfranchisement of mankind by machines. Ruskin wished to return the industrial labourer to self-employed activity, in order to liberate him from the slavery of capitalism. Labour conditions in England at the time were doubtless so oppressive that Utopian notions of this sort were an understandable response. Ruskin had in mind a solution to social problems, but also a salvaging of formal traditions. William Morris put enormous energy and drive into realising these ideals, which amounted to an idealised revival of mediaeval craftsmanship. He founded several workshops and underwent training in the different crafts. He turned out exquisite products which were of such good quality and so difficult to make that only a few rich customers could afford to buy them. Since the highest standards had to be applied to design and production – in order to distinguish them

from the prevailing bad taste of the times – the products could not be described merely in terms of "crafts". It was necessary to coin the phrase "arts and crafts", which resulted in a certain alienation and loss of relevance to most of society. Those who worked for Morris were to be counted fortunate, but could hardly be thought to exemplify the liberation of the working class.

Morris soon recognized the dilemma: that in competitive business terms crafts could only survive with the enhancement of art, and could only provide a living for a minority, whereas the original aims had been nothing less than a total reform of social conditions. He took the most sensible step possible by turning his attention direct to politics. In 1883 he became a member of the Democratic Federation, and two years later a founder member of the Socialist League. He sought a solution to the problems of society on the only level where such a solution could be found, but few were able to follow his line of thought. Although Morris had demonstrated the absurdity of Ruskin's ideas by faithfully putting them into practice, these notions retained their currency and were very much alive at the turn of the century.

As a designer Morris still had an enormous influence, his products were highly regarded and fetched high prices. He was a trail-blazer for Art Nouveau, which was beginning to emerge at the time of his death (1896). One of his keenest disciples, the Belgian Henry van de Velde, said in 1894: "Anything that benefits only one individual is almost useless; the society of the future will admire what is useful to everybody"*. But in this matter van de Velde and his generation were no more successful than Morris had been. Like him, they were obliged to cater for a public that

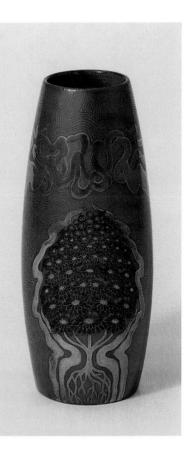

<u>Vilmos Zsolnay and Lajos Mack</u>, stoneware vase with luster decoration, Hungary, c. 1900, 31 cm high. Private collection, Munich

<u>Juriaan Kok</u>, three vases of eggshell porcelain, Holland, 1901–1903, made by Rozenburg, The Hague, 21 to 28.5cm high. Private collection, Munich

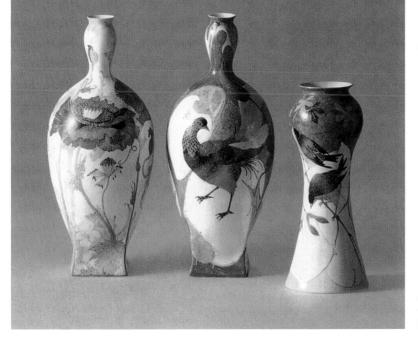

* Henry van de Velde: Säuberung der Kunst, 1894 lecture in Brussels, from: Kunstgewerbliche Laienpredigten, Leipzig, 1902

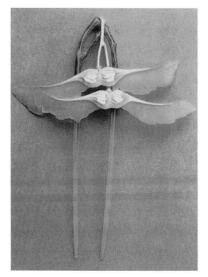

<u>Lucien Gaillard,</u> hairpin, Paris 1906, gold and horn. Museum für Angewandte Kunst. Coloane

Eugène Gaillard, chair from a dining-room shown at the Paris World Exhibition in 1900, polished walnut with embossed leather. Museum für Kunsthandwerk, Frankfurt/Main demanded the exceptional, and not the utilitarian item. The members of the Wiener Werkstätte (Vienna Workshops), for example, were almost always obliged to cater for exceptional needs.

The inheritance of the nineteenth century weighed heavily on its successors; to overcome it demanded extreme measures. The insistent individuality and inner restlessness of Art Nouveau can be understood as responses to the long period of artistic sterility which historicism had represented, but also as the expression of a compelling urge for reform at all costs. The destructive influence of historicism on the development of art was too severe for any moderate counter-movement to be effective. The rebellion, when it came, was in part purely artistic protest, but there were other factors to be taken into account. Historicism may well have arisen from a sense of insecurity caused by the abandoning of conventional aesthetic norms as a result of the autonomy of technology. Art Nouveau in turn could be interpreted as a kind of reflex response to the encroachment of technology on the traditional territory of art – on architecture, for

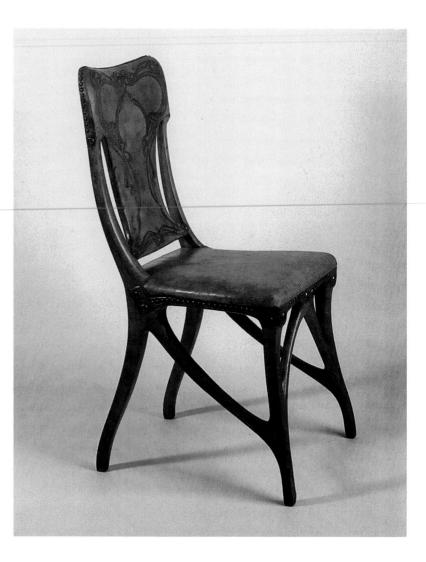

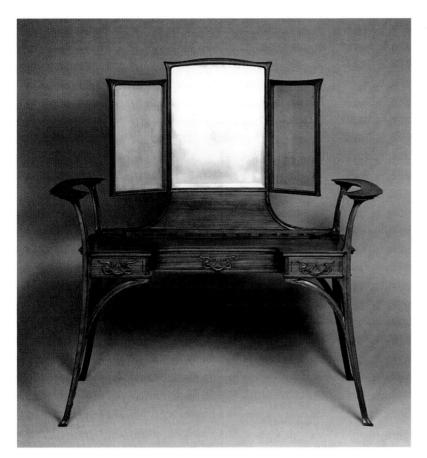

instance. To put it another way: whereas historicism attempted to defend its territory against the unfathomable phenomenon of technology by conjuring up the past, Art Nouveau risked an artistic salky into enemy territory in a bid to regain lost ground. It was a bold but desperate strategy.

It should be noted at this point that Art Nouveau and historicism, were in some ways similar, and that their- apparently large differences were in part a matter of internal dispute. Art Nouveau, like historicism, was a movement which promoted above all the interests of artists; if social reforms were pursued, then this was usually undertaken as from afar, without clear knowledge of the real social issues. Numerous artists at the time declared that they were "descending" to the design of furniture, household wares and cheapest possible forms of housing, but that did not mean that they were willing to be regarded as anything other than artists. They provided an aesthetic ingredient to objects where revelation of essential form would have sufficed. Sometimes this unveiling of the essence took place, but then as it were by chance, as an integral element of the whole.

The delight of new ornamentation could easily be a distraction, and where Art Nouveau turned its attention to domestification with aesthetic means at a general level rather than for individual commissions, its <u>Charles Plumet and Tony Selmersheim,</u> vanity table shown at the Paris World Exhibition in 1900.

Museum für Kunst und Gewerbe, Hamburg

<u>Hector Guimard,</u> design for a fireplace, Paris c. 1900. Musée des Arts Décoratifs, Paris

<u>Hector Guimard,</u> sideboard, Paris 1899/1900, fruit-wood with carvings, 217 cm high. Bröhan Museum, Berlin solutions usually reflected a doll's-house or popular character. Although there was no lack of good will in the recourse to folklore, the false note revealed the false foundations. This is particularly true of Art Nouveau in Germany, whose aims from the very beginning were higher than elsewhere in Europe. The German name for the movement, "Jugendstil", signified a whole set of intentions: not only did it have artistic associations, it also suggested a return to a natural way of life, youthful idealism and rejoicing in nature. The word is made up of two parts: "Jugend" = "youth", involving the renewal of exuberance and euphoria, "Stil" = "style", involving artistic conformity to a pattern. There was a fundamental contradiction between the two, since youth will always tend to avoid strict rules. Either *Jugend* was not genuine, or *Stil* was weakened. The attempt to unite opposites – revolution and its artistic course – shows just how complex, how paradoxical, and perhaps untenable the situation was.

There was something grotesque in the attempt to combine the technological concision of nineteenth century bridges, railways and machines with

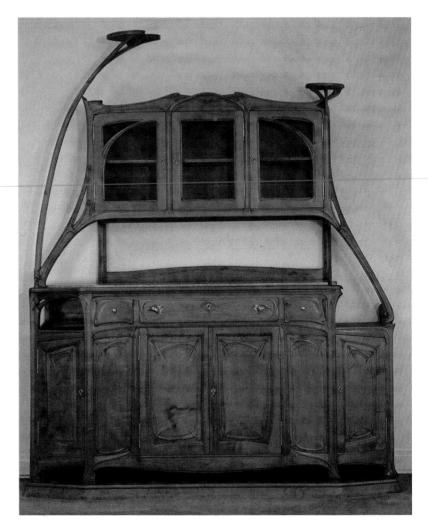

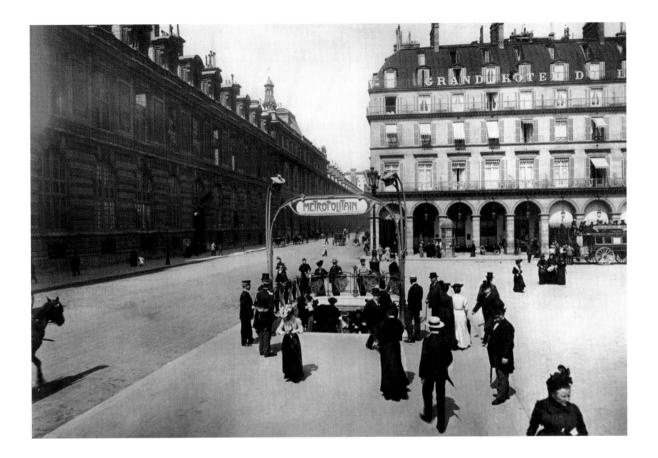

the artificial, ideologically overloaded world of Art Nouveau. What sense could there be in the whimsical Paris métro entrances, considered as part of the whole new underground system with its excellent design? Surely very little – yet at the same time a great deal, since they constituted the common ground between the old century and the new, between technology and art, between that which was hidden and that which was ostentatiously put on show. Doubtless it was unusually bold to abandon the historicist style – which might have shaped these entrances as miniature temples - and to build them instead in the nascent style of Art Nouveau. It might seem that the solution would have been to design them in exactly the same spirit of efficiency and relative simplicity as the underground itself, but that was clearly not possible in 1900, and would have run counter to expectations. The transition from the efficiency under the ground to the glittering street life of the metropolis demanded artistic lubrication; the result abounded in artifice. There was actually no good reason for these enormous ornamentals with their stylised tendrils. Yet they did have the effect of elevating the prosaic utility to something so unique that it could more easily gain acceptance. They celebrated banality in a way that was actually cynical, but also, for some people, pleasurable.

Perhaps that is the key: the new style had some most beguiling features. The historicist mask made it impossible to see technology in its essence, <u>Hector Guimard</u>, Palais-Royal metro station in Paris, c. 1900.

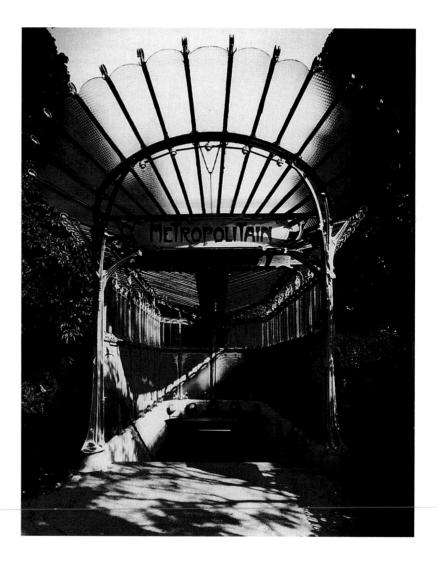

impossible to see functional, constructional, material relationships. Education of the senses, heightened sensibility was necessary if insights were to be gained, if anxieties were to be dispelled. Art Nouveau's way of seeing things could be very helpful in this respect, and this probably explains its popularity. Seen from this angle, the delight in ornamentation takes on a new meaning. In its most thoughtfully conceived designs it was not just decoration, not an added extra, but an expression of the whole. A key figure in this development was the Belgian Henry van de Velde, of whom mention has already been made. The dynamic contours of his designs are particularly expressive. Most of his early works were distinguished by an inner life which is not the result of naturalistic leanings but rather of extreme functionality. In this they were the quintessence of Art Nouveau: they represented a bold attempt to make economic necessity into an aesthetic experience, or, to put it rather differently, to make the purposeful pleasurable.

For example: one of van de Velde's best-known pieces of furniture is the

<u>Georges Chedanne</u>, editorial headquarters of "Le Parisien" in Paris, 1903–1905.

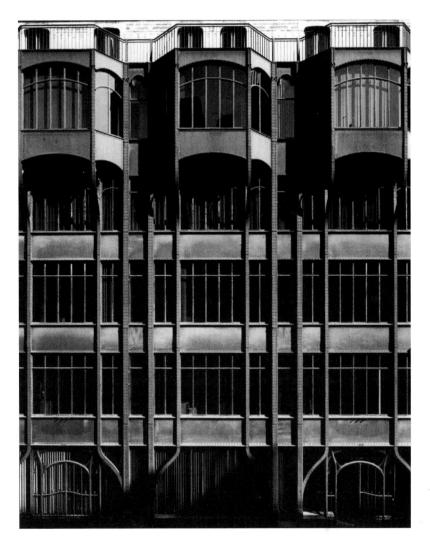

enormous kidney-bean desk created in 1899 that soon came to be his victual trademark. Although made of solid wood, the desk resolves into groups of sinuous lines. Lines of energy flow from one part to the next, give form to its interior and tension to seemingly inert surfaces. It has an idiosyncratic beauty which is more than just a matter of aesthetic balance. Every detail can be accounted for in terms of usefulness. The curving surface yields to the user's outstretched arms, the hollowed outer edge both strengthes and serves to house writing utensils. A broadening creates the base for a candlestick-holder at either end. This dominant sweep is echoed by a delicate band of brass drawn from one candlestick-base to the other, creating a small containing edge, and integrating the candlesticks organically into the whole.

The front of the desk harmonizes with the top. A single line curves round the opening for the chair and, on either side, the cupboards and drawers. This makes the plastic cohesion of construction very clear, but it also helps the viewer to focus on the centre of the complet. The boldly model-

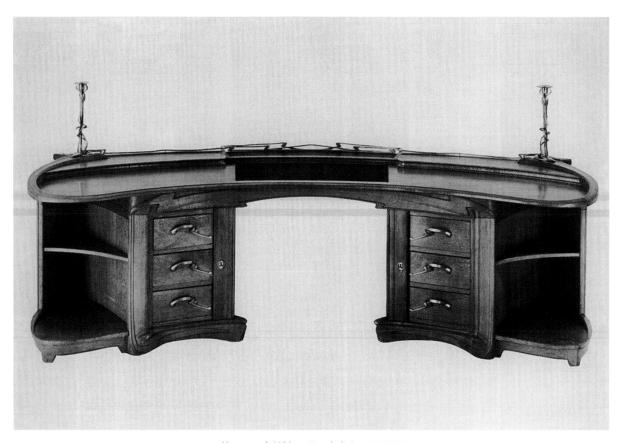

<u>Henry van de Velde,</u> writing desk, Brussels, 1899, oak with brass. Germanisches Nationalmuseum, Nuremberg <u>Henry van de Velde,</u> theatre at the Werkbund Exhibition in Cologne, 1914.

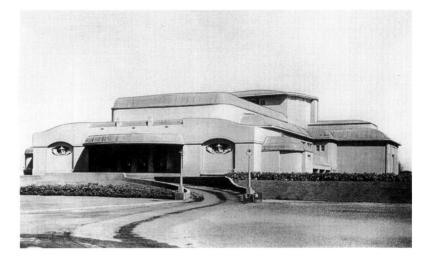

<u>Henry van de Velde,</u> chair, Brussels, 1898, walnut with ribbed upholstery. Hessisches Landesmuseum, Darmstadt

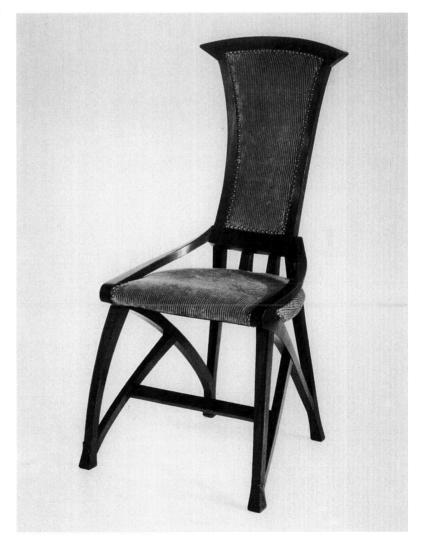

<u>Peter Behrens</u>, stoneware plate, part of a service, Munich, 1898, Villeroy & Boch, Mettlach, dia. 26 cm. Private collection, Munich

Unknown designer, vignette, c. 1900.

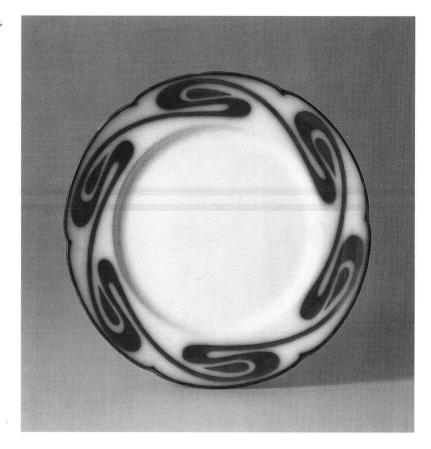

led relief has its own value, but also serves the overall effect. The concave spaces at the outer ends serve a dual purpose: they are useful as book-shelves and they contrast with the adjacent mass of wood.

Formal and functional elements combine in powerful symbiosis; neither is subordinate, the contrast makes each more dramatic. Every detail is at once ornamental and useful, which shows a highly unusual notion of a piece of furniture. The desk is not passive, but has an active message to convey in elevated rhetoric: things should not only be useful, their outer form should express their function. The desk must be desk through and through, in all its parts. Every detail must contribute to the elevated functionality which was van de Velde's ideal. The kidney-bean shape and the vigorous play of lines are intended to grip the viewer, to draw him in. The desk confidently demonstrates its own value and shows at the same time how marvellous it must be to work at it.

This detailed description has been accorded to a particularly fine example of Art Nouveau work; it would be possible to find equally remarkable works by other artists. An almost greater virtuoso in the intertwining of ornament and construction to form a single whole was van de Velde's fellow Belgian Victor Horta, who began to work in this manner as early as 1893 in Brussels (pp. 30, 31). Distinctive characteristics of a comparable nature can be found in the oeuvre of the French designers Eugène Gaillard (p. 18) and Hector Guimard (pp. 20–22), though in the latter

with less control. The same may be said of Antoni Gaudí in Barcelona, and in a broader sense of Charles Rennie Mackintosh in Scotland, and finally, in a simplified and straightlined form, of Bruno Paul and Richard Riemerschmid in Munich. Close scrutiny of selected characteristics reveals the similarities between these artists. Their analytically constructivist approach is a direct response to the challenge of the monuments of technology, the "accelerated" form of their individual aesthetic an indirect one. It is as if the rapid rhythms of machines had been drawn into their work. There was a risk that they might run out of breath, but for a time at least they held the pace.

Van de Velde was one of the few, perhaps the only one, who succeeded in sustaining over a long period the lofty aims professed at the beginning, without compromise or modification. The theatre design of 1914, for an exhibition in Cologne (p. 25), is in plasticity and functionality closely

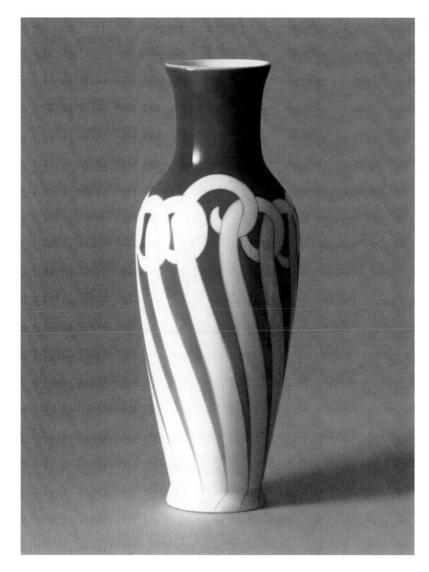

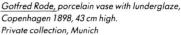

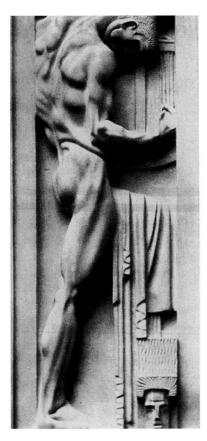

<u>Franz Metzner,</u> plaster design for a relief on Haus Rheingold in Berlin, c. 1905. Missing.

<u>Bruno Schmitz</u>, memorial to the Battle of the Nations in Leipzig, begun 1898, dedicated 1913, with sculptures by Christian Behrens and – after the Latter's death in 1905 – Franz Metzner.

related to the desk made fifteen years earlier; its parts flow into one another, yet each part has a clear function of its own. The aesthetic experience lies in the transition from analysis to synthesis which led to this entirely unconventional style of architecture, independent of any rigid basic form. The original commission was for something less challenging; van de Velde was "only" supposed to build a cinema in a limited space. He delivered one of his most inventive designs. Within the astonishingly ornamental ground plan the foyer swept right round the auditorium, taking advantage of the fact that no stage was needed to create a generous sense of space. Unfortunately this late symbiosis of Art Nouveau and cinematic aesthetics never progressed beyond the design. This survey of Art Nouveau has focused on a few basic characteristics, in order to preserve an overall view. More attention has been paid to aspects of culture in general than of art in particular, and the emphasis given to movement in design best serves to demonstrate the extent to which Art Nouveau was a response to external stimuli. Seen from this angle, it appears to be largely a reflex reaction to the impact of technology and its accompanying phenomena. But not all the developments emerging around 1900 can be accounted for in this way. This is particularly true of the extraordinarily concentrated developments in Vienna, and the work of Frank Lloyd Wright in Chicago. Progress here was less hectic and abrupt, there were no unexpected beginnings or rapid endings, and the results therefore had a timeless quality which is still valid today. The question arises as to whether the attribution of the Viennese and American works to Art Nouveau is apt. The era is the same and there are ample points of contact in style, and yet the underlying attitudes

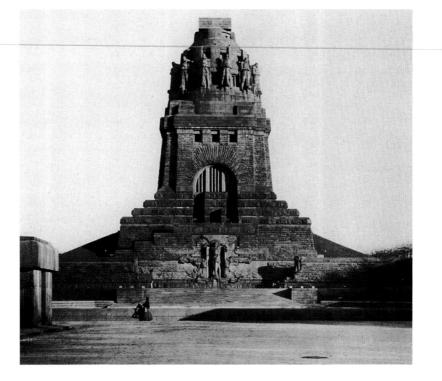

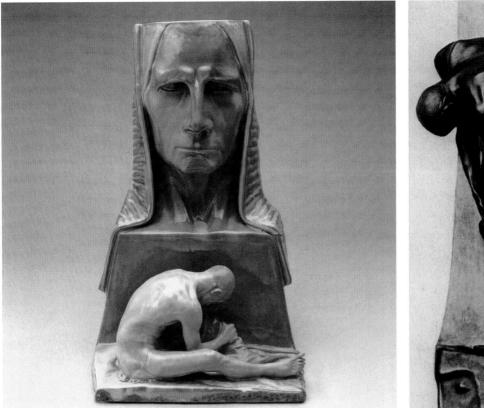

diverge. A case can be made for a view of Art Nouveau as above all a successful escape from the nineteenth century, as artistic fireworks bound to dazzle and then to fade, more an ending than a beginning, while in Vienna and Chicago the future was better served by intensity and calm. There was no need in these cities for violent external movement; clarity and control prevailed over protean virtuosity.

The same may be said for the many unremarkable examples of an artistic reform which took place at the turn of the century. Regardless of any name it may be given, its spectrum ranged from the delicate caprices of Juriaan Kok (p. 17) to the vases and boxes of an artist such as Christian Valdemar Engelhardt (p. 16), all of which pleasingly display much *Jugend* and less *Stil.*

The question of whether or not a generic name can be given where there is such disparity has no more than rhetorical value, since an answer has long since been given. There is a feeling that the artists of this era belong together, and the disparate unity has to include even Franz Metzner's suffering youths (pp. 28, 29) in their distress and resignation. Nothing is more transitional than this early stage of life, privileged to be unknowing and immature. <u>Franz Metzner</u>, "Sphinx of Life" vase, shown at the Paris World Exhibition in 1900, Königliche Porzellan Manufaktur, Berlin, 1898, 36 cm high. Bröhan Museum, Berlin

<u>Franz Metzner,</u> "Fate", plaster design for a grave, shortly after 1900. Missing.

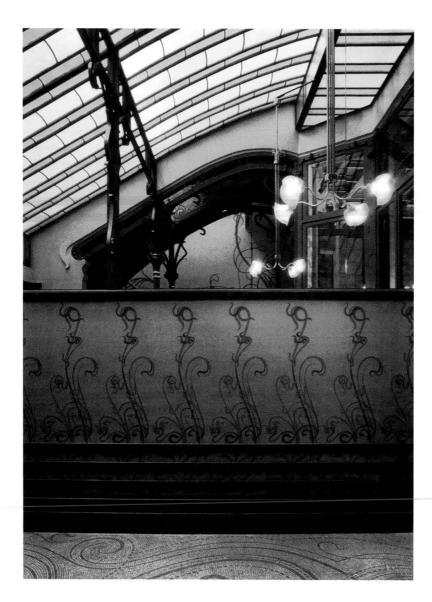

<u>Victor Horta</u>, staircase and mirrored side wall in the entrance hall of the Hôtel Tassel in Brussels, 1893.

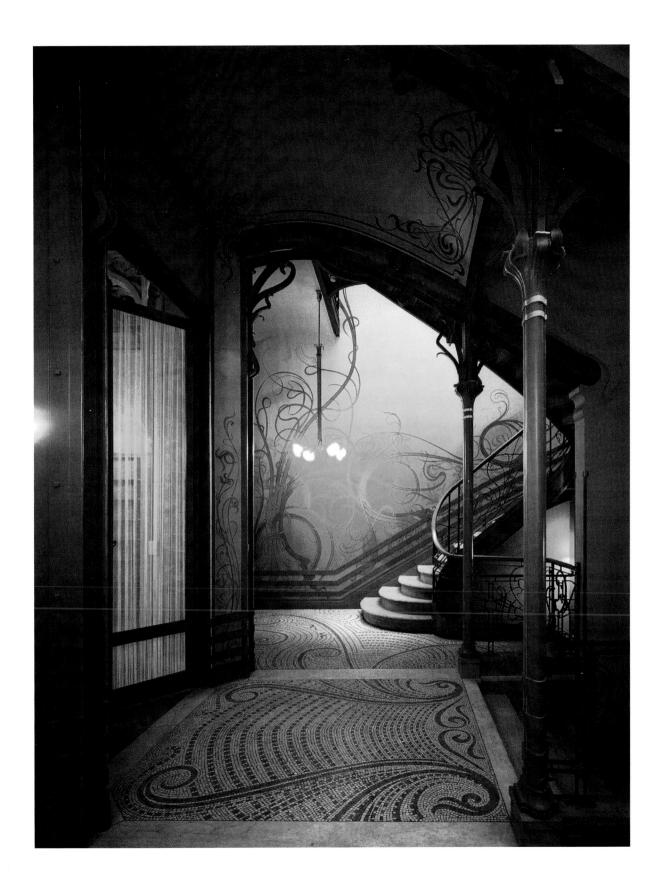

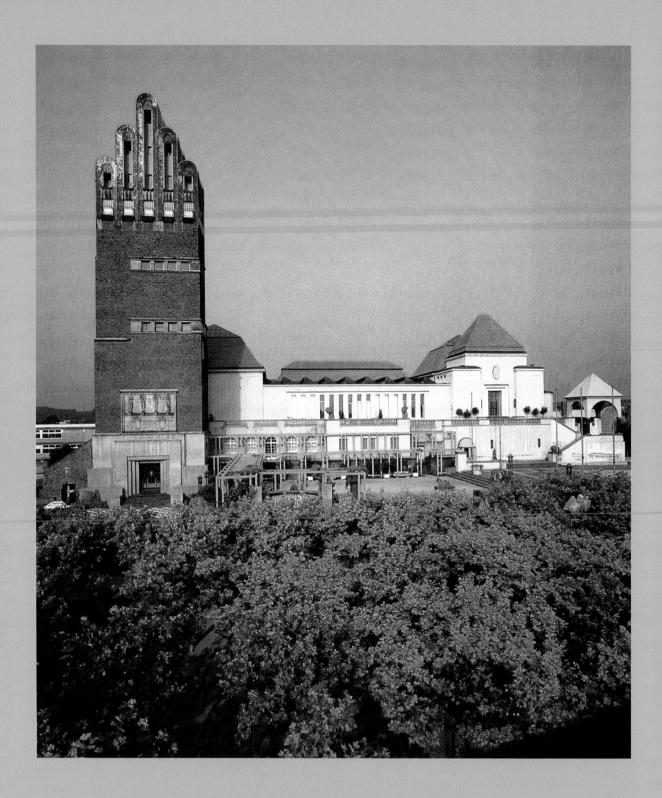

UNREST UPRISINGS IN THE PROVINCES

To see Art Nouveau only as a configuration of notions about art and about a better way of life is too limited. For one thing, it did not last long enough. The central focus of this fleeting phenomenon must be more complex. Leaving behind the confines of art history, with its tracing of derivational and attributional minutiae, and taking a more general topographical view, it is striking that the new departures are to be found less in the metropolises than in cities of more peripheral status. Glasgow, Darmstadt and Weimar, not forgetting Nancy, Barcelona and Helsinki. No doubt there was a lot going on in Paris, and Berlin was also involved, but not London, and certainly not Madrid. It is true that Munich was sometimes thought of as a city of culture, but usually with a certain benevolent condescension; Brussels was a capital city, but overshadowed by Paris and with a reputation for favouring the bizarre. In distant America there was surprisingly more going on in Chicago than in New York, for all the latter's apparent advantages. It is therefore the case that the provinces not only shared in the new developments, but played a major part in them.

The provincial cities had always enjoyed the right to transcend their limitations, indeed to utilise their situation in creating particular strengths. Nevertheless it is surprising that they should have achieved this with so sophisticated an art form as Art Nouveau, associated not without reason with the high public and private expenditure typical of the metropolis, in spite of all its claims to social reform. Moreover, one might have expected concern with the major issues of the time, which were not only of an aesthetic nature, to be concentraded in the chief centres of business and commerce, not at a distance from them; the idea of a new "Weimar" seemed hardly thinkable. But that is exactly what happened, several times over, in several countries, although of course with varying significance.

Title page: present-day view of the exhibition building on the Mathildenhöhe in Darmstadt, built by Joseph Maria Olbrich, 1905–1908.

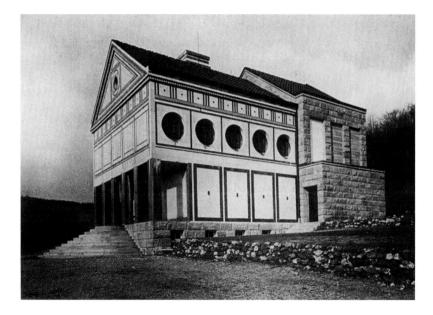

If one attempts not, as is often done, to highlight the specific characteristics of each individual place, but rather the characteristic that they all share, namely their location in the provinces, then a common factor emerges of more than just art historical import. Indeed, one comes to suspect that preoccupation with art history has releasted the most important factor to second place. The cumulation of initiatives undertaken by artists scattered in different places would scarcely have merged into one heterogeneous style without the play of other forces. Certainly there was enough publicity for artists to get to know one another's work, yet that does not sufficiently explain the overall coherence of Art Nouveau. lacking, as it does, a single dominant centre. If one looks more closely it is possible to see that the different cities did not on the whole stop at provincial civic pride, but saw their development as an important challenge. If Munich, Darmstadt and Weimar, as well as Dresden and Hagen, were bolder in their artistic endeavours than Berlin, it was a sign not of allegiance but of fully conscious confrontation with official imperial art policy. In other words, uprising. Brussels took further a development which had begun several decades earlier in Paris, but had in the meantime lost force and commitment there, thereby giving the Belgian metropolis an opportunity to emerge from the shadow of its bigger neighbour. Even more important perhaps was the opportunity for Brussels to re-iterate its central position as capital in a country where composition was appearing increasingly artificial. Nancy had an even more dramatic need to insist on its position, at the centre of a province not only dependent but also divided between France and Germany. The first signs of political injustice as a motivating force are unmistakable, and subsequent events confirm this even more clearly in the Finns' fight for freedom from renewed Russian oppression. There is not sufficient evidence in the case of Glasgow to say that there was a conscious setting out of Scottish

<u>Hermann Billing,</u> the Kunsthalle in Mannheim, 1907. (p. 34)

<u>Peter Behrens</u>, the crematorium in Hagen/Westphalia, 1906/07.

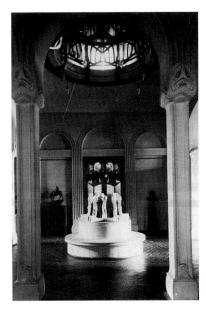

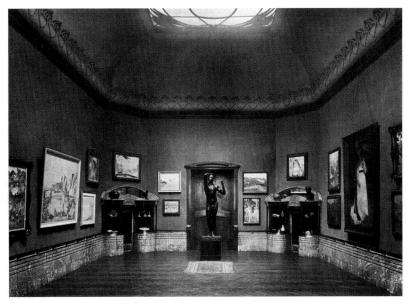

<u>Henry van de Velde, the entrance hall and the</u> large picture gallery in the Folkwang Museum in Hagen/Westphalia, 1901. interests as against those of England; although there were of course separatist movements, they had little to do with movements in art.

The most striking coincidence of political and artistic revolt took place in Barcelona, where both forms of revolt were made manifest in the life and work of Antoni Gaudí. Catalonia's claims to independence from the rest of Spain had been staked out several hundred years earlier, but they were articulated with particular vehemence around 1900. Barcelona is therefore a useful illustration of the thesis that at the end of the nineteenth century the minorities' revolt was not just a revolt by avant-garde artists, but one by the culturally and politically-oppressed provinces. The two groups of interests united, whether blatently or latently, and incontrovertibly to anyone not overly concerned with making the distinction between aesthetics and a clenched fist. The political ingredient makes it possible to see the dubious qualities of Art Nouveau as art in a different light. There is a heroic element in the attempts in these fin-de-siècle centres of unrest to have art function, if not as a weapon, then as a means of selfrealisation.

Art Nouveau had already defined itself as utilitarian by declaring its intention to serve useful ends in appropriate forms. It also had a commercial contribution to make, since its inventiveness excited curiosity which encouraged people to buy during a period of economic fluctuations. The new style was not welcomed as a means of camouflage only: it had strategic potential for the economy in that it helped to revive flagging industries and languishing crafts. No attempt was made to conceal this: the efforts to make Darmstadt and Weimar into centres of *Jugendstil* in Germany were inspired wholly or in part by the desire to help awaken – by buying in well-known artists – an aesthetic awareness in local industry, and threreby to help it to a wider and wealthier clientèle.

This might seem far-fetched if judged only on personalities, on the

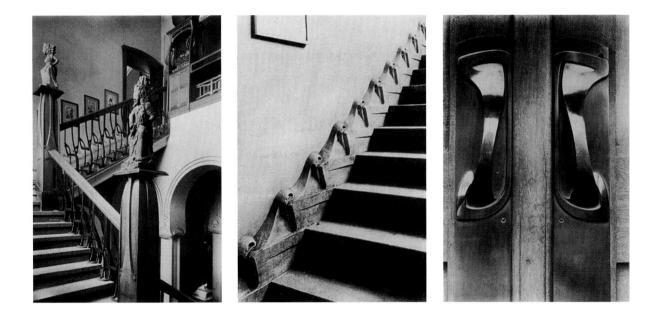

appointment of the Viennese architect Joseph Maria Olbrich to Darmstadt, or of the Belgian Henry van de Velde to Weimar. But in each case these appointments brought economic advantages and financial gain. This is a further indication that what counted most was not the link with a particular place, in other words something specifically artistic, but rather the potential of Art Nouveau to raise awareness wherever it might be. This quality enabled it to move easily from one country to another.

Mention of economy and commerce may seem detrimental to the image of fine art, but it is necessary. It is common knowledge that *Jugendstil* led to the setting up of new workshops in Munich, Dresden and elsewhere. It was less fortunate that unthinking mass producers followed it with kitsch. But there is another way of looking even at this: Art Nouveau was good for ever that. Economic aspects, too, belonged to the overall emancipation taking place with the help of the new style.

Darmstadt is the best example of the merging of these diverse interests and purposes. When Grand Duke Ernst Ludwig took up the plan of establishing a colony of artists, he initially had in mind ideals of a new way of life and its architectural expression, but under the motto of prosperity for his dukedom he also aimed to encourage the local economy. Ernst Ludwig was an astute leader and patron, and his aim was to develop an artistic alternative to the official image of the Prussianruled Reich. In this he displayed exceptional courage, and since he was related to the Kaiser the affront was particularly grave.

The brilliance of these endeavours can still be seen today, but history has extensively isolated it from the controversies of its original context. A sharp focus on everything labelled "Art Nouveau" can prevent one from seeing any parallel developments in art at the turn of the century other than those which serve to support or contradict one's thesis.

Art Nouveau was not the only style at the time, nor is it right to see

<u>Henry van de Velde</u>, stairs, detail of sidepiece and door handles in the Folkwang Museum in Hagen/Westphalia, 1901.

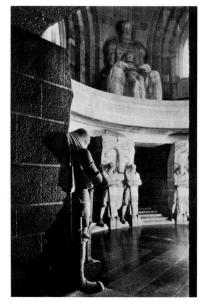

<u>Franz Metzner</u>, figures in the interior of the memorial to the Battle to the Nations in Leipzig, after 1905.

Wilhelm Kreis, Bismarck tower in Eisenach, c. 1900.

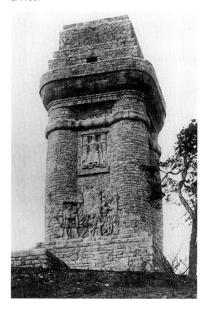

outmoded historicism as its only alternative. Its assertiveness all the more demonstrative for being tentative, the German Empire proved inventive enough to establish its own forms of expression. There was some plagiarism in this, but there were also new departures of great promise and originality. It comes as no surprise that these are most in evidence where history and power are involved. Wilhelmine aesthetics encompassed not only the pomposity of the Siegesallee and the cheap neo-rococo interiors of the imperial residence, but also the crisp functionality of battleships, and the monumental stone of numerous memorials which are not only imposing in substance but also remarkably powerful in form. Examples can be found in the many Bismarck monuments erected all over Germany; typical of this attitude was the most nationalistist memorial of its age, planned and begun even before 1900 the Leipzig memorial to the Battle of the Nations (p. 28). Distaste is understandable, but any assessment of the work should take into account its success in doing what it set out to do.

The disturbingly powerful impact of these monuments lies partly in the fact that they were designed more as architecture than as sculpture, which introduces a level of abstraction. There is some justification for seeing in them, rather than in *Jugendstil*, the beginning of the path which led to Peter Behrens' AEG factory and other similar buildings. The ambivalence of the historical colossus, unrelated as it may be in spirit to Art Nouveau, is all the more apparent when one considers that one artist might create work in both styles. The sculptor Franz Metzner was responsible for the topmost figures on the Leipzig memorial and for those in the interior, and the architect Wilhelm Kreis was a particular adept in erecting Bismarck towers. This ease of transition is exemplified by the avant-garde architect Behrens, who in 1901, one year after his appointment in Darmstadt, was chosen national artist for an exhibition hall which does indeed provide some justification for the title (p. 158).

Behrens displayed some virtuosity in occupying different positions. In the years that followed he received several commissions from the committed millionaire patron of culture, Karl Ernst Osthaus, in Hagen: from an clever design for an interior (1904), boldly extended to the exterior, by way of several villas, to the construction of a crematorium (p. 35), which had a certain propaganda value inasmuch as Osthaus was an active campaigner for cremation. It was probably natural inclination as much as the solemnity of the task that led the architect to develop to the full the monumental geometric style for which he came to be known after 1900. Only in the generosity of ornamentation, based on the theme of square and circle, was there any reminder of Art Nouveau.

Behrens was only one of the architects whom Osthaus liked to employ. Others active in Hagen were Riemerschmid and, at a later date, the strong-willed Dutchman J.L.M. Lauweriks, and above all van de Velde, who twice left his mark on the city: in 1901 with the extension of the Folkwang Museum (pp. 36, 37), begun in an impoverished historicist style; and later, after work on several other villas, with the Hohenhof, the private residence of the generous patron himself, who was possessed by the belief that art in all forms could rouse his ponderous city to new life. Although this attempt to transform a provincial city into a centre of art may seem contrived, it nevertheless possessed power, consistency and perseverance. Osthaus never tired in his undertaking and he retained a startling impartiality in his artistic judgement, as is shown by his choice of very different architects. Although most of his initiatives, which are too numerous to be listed here in entirety, were post-1900 in date and in style, the turn of the century was their starting-point.

The first project that Osthaus supported with his own means blazed the trail for many others. Van de Velde's completion of the Folkwang Museum was eminently successful on its own terms, and also gave the new art official sanction. Something that had seemed unthinkable in other places was now demonstrably possible: the Modern Style could be a museum style. Osthaus had chosen van de Velde as interior designer on the strength of his first publication, and his energy and commitment now enabled him to persuade the financier that the new building should be devoted to modern art rather than to a collection of minerals. Osthaus immediately made some excellent purchases and created an artistic gem which was far ahead of the great museums in content and concept in spite of its location in a provincial city unusually devoid of history.

<u>Fidus,</u> poster, 1902. SMPK Kunstbibliothek, Berlin

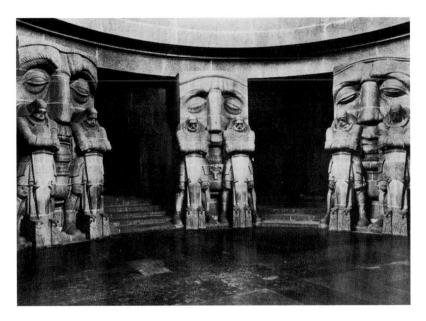

Franz Metzner, figures in the crypt of the memorial to the Battle of the Nations in Leipzig, after 1905.

Brussels

Although the founding of the Belgian kingdom in 1831 had been a logical conclusion, some uncertainty remained as to the long-term sense of waiting the two provinces of Wallonia and Flanders. It seemed all too clear that one tended towards France, the other to wards the Netherlands. Yet the prevailing tendency was one of solidarity, particularly after the repeated changes of allegiance of recent history. Patently, the only solution was an independent united country.

Until 1792 both had been part of the Habsburg empire, after which they were ruled by France until 1815. For the following fifteen years they were part of the newly created kingdom of the Netherlands, with Brussels, rich in cultural tradition, alternating with the Hague as capital – an artificial and laborious compromise. The strengthening of the economy after the end of the Napoleonic era gave increasing strength to the call for autonomy. In 1830 there was a dramatic turn of events: during a performance of Auber's revolution opera "La Muette de Portici" on August 25 in Brussels, rebellion broke out; the fight for freedom had begun.

The result was an independent kingdom of Belgium, with Leopold of Saxe-Coburg as its first regent. The new constitution was progressive, granting all citizens equality before the law, freedom of assembly and freedom of opinion, and ensuring the separation of Church and State. The function of the monarch was largely representative. Brussels became the capital, but in spite of all the changes it was able to retain its traditional role as the home of luxury industry, while the lively atmosphere made it increasingly attractive to wealthy newcomers from abroad. In 1900 various areas of the city provided homes for some 10,000 Germans, more than 5,000 French and some 4,000 Dutch. The population had grown from 125,000 in 1850 to 195,000 by the end of the century. Brussels in 1900 was considered a fashionable city, with wide boulevards, elegant shops and extensive parks to recommend it.

Yet the outer splendour could not hide the inner division of the country, and both were visible in the capital, in language as well as in society. The wealthy upper town was francophone, while most of the tradesmen, craftsmen and workers who inhabited the old city centre round the *Grande Place* spoke Flemish. The most important branches of industry were located in Wallonia, making the contribution of this part of the

Opposite page: wallpaper design by Henry van de Velde, Brussels 1895, one which he used frequently in his early interiors (cf. pp. 53 and 55).

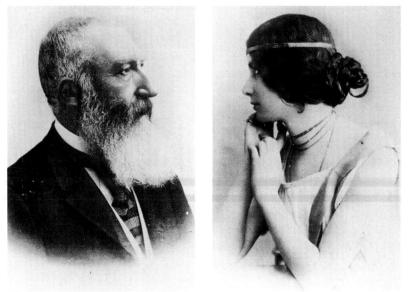

<u>Bruno Paul(?)</u>, caricature of the relationship between King Leopold II and the dancer Cléo de Mérode.

<u>Unknown photographer</u>, King Leopold II of Belgium, c. 1900.

<u>Unknown photographer,</u> the dancer Cléo de Mérode, c. 1900. country very significant. The prevailing cultural dominance of France in the nineteenth century created a different one-sidedness. The cultural superiority imported from outside reinforced the increasing social divisions within the country.

This somewhat schizophrenic situation led to certain eccentricities in Belgium which would hardly have arisen elsewhere. Since it was difficult to discern exactly what about the country was authentic and what was not, artifice could reign triumphant. The 1880s saw the erection of one of the most monstrous buildings of the time, the Palace of Justice, built by Joseph Poelart on the outskirts of the upper town. The labyrinthine concavity of the design was so powerful that it surpassed everything else in Europe. Less extravagant, but of bizarre splendour nonetheless, were the conservatories built at about the same time in the Laeken parks just outside Brussels by the new King Leopold II (1835–1909), who left his mark on the country more than any other monarch. They expressed his deepest desires so perfectly that he wished to die in them – a wish that was to be fulfilled.

His taste for the exotic had already led him to negotiate in Africa the private purchase of huge areas of the Congo. This was a most unusual undertaking, but one that demonstrates very well the boldness of the newly rich and the will to amaze, if not to shock, which Belgium was to teach the world. Entirely lord of his possessions, Leopold ruled his colony very seriously; later, when he had transferred his territories to the state, they turned out to be extremely profitable. It must have seemed that the steamy air of the conservatories could foster growth to other spheres when, at the end of the century, the king's liaison with the dancer Cléo de Mérode filled the gossip columns of Europe. It was in 1896 in Paris that the stiff-looking elderly king had made the acquaintance of this strikingly lovely woman, with her simple coiffure and middle parting. She too was Belgian, but she was forty years younger than the king. There must have

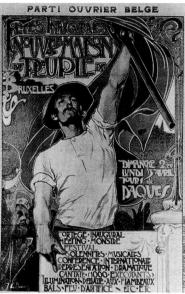

been something touching about the relationship: in spite of the gossip there were no jeers, and the king, re-named "Cléopold", suddenly seemed more human and likeable.

The monarch's private version of "youth Style" could be perceived as the culmination of the promising new departures visible on all sides, and there was no denying that it represented the fulfilment of a secret wish – the coupling of power with beauty. One of the figure-heads of nineteenth century imperialism had met the incarnation of art's new yearnings. The dancer Cléo de Mérode was an early forerunner of Isadora Duncan. Affairs between well-known wealthy men and exceptionally beautiful women were frequent enough, but Cléo de Mérode managed to retain a kind of sanctity, if not innocence. Half a century later she sought to deny that she had been a courtesan, and insisted in court that her role had been platonic and quasi-diplomatic. This had little effect on public opinion, it simply intensified the symbolic significance of what had been.

Royal dalliance contrasted with a quite different reality: in 1895, after long years of struggle, the Belgian Workers' Party, the "Parti Ouvrier Belge", had been founded; a year later the country was shaken by uprisings that were put down by radical military measures. This suppression ensured the support of intellectuals from more bourgeois circles, such as young lawyers and writers, who then influenced the internal and external development of the party. They added their voices to those who urged that the little known young architect Victor Horta should be allowed to build the "Maison du Peuple" in Brussels in 1897 (pp. 48, 49). The building was a forerunner of things to come: its clarity of design and construction fulfilled its particular purpose and function perfectly. The second exponent of the new art in Belgium, van de Velde, was also commissioned at an early date to provide the party with graphic designs. The Belgian Workers' Party was not only an active promoter and initiator, it was also open to new ideas from all sides. It was in close touch Victor Horta, the "Maison du Peuple" in Brussels, 1897.

<u>Jules van Riesbroek</u>, poster for the opening of the "Maison du Peuple" in Brussels, 1897.

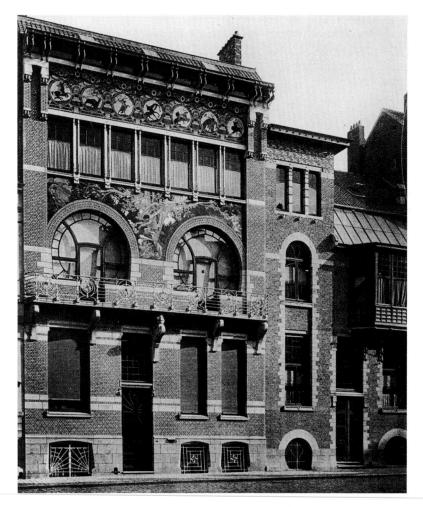

<u>Paul Hankar</u>, house of the painter Ciamberlani in Brussels, 1897.

<u>Gustave Serrurier-Bovy</u>, interior shown at exhibition in Liège, 1899.

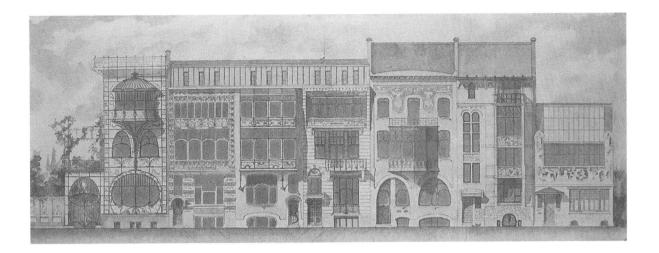

with literary circles as well as with artists' associations. All progressive forces made common cause, and unprecedented intellectual awareness animated Brussels as the century drew to a close. It was no wonder that the patrons of the avant-garde included young engineers and even businessmen who had gained an unusual degree of independence, some of them through service in the colonies. It was from these circles that Horta won commissions for the city residences that gave him free rein to put his architectural ideas into practice.

It would be unjust to omit the names of Paul Hankar and Gustave Serrurier-Bovy, who deserve historical mention before closer attention is paid to Horta and van de Velde. The two may be regarded as the inventors of the rib-and-spar style typical of early Art Nouveau, which van de Velde also followed for a time. Distinctive developments had already taken place; in particular there was a predilection for generously curving and branching forms. The strange mixture of clumsiness and daring in Serrurier- Bovy's furniture may be traced back to English models, whose influence he acknowledged. He was an important intermediary, as was the architect Hankar, who died aged forty in 1901 and whose completed œuvre was thus limited.

The constructive innovations clearly discernible, despite the decorative overlay in the work of Serrurier-Bovy and Hankar, were transposed from wood to iron, from craft to technology, from the traditional to the modern, by Horta. His work is a tangible manifestation of the new approach, attested for the first time in the entrance hall of engineer Tassel's residence in Brussels (pp. 30, 31). This work abounds in energy and verve, displaying the possibilities but also the hazards of the new style. It marks a new departure not only in time but also in its level of complexity.

The building's transparency and the use of slender iron components at once suggest an engineer's notion of space, but at the same time the sensuously decorative ambience suggests a wild jungle rather than a piece of architecture. There is elemental tension in the symbiosis of the rational and the artistic; neither dominates, yet the equilibrium is fluid. It is pointless to describe the decoration as self-indulgent or superfluous Paul Hankar, design for a terrace, Brussels c. 1900.

Paul Hankar, a shop entrance, Brussels c. 1900.

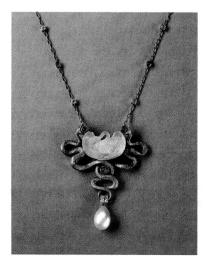

and, by implication, suggest the design could have been simpler and less organic. The aim was neither self-sufficiency, nor rational economy, but for mutual absorption. The flamboyant composition parallels the sophisticated blend of hard and soft in the chandelier by the Belgian artist Frans Hoosemans.

There was nothing new in using visible ironwork in interior decoration; it had often been done in the nineteenth century. What was unusual was to do this in a relatively unostentatious private house, where it could easily have been avoided. The dimensions of the entrance hall could have been achieved more conventionally, but at the cost of transparency. But this overall lightness must from the very beginning have been of the greatest importance to the architect; in the years that followed he strove for this effect with increasing virtuosity. A contributory exterior factor may have been the narrowness of the average Brussels building plot, which made it highly desirable that the interior should be made to seem larger than it

<u>Philippe Wolfers,</u> necklace, Brussels 1898. Private collection

<u>Frans Hoosemans</u>, candelabra, Brussels c. 1900, silver and ivory, 37 cm high. SMPK Kunstgewerbemuseum, Berlin

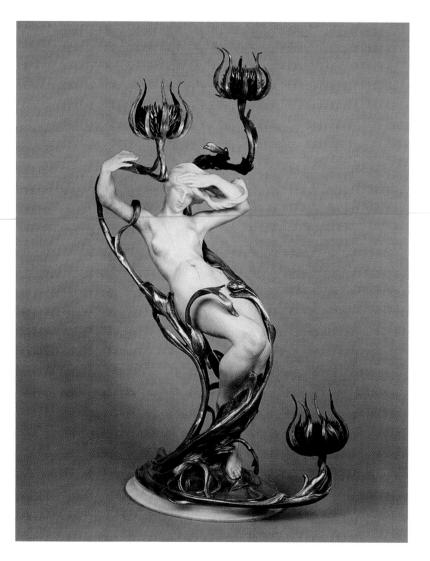

<u>Victor Horta, entrance hall of Hôtel Tassel in</u> Brussels, 1893.

Victor Horta, 1861-1947

Studied at the Brussels Académie des Beaux-Arts from 1881, and afterwards joined the office of neo-classical architect Alphonse Balat. With the villa for the industrialist Tassel, built in 1893, he created one of Europe's first definitive examples of an Art Nouveau building. He taught at the open university in Brussels, as from 1897, and from 1912 to 1931 at the Académie des Beaux-Arts.

Major works: the Hôtels Solvay, 1894, and van Eetvelde, 1897–1900; the headquarters of the Belgian Socialist Party, the "Maison du Peuple", which was commissioned in 1895. All buildings were erected in Brussels.

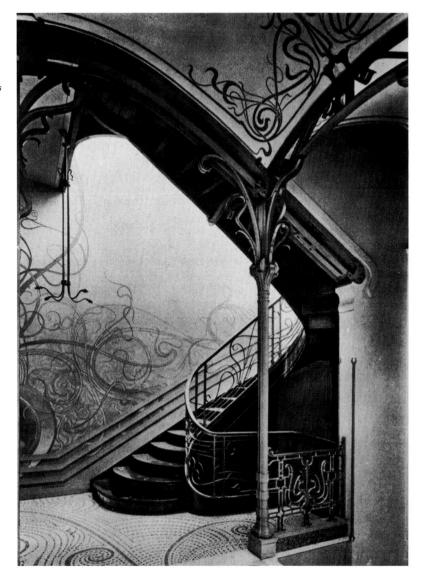

was. Glass roofing, with light falling through open stair-wells to give a sense of vertical expansiveness, or mirrors facing one another to extend the image of the rooms to infinity, served this same purpose. Horta did far more than meet this simple need: he developed from it an artistic principle. In the Hôtel Tassel the first signs of this distinctive treatment of space can be observed.

The use of plant motifs in the ironwork followed classical models, but the use of the material was original. Most unusual is the treatment of the upright beneath the staircase. It is subdivided into several parts, possibly a structural solution, although more probably done for purely aesthetic reasons. The joist is thereby absorbed into the overall composition. The curve leading to the next upright grows out of its branches, illustrating in visual terms the point of load transferal. Remarkable also is the thought-

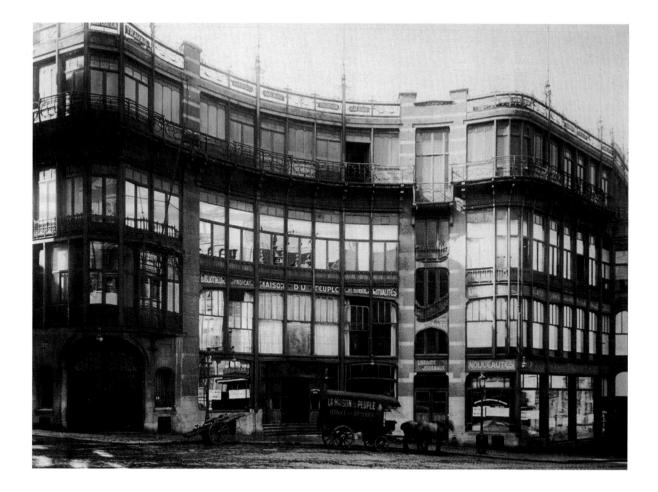

<u>Victor Horta,</u> the "Maison du Peuple" in Brussels, 1897.

ful design of the support, the sensitive point where stone and iron interlink.

Turning to the decorative elements of construction, it is immediately evident that they seek to compliment their plastic counterparts, possessing both supporting and supplementary functions. The spirals on flooring and walls enhance the upward movement of the spiralling staircase. The banister, seemingly static at first, is drawn upwards too. This maximizing of the use of decoration is idiosyncratic but by no means arbitrary. Every detail was rationally thought out and stylistically cohesive – which was not the case in less successful imitations. The unity of the whole was not only maintained but intensified, there was no lessening of the architectural achievement, and yet a daring re-evaluation of established tradition had taken place.

Compared with the complex interior of the house, the façade is rather simple: only in the middle section is there any sign of the transparent inner quality, with ironwork set into the stone. Quite different is Horta's major early work, the "Maison du Peuple" in Brussels, in which walls seem to have been eliminated, only rudiments of masonry are to be seen, and the building is reduced to a mere skeleton. Large windows and slender iron ribs are dominant. Here Horta was totally successful in transposing his architectural concept from the interior to the exterior. Since the irregularly-shaped site adjoined a circular *place*, Horta took the opportunity of expressing the flexibility of his basic principle in sweeping contours. The façade thus resembles a folding screen whose wings could have taken a different angle (this suggested mobility) was ultimately catastrophic inasmuch as the building was pulled down in the 1960s without a qualm). Again the use of iron as such in the building was less startling than the way in which it was used, this time quite independent of classical models. Whereas in the Hôtel Tassel it had been part of the decoration, its use in the "Maison du Peuple" was unpretentious, almost cheap. The structure of the building was undisguised; only the light curves of the central supports alleviated somewhat the prevailing sparseness. The result was not exactly beautiful, but it was uncompromisingly honest; it made no attempt to gloss over its factory-like exterior.

The "Maison du Peuple" was of great significance not only as an architectural manifesto, but also in its designated purpose as a socialist "House of the People". It is unlike anything else that Horta built. Subsequent commissions obviously required more display of wealth. This is noticeable in two department stores built in Brussels in the early 1900s. The steel façade of "A l'Innovation" expands into one enormous window, while the "Grand Bazar Anspach" (p. 50) was built in a mixture of steel and stone, with relatively moderate use of glass. What is interesting in the latter building is the plasticity and mobility of forces playing upwards from the lower half und forwards from the upper half, a most ingenious way of demonstrating how loads can be absorbed and transformed into architectural components. Horta had once again proved himself the leading architect of the new style.

<u>Victor Horta</u>, detail of the façade, and the conference room in the top storey of the "Maison du Peuple" in Brussels, 1897.

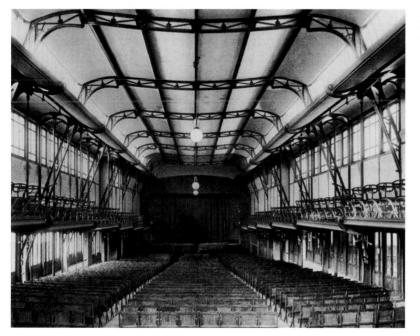

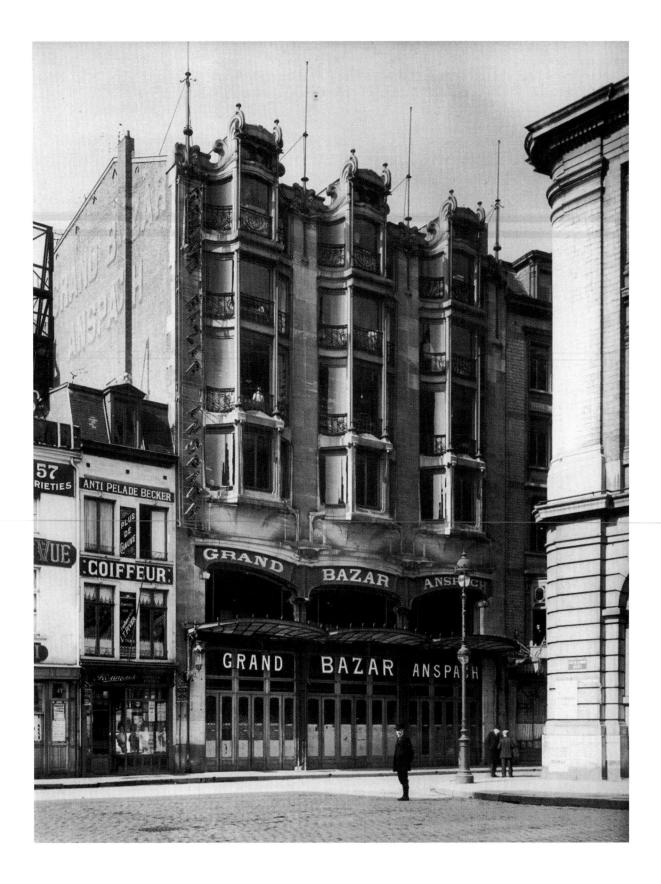

<u>Victor Horta,</u> the "Grand Bazar Anspach" department store in Brussels, 1903.

<u>Victor Horta,</u> door handles in the Hôtel Wissinger in Brussels, 1895/96.

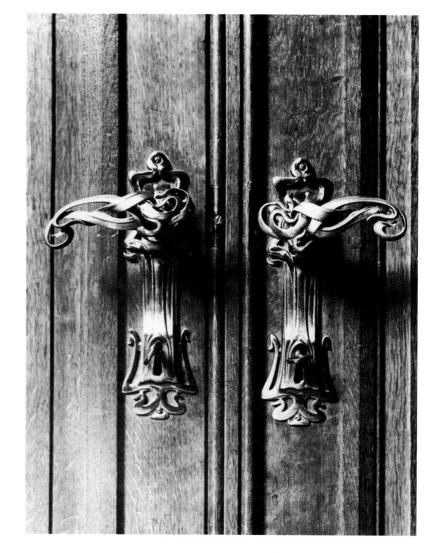

Horta's work could have sufficed to secure for himself and his country a high reputation. But he was to be outshone by another Belgian artist, whose career was only just beginning. Henry van de Velde was a rival to Horta not so much because of his œuvre but rather because of his ideas and his presentation of himself as an artist. Horta was the skilful, selfassured professional who had actually studied architecture, whereas van de Velde was more the type of the languishing modern artist, tentatively seeking to establish his position. Since van de Velde was gifted in rhetoric and self-presentation, he had far more popular appeal, and he let his public participate in his quest for true art. Moreover, his attempts to provide a theoretical grounding for what he did were intriguing.

He had started out as a talented painter, assimilating and imitating in succession the styles of Claude Monet, Auguste Renoir, Vincent van Gogh and others, before coming to rest temporarily in the Pointillism of Georges Seurat. But the unavoidable crisis came and he realized that the fine artist's existence was not likely to satisfy him, personally or

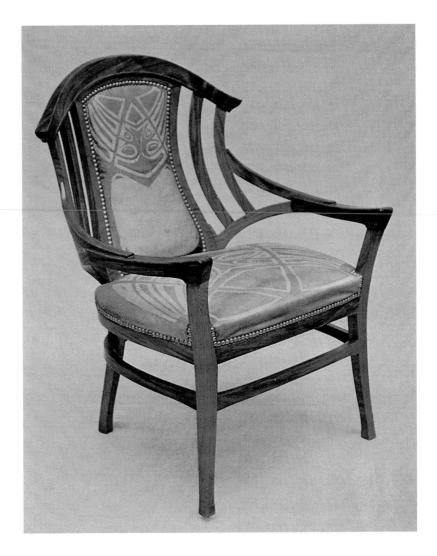

<u>Henry van de Velde,</u> chair, Brussels 1898, padouk wood with batik upholstery. Nordenfjeldske Kunstindustrimuseum, Trondheim <u>Henry van de Velde,</u> interior in Brussels, 1899, from: Innendekoration XIII, 1902. Now in the Museum voor Sierkunst in Ghent

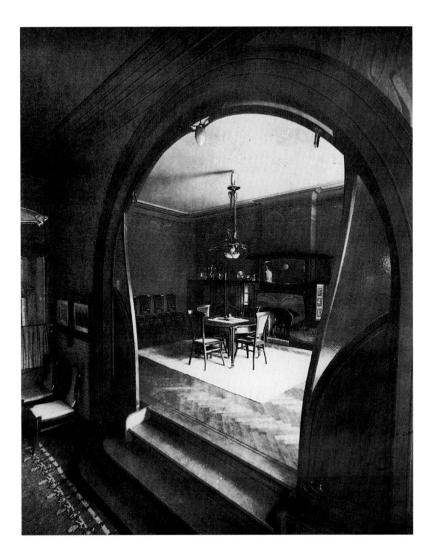

Henry van de Velde, 1863–1957

Studied painting at the Academy in Antwerp from 1881 to 1884, and joined the avant-gardist Brussels group "Les Vingt" in 1889. From 1901 onwards, he was artistic advisor at the Weimar court of Grand-Duke Wilhelm Ernst; from 1906 to 1914 he was director of the newly-founded Weimar school of Applied Arts. He emiarated to Switzerland in 1917. In 1925 he founded the Brussels "Institut Supérieur d'Architecture et des Arts Décoratifs", of which he was director for ten years. He spent his retirement in Switzerland. Major works: the Karl-Ernst-Osthaus Museum in Hagen, 1907/08; the Villa Hohenhof in Hagen, 1907/08; the theatre at the Deutscher Werkbund exhibition in Cologne, 1914; the Rijksmuseum Kröller-Müller in Otterlo/Netherlands, 1936-1953.

philosophically. About 1893 he turned in consequence to the applied arts, motivated in part by the opportunity of building a house of his own for himself and his young family. He was able to reinforce his claim to be an architect and furniture designer despite lack of training.

Up to this point van de Velde's development was not atypical; in Germany Behrens, Riemerschmid, Berhard Pankok, Otto Eckmann and others were experiencing similar changes in their way of thinking. They were turning from the free life of the isolated artist towards more direct social obligations, following in the footsteps of William Morris, who had tried years earlier to unite in his own person the writer, the craftsman, the painter, and the committed socialist. The hub of his activities was in his own workshops; he designed for them, and at the same time they represented his ideal of the workplace. In Belgium van de Velde was his most ardent disciple, and did much to spread his name on the continent. Horta's ironwork architecture had been inspired largely by French mod-

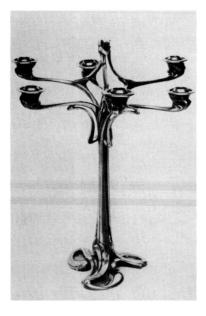

<u>Henry van de Velde,</u> candelabra, Brussels, 1899 or earlier, silver-plated bronze, 59 cm high. Nordenfjeldske Kunstindustrimuseum, Trondheim

<u>Henry van de Velde,</u> bookcover, Brussels 1895. Museum für Kunst und Gewerbe, Hamburg els, and he remained close to France in style, while van de Velde championed forms and ideas from further north. Not only was Morris acclaimed in lectures, he was also followed in practice. The agreeably unpretentious house – "Bloemenwerf" – that van de Velde built himself in 1895 in the Brussels suburb of Uccle was a first step in this direction, and the frequent use of materials and wallpapers designed by Morris in van de Velde's early interiors is a direct tribute. Even more decisive was van de Velde's decision to go into business himself.

It was inevitable that he and Horta should become rivals. Some of the commissions that he undertook for wealthy Brussels homes were comparable to interiors designed by Horta, but less elegant, and less bold. Van de Velde's anglicized insistence on first principles was too doctrinaire for Belgian taste; the French nuances of Horta's work found more favour. It must therefore have been something of a relief for van de Velde to move to Germany around 1900, where earlier encounters had suggested an affinity with his artistic philosophy and with his trend-setting aims. He was acknowledged as the preceptor he wanted to be, and the response to his work was from the outset lively, and usually positive.

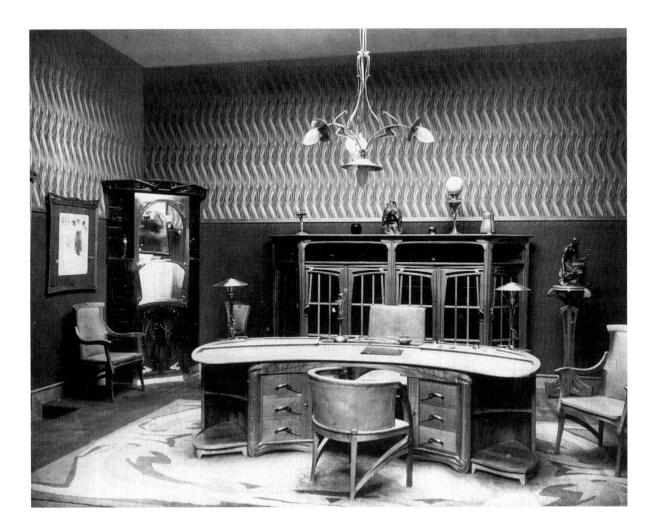

Berlin was a suitable place for him to live and work in 1900/1901; the city was in some ways very like Brussels, and offered the very possibilities that had previously been withheld. Both cities had something of the nouveau riche, but were nevertheless daring and unconventional. Van de Velde made good use of his time in Berlin, became a leading figure in the art world and executed some spectacular commissions. His connection with the Hohenzollern art and crafts workshops seemed at first to guarantee work of high quality, but it turned out not to be the case. In order to deliver products that were at all competitive in price, the proprietor, Wilhelm Hirschwald, had to have van de Velde's costly designs carried out by cheap labour. The great ideals of the Uccle era were lost, and could only be retrieved in part during the later years in Weimar.

Van de Velde's time in Berlin was justified by his success there as an artist. Everything that was distinctive in his work came to maturity during this time, above all the strongly suggestive quality of his style. Particularly inspired are some of his designs for business premises – in other words, rooms attracting a broad public – such as the Havana Tobacco Co. store or the elegant salon of imperial barber François Haby. He saw their

<u>Henry van de Velde</u>, study shown at the Munich Secession exhibition in 1899; the desk is almost identical to the one shown on page 24.

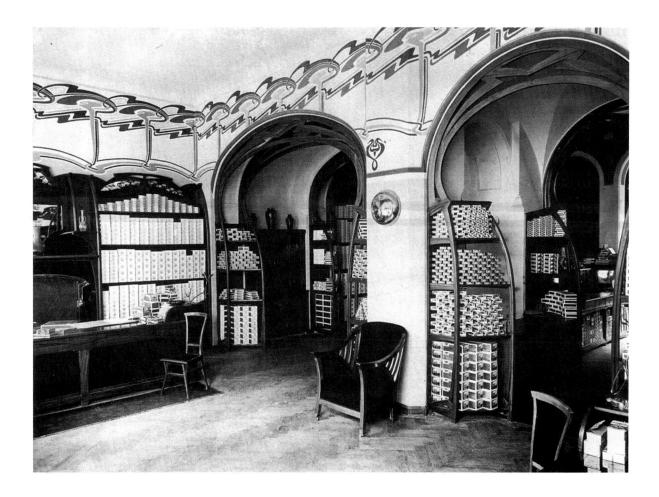

<u>Henry van de Velde,</u> premises of the Havana Tobacco Company in Berlin, 1899. didactic potential. In each there is a symbiosis of construction and ornament, of usefulness and edification. Both merge seamlessly, their functions never restricted to the one-dimensional. In the tobacco store the ribs of the shelves prepare for the wall above; nor is this linear cycle a purely formal element, but echoes the upward spiralling of cigar smoke, in response to the purpose of the rooms. Even more spectacular is the matching of form and function in the barber shop: all the pipes were openly displayed instead of being concealed, as was customary, behind the fixtures. The all-important gas and water pipes flowed smoothly over wood and marble, making their technical indispensability into a unique aesthetic experience.

The reaction was predictable. The artist Max Liebermann's comment on the display was that nobody after all carried his own colon around as a watch-chain. That was correct, but the comparison was not entirely apt in that he presupposed an organic starting-point whereas van de Velde prided himself on its very rejection. His abstract linearity was intended as a direct expression of constructive logic, dispensing with traditional forms. In this he went further than most of his co-founders of the new style. All too often innovation had consisted in little more than a fresh disposition of plants, tresses and waves. He outdid even Horta, whose designs,

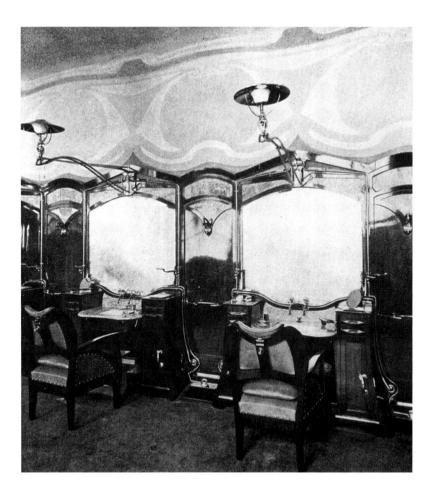

<u>Henry van de Velde,</u> the salon of imperial barber, François Haby in Berlin, 1901.

however bold, were ultimately drawn from botanical models. Van de Velde may not have invented the symbiosis of art and engineering which triumphed at the turn of the century, but he was its most radical practitioner.

While he was busy disciplining his forms, bringing them into line with his own theorising, Horta was continuing his career as both an academic and courageous architect in Brussels. His comprehensive training ensured him the enormous virtuosity which is most in evidence in the increasing numbers of wealthy city houses which he was now able to build, continuing what had begun in the interior of the Hôtel Tassel. As before, the challenge was to create a sense of opulence and spaciousness where little space was available. This was realised in a more modest way in his own house. The manner in which Horta transforms an almost incidental support at the foot of the stairs into latticed iron is indicative of his intentions. This early hint, given as one enters the house, prepares the visitor for the climax at the top of the stairs, where a glass ceiling arches over the hall. Two mirrors facing one another on either side contribute to the sense of space explosively extending in all directions. Lamps set in clinging tendrils add further complexities to the ingenious game of illusion.

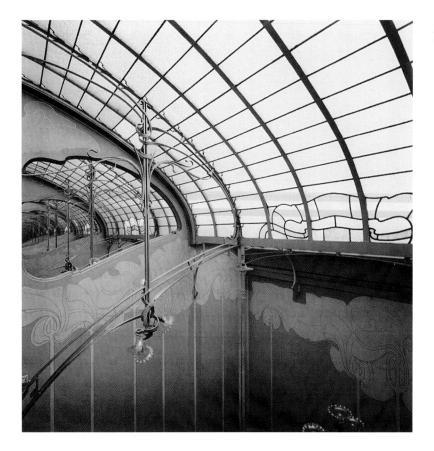

Victor Horta, the upper end of the entrance hall and stairwell in his own house in Brussels, 1898–1900.

There could be a staccato lack of cohesion in such effects, but in the Hôtel van Eetvelde Horta succeeded in subordinating the entire design to a single concept (pp. 61, 63). The ground-plot, again narrow, is the foundation for a serpentine movement which begins with the front door set in the right side of the façade, continues diagonally as a corridor across the lower ground floor to become, against the left side wall, a rising circle whose diameter corresponds to the breadth of the house. Together with spatial ascent there is an increasing sense of ascent towards the light. A few steps lead up to a landing which gives access on the one side to an octagonal room, on the other to a passage leading through to the neighbouring house, which Horta had built a few years earlier. The ascent continues, following the spiral away from the side wall, more towards the main axis of the house and up to the main floor. There is access to a large reception room towards the back, and various smaller rooms. But the visitor is drawn ever upwards, to complete the circle. His path leads around the open, round room, almost too brightly lit from above, to the front of the house, where a large room fills the entire width. A glass bay leads back inner to the centre. This is the magnificent culmination of the movement begun at ground level and governing the whole house.

There are few other examples of such a high degree of architectural inventiveness in movement from one floor to the next, or in penetration of

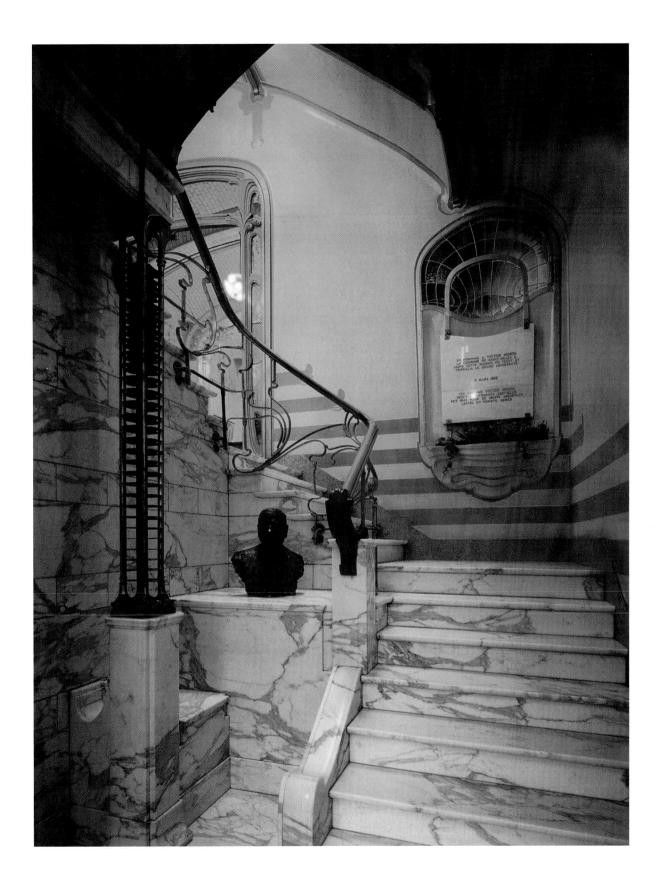

the organic interior of a house. It may well be that the need to provide a link, half-way up, with the house next door was decisive, but the link (no longer there today) could have been been accomplished with a linear design. The ingenuity of the round space with the spiral ascending its circumference is both original and yet a transposition, in a sense, of the familiar Art Nouveau motif of body or plant embracing a vase. It comes as no surprise that the central room of the Hôtel van Eetvelde is a filigree structure of glass and iron. The façade, too, has a limber quality of design which contrasts strikingly with the massive stone frontage of the neighbouring house.

Horta achieved even more striking effects with the town-house built for the rich manufacturer Solvay in the expensive Avenue de Louise (pp. 60, 62). Again the house was part of a terrace, but with rather more space than was usual in Brussels. The façade anticipates some of the features of the "Grand Bazar Anspach" (p. 50), the upward movement of the main floors enabling one to see the architect also as sculptor. Inside, vertically transmitted light meets horizontal light. Almost the entire storey dissolves into glass walls and windows, some which slide. The whole floor can be taken in at a single glance. It is hard to say whether the impression is <u>Victor Horta,</u> Hôtel Solvay in Brussels, 1895–1900.

more daring or festive: again the ironwork is undisguised, here joined by wood and marble of the highest quality.

This must have seemed to exhaust the full range of possibilities available to Horta. More conventional features began to appear in his work and the details took on a somewhat routine look. He had never pursued unity of style with anything like van de Velde's zeal; he was always more of an architect than a designer of furniture, balustrades, lamps and so forth. It is therefore understandable that while he remained a significant architect, he showed himself capricious in style. <u>Victor Horta,</u> the Hôtel van Eetvelde duplex in Brussels, 1897 and earlier.

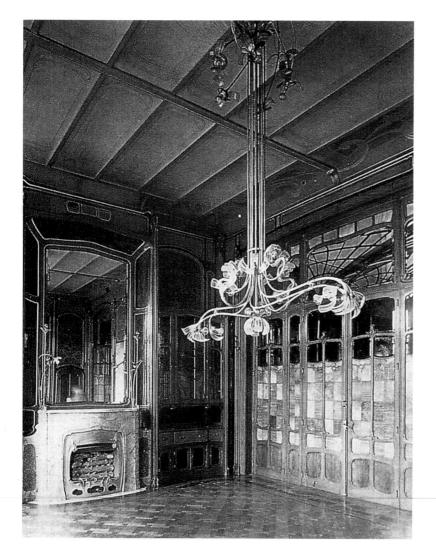

Victor Horta, dining-room in the Hôtel Solvay in Brussels, 1895–1900.

<u>Victor Horta</u>, central hall in the Hôtel van Eetvelde in Brussels, 1899. In the right of the picture are the stairs leading up from the ground floor, and in the background the large room overlooking the street.

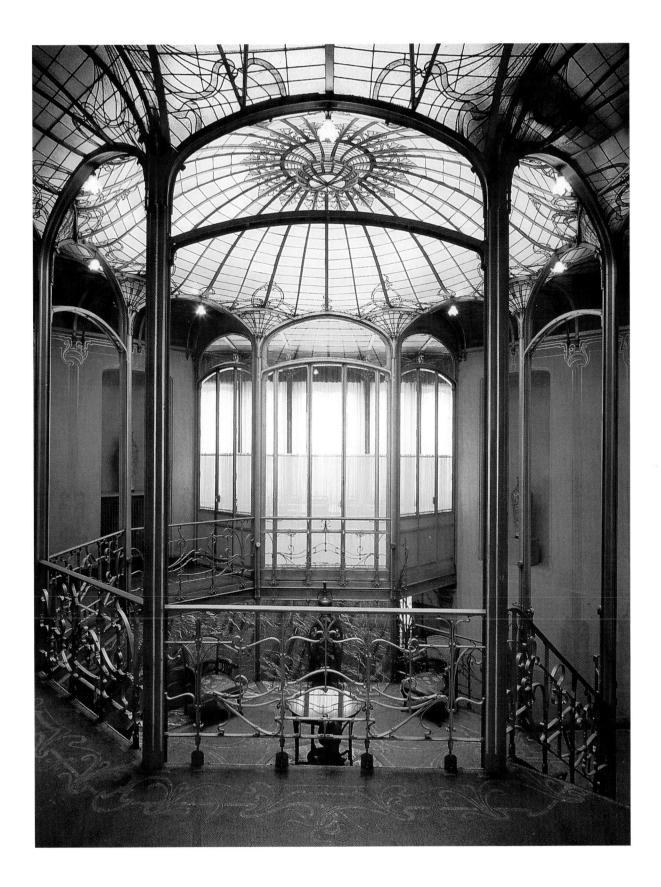

Nancy

Several times during its history, Nancy achieved significance far beyond what might have been expected. On each occasion, circumstances gave it unusual splendour. This had happened once in the eighteenth century, and it happened again around 1900, for quite different reasons, although on each occasion it was exiles from abroad who brought good fortune.

In 1736 the Polish king Stanislaus Leczinski had been forced to leave his home country, and was able to become Duke of Lorraine because the ruling house happened to have died out at precisely this time. In the thirty years that followed, his residence became an architectural jewel, and provincial Nancy became renowned far and wide for its main square. In 1766, after the death of Stanislaus, the dukedom lost its independence and fell to France. A century later – in 1871 – France had to cede not only Alsace but also parts of Lorraine, including Metz, to the new German Reich. The lost war thus had far-reaching consequences for Nancy. Having been in the centre of an undivided province, it suddenly found itself on the periphery, with a frontier no more than twenty kilometres away.

The amputation of the region to the east surprisingly turned out to be very advantageous for the city. On the one hand, France resolved to strengthen Nancy and the whole of Lorraine politically and economically; on the other, between 1871 and 1900 there was an influx of people from the annexed areas who did not want to end their days as Prussians. This exodus was all the more significant in that it was usually the well established families in the large towns who decided to move to France. Within a few years Metz had lost half its population, Strasbourg was deserted by almost all its top civil servants and academics, and also by many of the self-employed. The German administration was much more highly centralized than the French, and such attempts to promote independent regional culture as had been initiated under Napoleon III were now halted.

Many of the émigrés headed for Nancy and its environs, and the advantage of this was that they often brought with them capital and valuable skills. The city's prosperity increased, more goods were on offer, of higher quality. This was especially true – the date being around 1900 – of

Opposite page: Emile Gallé in his studio. Painting by Victor Prouvé, Nancy c. 1900.

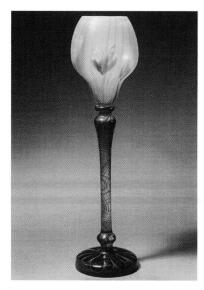

<u>Emile Gallé</u>, vase with crocus decoration, c. 1900, 38 cm high. Sotheby's, New York

<u>Emile Gallé,</u> wood intarsia on a chest, Nancy c. 1900. Münchner Stadtmuseum, Munich

Emile Gallé, 1846-1904

As a student, he showed a great interest in rhetoric, philosophy, botany and chemistry. Practical training in his father's glass and ceramic processing workshop from 1864 to 1866, as well as studies in drawing and model design in Weimar. In 1867 his first own designs for faience decoration were executed and shown at the World Exhibition in Paris. In 1874 he took over as artistic director of his father's firm. Numerous designs for ceramics, glass and furniture from 1880 onwards, and from 1885 commercial links with Burgun, Schverer & Co. manufacturers in Meisenbach, which had been part of German Lorraine since 1871 and provided most of the raw glass. Great success at the 1889 World Exhibition in Paris, where the "Genre Gallé" became the yardstick for competitors. From the mid-nineties onwards, increasingly typical Art Nouveau forms.

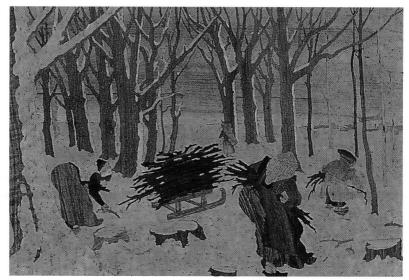

luxury and sophisticated goods. But the cultural life of the city was also enhanced by the growing academic circles.

By 1900 the city of Nancy was second to none in eastern France, politically, economically and culturally. It was given strategic importance by a garrison of 10,000 men – almost ten percent of the population. Its prosperity was based on textiles and leather goods industries, from breweries and from the manufacture of furniture, glassware and ceramics. Canals and railways provided excellent transportation links.

But this prosperity would have lacked lustre had it not been for the influx of artists and craftsmen. A good example is the immigrant Jean Daum, whose "Verrerie Sainte-Cathérine" had been founded in 1878, to be renamed "Verrerie de Nancy" a short time later; from 1895 he produced glassware in Art Nouveau style very successfully. From Metz came skilled cabinet-makers, such as Jacques Gruber, whose products again helped to make Nancy known throughout the world. It was for extravagant cut glass and marquetry that the Ecole de Nancy became famous. Emile Gallé, the most ingenious and versatile of all the artists, set out to become a master of both crafts.

Reactions to the geographical partitioning were reflected in art, in symbols and insignia for instance: the cross of Lorraine, intact or broken, was favoured as a decorative motif. Gallé incorporated it for a time into his signature. Then there was Joan of Arc, Lorraine's champion against foreign powers, and Nancy's motto "Qui s'y frotte, s'y pique" ("He who touches feels the thorn"), and the heraldic thistle from the city's coat of arms. This patriotically-significant flower, symbol of defence, often appeared in stylized form on the products of the Ecole de Nancy.

Whether or not all this had the desired effect, is debatable. Between 1871 and 1900 there was nevertheless growing respect in France for things that came from Lorraine. There were some influential advocates: critic Edmond de Goncourt, born in Nancy, kept open house in Paris for literary figures and artists; Roger Marx, also from Nancy and a friend and admirer of Gallé, became general inspector of the museums of France and in this capacity furthered the interests of Lorraine.

From 1871 the fate of the divided province became a national issue, and hopes of revenge never faded. Yet the patriotic warmth towards Lorraine produced mixed feelings. In several respects this embrace appeared too clinging, and there was still a call for devolution of centralized French authority. Even Gallé, who had much to gain from the situation, deplored the narrowness of the cultural field in which: Lorraine could operate. The province was gaining in self-assurance, though perhaps less in a spirit of antagonism towards the national capital than in clever exploitation of the preferential position accorded it by political developments.

It was a great advantage that the leading artist of the Ecole de Nancy should have gained renown beyond the frontiers of France: Gallé became an international figure-head for Art Nouveau, his name always among the first to spring to mind. This was probably owing to the sphere in which he excelled, for glass was one of the most favoured Art Nouveau materials (pp. 14, 15). The design could be simple or extravagant, and

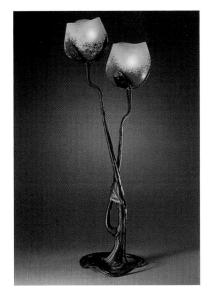

<u>Daum, Nancy and Louis Majorelle</u>, lotus lamp, c. 1900, 67 cm high. Sotheby's, New York

Emile Gallé, table, Nancy c. 1900. Münchner Stadtmuseum, Munich

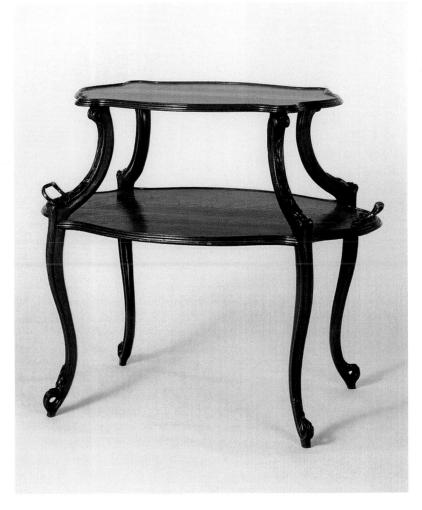

Emile Gallé, glasss jug, Nancy, shortly after 1900, ribbed and polished glass, 32 cm high. Österreichisches Museum für Angewandte Kunst, Vienna

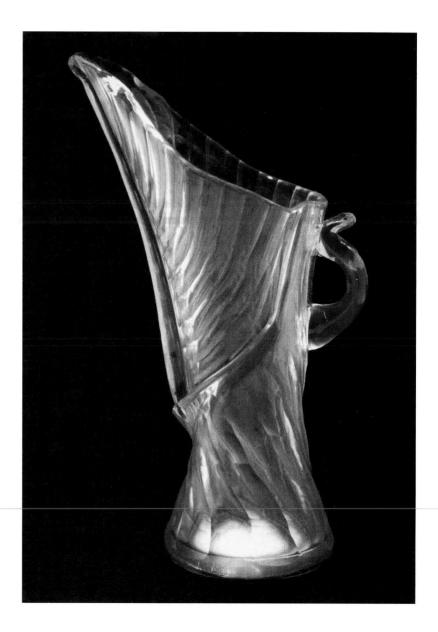

the surface could be treated in many different ways – a field in which Lorraine excelled. The material could be shaped into lamps, exploiting the full spectrum of colours (pp. 66, 67). There was no lack of connoisseurs, and Gallé's products were well-established in the international art market.

The general enthusiasm made it easy to forget that not all the products were of equally high quality, that in fact many of them were little more than standard, off-the-shelf items. Alongside pieces which may well have been inspired by Gallé himself were many which simply reproduced his style. Compared with the flamboyant delicacy and magic of the fragile coloured glass that Louis Comfort Tiffany was producing in America, some of the vases made in Nancy seem laboured and heavy, complying Emile Gallé, vase with autumn crocus decoration, Nancy 1899, flashed glass, 37 cm high. Private collection, Munich

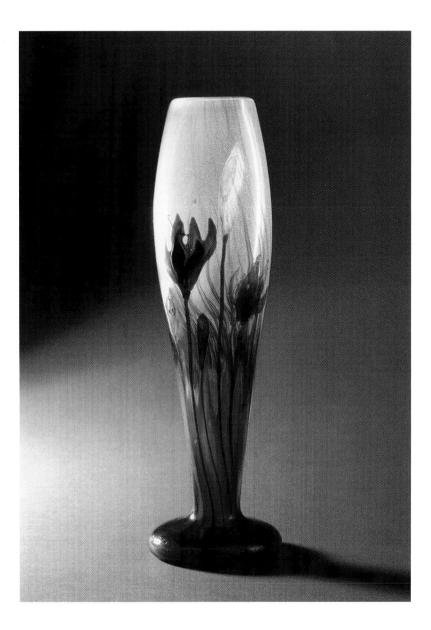

with bourgeois taste, and probably popular for that very reason. They are excellent examples of the French style of handicrafts that had reached its peak of excellence well before 1900, but was still universally valued. The challenge of innovation had never been of prime importance here, and the turn of the century brought no change in attitude. Close scrutiny soon reveals that most products of Art Nouveau were re-workings of earlier models found most frequently, and understandably, amidst the heroic splendour of the eighteenth century. That is true above all of the furniture favoured by the Ecole de Nancy. Gallé showed no ambition in this field, being content to limit his skills to marquetry, while Louis Majorelle's furnishings demonstrate the desire to give modern dynamism, elegance and excitement to traditional forms. Since the ap-

Jacques Gruber, three-part screen, Nancy, c. 1900, walnut with inlay and glass, 170 cm high. Münchner Stadtmuseum, Munich

Louis Majorelle, room in the Café de Paris, Nancy 1899, from: Dekorative Kunst III, 1899.

proach focused more on plasticity than on construction, it produced above all surface treatment. It was hard to compete with the riches of history, and in any case, why sacrifice what had proved its worth? Nevertheless, as the Paris exhibition of 1900 demonstrated, new forces were there to be reckoned with. French interiors were most successful where a vivid overlay of ornamentation was applied to a traditional base, as demonstrated in a café interior by Majorelle. But it was the end, and not the beginning, of an era.

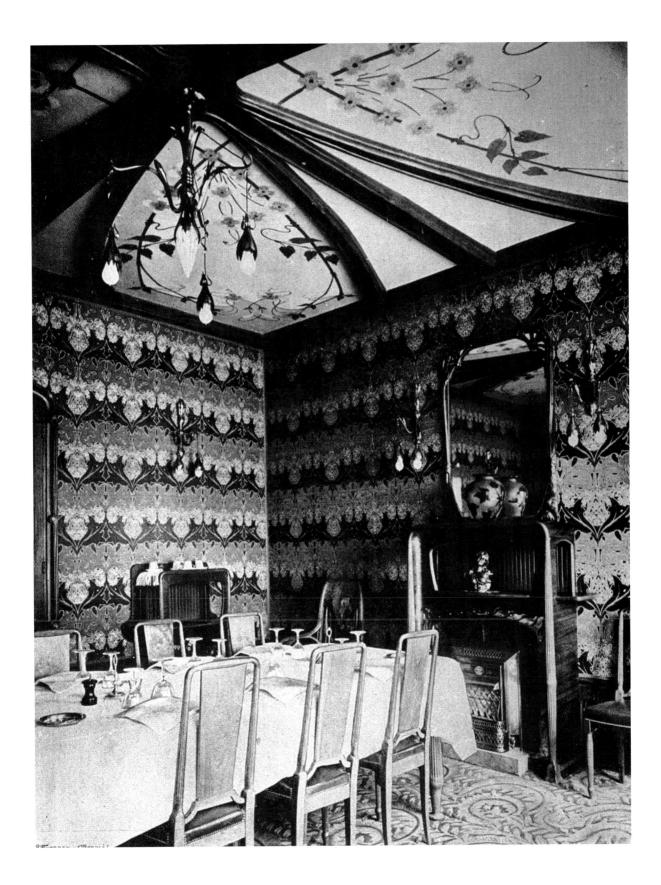

Barcelona

The political and cultural situation in Catalonia, with Barcelona as its centre, was by 1900 characterised – like almost no other region in Europe – by a struggle for independence dating back several hundred years. Its disputes went right back to the fifteenth century; at the beginning of the eighteenth century they were intensified. In 1714 Philip V declared all the region's special privileges null and void, and the province subject to Castilian rule, but every attempt by central government at cultural as well as political suppression precipitated renewed conflict and the "Catalan question" remained a permanent difficulty in Spanish home affairs. The nineteenth century was marked by a succession of attempted rebellions, uprisings and assassinations.

In the Middle Ages Barcelona, the acknowledged centre of the province, had been one of the world's major ports, but it subsequently suffered a long decline and had reached a low point by the middle of the eighteenth century. Excluded for political reasons from trade with America, it remained of little significance. Deprived of power and jealously watched over from Madrid, the Catalan population turned its attention more to economic enterprise. The proximity of France, incomparably more attuned to modernisation than Spain, helped fuel progress. By the end of the eighteenth century Catalonia had become one of the most modern of the Mediterranean regions. The beginning of the nineteenth century saw the start of a long rise to prosperity, with Barcelona being admitted to the profitable trade with America. Industrialisation was also able to make progress here more easily than in other parts of Spain.

Barcelona's population grew very rapidly, from 175,000 in 1850 to more than 500,000 in 1900, largely due to the influx of factory workers. The old city centre could not contain the expansion; from 1860 new well-planned areas in chess-board pattern were built, with wide boulevards reflecting french influence.

In 1900 Catalonia was still dominated by Madrid, but it had become the leading industrial region, outstripping the rest of Spain, which had remained backward in its agrarian structure. It was the wealthiest of all the Spanish provinces, with the greatest density of population and the busiest trade. It did not cover so large an area as Madrid, and the population was smaller, but it was in effect the centre of the economy. It displayed

Opposite page: Sagrada Familia church in Barcelona, taken around 1920.

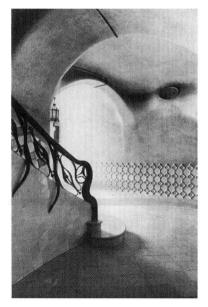

Antoni Gaudí, the entrance hall of the Casa Batlló in Barcelona, 1904–1906.

Antoni Gaudí, entrance hall of the Casa Miralles near Barcelona, 1901/02.

Antoni Gaudí, 1852–1926

Architectural studies begun at seventeen; after completion, first buildings with motifs from Islamic models from 1878 onwards. Under the influence of the romantic Catalan movement "Renaixenca" from an early stage, out of which "Modernisme" developed around 1890. In 1883, commissioned to continue building the Sagrada Familia church in Barcelona, originally begun in Gothic form, which occupied him for the rest of his life. Close association with the textile manufacturer Güell, who gave him numerous commissions. Major works: Palais Güell, 1885–1889; chapel of the Colonia Güell, 1898–1911; Güell Park, 1900–14; Casa Mila, 1905–1911; all buildings in Barcelona and vicinity. features typical of a "second" city, attempting to compensate with economic strength for the recognition history had denied it – a fate shared by Glasgow and Chicago. Its status was helped by a World Exhibition in 1888, by which time the port had become a major intersection for international sea-routes, including for the steamers to and from Genoa, Marseilles, Liverpool, Hamburg, Rio de Janeiro and Buenos Aires. Transportation into the interior, and across the border to France, was provided by several railways. The city's cultural lead was secured by numerous scientific and scholarly institutions. The famous Liceo was the largest opera house in the country.

The sense of regained importance and even superiority was reflected around 1900 in an intellectual atmosphere remarkably free by Spanish standards. But alongside growing prosperity there were inevitably social tensions. The rest of Spain had traditionally regarded the Catalan people as restless and rebellious, and Barcelona's large working population seemed to prove the point. In the otherwise relatively peaceful year of 1903 the city recorded seventy-three strikes. In 1870 Friedrich Engels had surmised that Barcelona had experienced more barricade battles than any other city in the world. In the years that followed, the intensifying campaign for autonomy merged with the spread of ideas of social revolut ead of ideas of social revolution. In 1880 a socialist trade union was founded in Barcelona, and the last years of the nineteenth century saw an increase in anarchist activities – assassinations alternated with executions at an ever-increasing pace.

The root of the desire for regional independence lay in the feeling that historically the ethnic and linguistic links with southern France were stronger than those with Spain. In the Middle Ages Catalan was one of the group Provençal dialects which are understood on both sides of the Pyrenees even today. As in Finland at the same time, awareness of language was an important component in the striving for greater self-

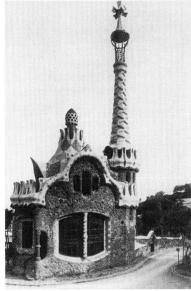

determination. Around 1900 Catalan was practically the only language spoken in Barcelona.

It was the only language spoken by the artist who came to symbolize the city's regeneration – the architect Antoni Gaudí. Although his output was not large, and his work was controversial at the time, it achieved an importance that exceeded its actual merit. Experimentation and the suggestiveness of associations blended in such a way that audacity was made conciliatory and even embraceable. Gaudí won public hearts by including the familiar amidst the bizarre – by means of gothicized constructions that reminded people of Catalonia's earlier splendour, or Moorish elements that were equally well-known, or shapes drawn from nature giving a sense of organic growth. His creations were stimulating, though not necessarily logical or consistent. Their ambivalence made them excellently well-suited to fulfil Art Nouveau expectations, their provocative style being reminiscent of Hector Guimard's Paris Métro designs.

Gaudí was ten to twenty years older than most of the artists who took up the centre of the revolutionary stage in 1900. He was in advance of the others in years, but it was only with the arrival of the twentieth century that his work gained in stringency and tight construction. Before that he had been an inventive collage artist, although with little sense of economy of means. On the other hand, he had never taken refuge in the safety of formalized historicism. His artistic freedom was given a secure foundation by the trust and generosity of wealthy patrons, among whom the foremost was the businessman Eusebio Güell. In addition to several private commissions, Güell procured for him the contract for a public park named after him in the north-western district of the city. This was the culmination of Gaudí's mature phase, in which he aimed not at additive but at integral effect.

The park was influenced by English models, and was grounded in social

<u>Antoni Gaudí,</u> the entrance to Güell Park in Barcelona, 1900–1914.

<u>Antoni Gaudí, gatehouse for Güell Park in Bar-</u> celona, 1900–1914.

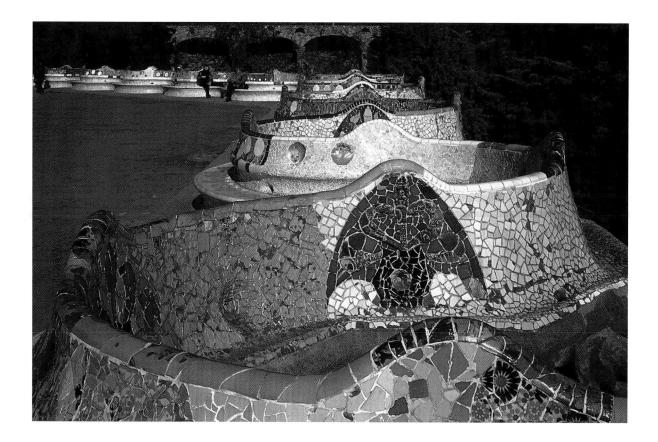

<u>Antoni Gaudí,</u> Güell Park in Barcelona, 1900–1914. Colonnaded hall and curved stone bench with mosaics made out of broken tiles.

commitment and concern. The original idea of building homes in some parts of the park was abandoned for lack of purchasers. Güell, who had financed it all, died in 1918, by which time Gaudí had already turned most of his attention to the building which was at once his most famous and his most unfortunate, the church of the Sagrada Familia (p. 72). The neo-Gothic design of the church, which he had taken over in 1883 from a predecessor, came more and more to be an expression of his faith. As a young man Gaudí was said to be something of a dandy, but towards the end of his life he lived as a recluse, obsessed with a building that he must have known he could never finish. When he died in an accident at the age of seventy-four he was revered, but scarcely anybody really knew him. This conflict between inner life and outer appearance was the last in a series of contradictions. Politically it was astonishing that one who became at the end of his life a religious fanatic should also be the symbol of a national fight for freedom. It was a struggle already supported more from right. Although a revolutionary, he enjoyed the favour and patronage of the wealthy - a situation not in itself unusual, and found also in Brussels, Darmstadt, Weimar, Glasgow and elsewhere. It was more surprising that the architect in him tended more and more towards sculpture, to such an extent that he started building houses without firm plans, modelling them as he went along. It was this unorthodox procedure that gave him legendary stature; he was credited with having achieved the impossible by freeing architecture from the tyranny of the

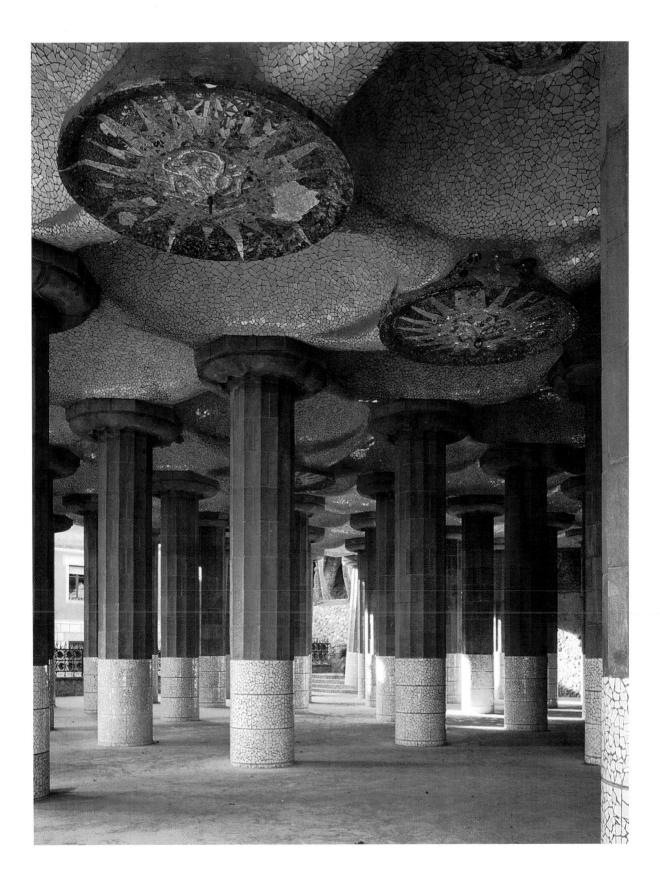

<u>Antoni Gaudí,</u> dining-room and front façade of the Casa Batlló in Barcelona, 1906.

right-angle. In spite of this apotheosis, no-one followed his example, and the static experiments and models which he made for the nave of the Sagrada Familia produced nothing new, amounting in fact to nothing more than an extension of Gothic principles, winning in their naïve plasticity. Gaudí showed himself, however, truly bold and inventive in an incidental work, the little school in the shadow of the church (p. 72, below right) intended as a temporary building; the effect of the strikingly thin but very carefully designed corrugation of roofing and walls is one of remarkable strength. The – often whimsical – sculptor shows himself here a precise engineer.

The fascination which Gaudí still exerts today can best be explained in terms of the freedom which he exacted as artist architect, and with which he also lived out a romantic ideal at the end of an era. As wish projection, however, the ideal remains indestructible.

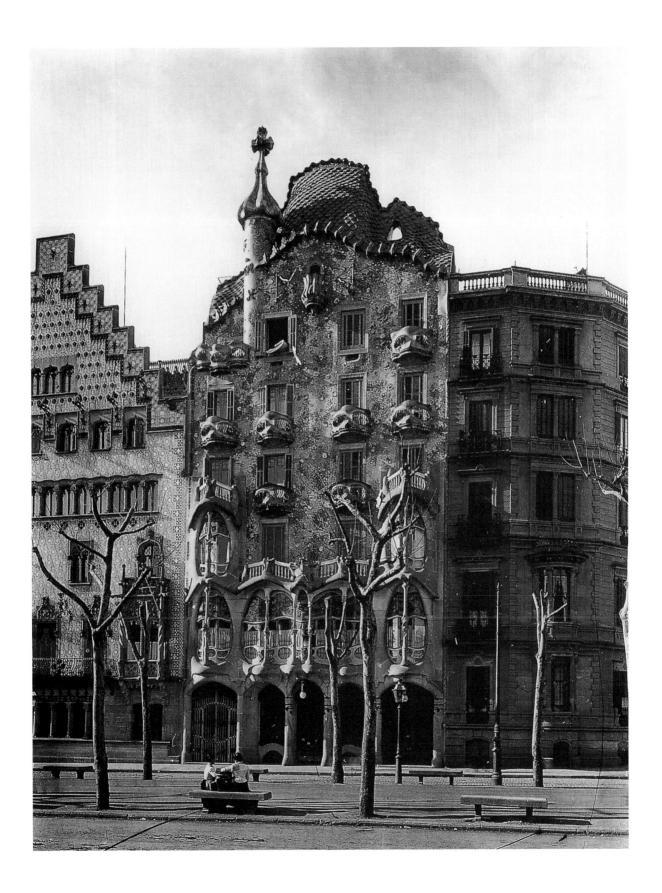

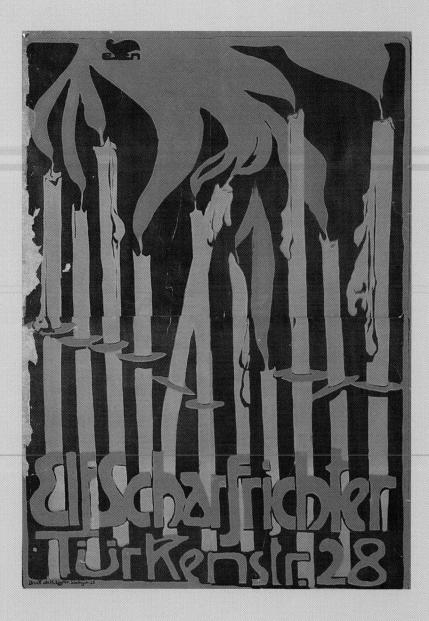

Munich

Of all the revivals in the arts taking place at the turn of the century, the one in Munich was probably felt closest to grass roots. The city displays examples of a touchingly "vulgar" *Jugendstil* demonstrating just how easily the boom in a new art world could be adapted to meet the needs of the bourgeoisie. Awe and respect would have been considered out of place. The good citizens of the Bavarian metropolis were on familiar terms with the muses, and they probably regarded some of the more provocative works of art merely as good jokes. Violent reactions were more likely to result from a fiery temper than from serious reflection.

It was a help that the new works of art had direct popular appeal, and that they were simple and pleasing. There was nothing indirect about them. Munich Art Nouveau was neither intellectual nor insubstantial. It was clearly rooted in its home province, as is shown above all by the designs of the architect Richard Riemerschmid with his frequent recourse to folkloric motifs.

The widespread sense of uprising took hold of Munich as it did of other cities, but the result here was a dichotomy of the innovative and unknown on the one hand – the Munich variation of European Art Nouveau – and revitalised tradition, bourgeois neo-classicism, on the other. In other places one succeeded the other: first came youthful rebellion and then a return to more time-honoured forms; but in Munich both happened simultaneously. It was typical of the people of this city that they were open to novelty, and yet not overcome with curiosity; styles favoured of old were not easily jettisoned for the sake of the new.

Sometimes the blend of antiquity and modernity could lead to strange results: in 1900 there was an exhibition of modern French art which included Rodin's "Thinker" in a Roman atrium constructed in the vast spaces of a crystal palace; in the *Friedensengel* (Angel of Peace) monument, antique myth was clothed in Modern-Style garb. Today it is possible to view this inoffensive lack of respect for the lofty and elevated as a kind of democracy in the arts.

The city's artistic past can account for what may be termed its conservative open-mindedness. Munich had escaped the excesses of Wilhelmine historicism; the period of rapid industrial expansion in the late nineteenth century had passed without altering its values. The city had grown at a

Opposite page: poster by Ernst Neumann for the Munich cabaret "Elf Scharfrichter", 1901. Die Neue Sammluna, Munich

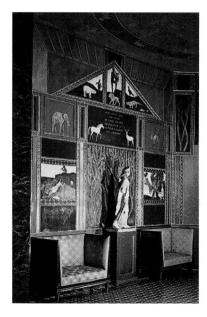

Franz von Stuck, the music room in his Munich villa, 1897/98.

Theodor Fischer, the Prinzregenten Bridge in Munich, with view towards the Friedensengel, 1901. steady pace, with no loss of self-assurance. One could sit back and watch things happen.

In the 1830s and 1840s, by contrast, Leo von Klenze, Friedrich von Gärtner and other architects had imprinted on the city a finely-modelled classicism and gently romanticized historicism, of which the Glyptothek and the University are the best examples. This official style of architecture was echoed in numerous unpretentious but well-proportioned bourgeois houses. Situated in the south of the country, the city took for granted an easy awareness of Mediterranean antiquity.

This era, stamped by the tastes of King Ludwig I, was followed by one quite different. From 1848 to 1864 Maximilian II reigned over Bavaria in a more pragmatic manner. He encouraged industrialisation, and turned not to ancient Greece for models as his aesthetic-minded father had done, but to England. Modern buildings made of glass and iron began to appear in the Bavarian metropolis, above all the Crystal Palace, which became a favourite venue for events of all sorts, from musical celebrations to lavishly decorated exhibitions, and it remained the unofficial cultural centre of Munich up to the time of its destruction by fire in 1931. It had been shown time and again that the transparent building was hardly suited for such purposes, and it frequently required alterations and additions, but such contradictions were more of a stimulus than a hindrance to a city accustomed to baroque extravaganzas.

In spite of the onset of industrialisation the city succeeded in maintaining its equilibrium in economic development as well as in planning and design. Nuremberg and Augsburg may have been the largest industrial cities in Bavaria, but Munich played its part. It was not simply an administrative centre; traditional industries continued to flourish. One consequence of the moderate pace of development was that there was more continuity than elsewhere, both in the economy and in art. There was no violent disruption, and the negative effects of rapid industrialisation and

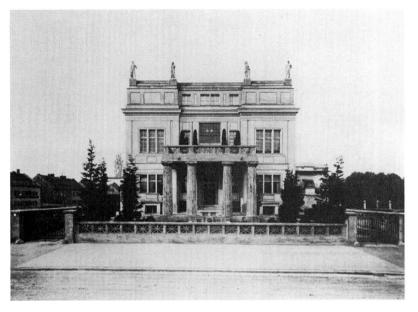

drastic changes in townscape were avoided. Only Ludwig II's whimsical castles, scattered throughout Bavaria, show the depths to which taste could sink in the region.

This strange king reigned from 1864 to 1886; it was during his reign and with his acquiescence – thanks to a substantial payment negotiated by Bismarck – that the Prussian king was crowned German emperor. Since Ludwig was unmarried and died without issue, he was succeeded by the youngest, but nevertheless ageing son of Ludwig I, the prince regent Luitpold, born in 1821. In a clear departure from his eccentric and at times misanthropic predecessor, Luitpold sought to rule as a friend of the people. Like his father before him he tried to be a patron of the arts, but revealed only rather indifferent Forstes. Half a century had passed and the public spirit had grown more independent. The artistic developments which took place in Munich around 1900 thus had natural roots, being neither so artificially induced as in Darmstadt nor so much a matter of economic necessity as in Weimar.

Munich's moderate historicist traditions were being kept alive then and later by the architect Gabriel von Seidl (1848–1913), who, however, did not follow historical orthodoxy slavishly, but integrated certain historical elements in unconventional forms. With its multiplicity of styles, the exterior of the Bavarian National Museum, built between 1894 and 1899, could almost be seen as an illustration of the exhibits within. It implied a reflective and distanced application of historicism which, although it might not actually create anything new, encouraged greater openness towards innovation.

It was from a background of this sort that the architect Theodor Fischer (1862–1938) started out, but in his work the traditional took the form less of historicism than of timeless simplicity, conveying a measured sincerity rather than creativity. Around 1900 Fischer built a number of bridges and schools which still determine the face of the city today (p. 82). He was one

Franz von Stuck, his villa on the Prinzregentenstrasse in Munich, 1897/98.

<u>Franz von Stuck,</u> the reception room in his Munich villa, 1897/98.

of the generation of artists who created *Jugendstil* in Germany, although his own work shows little sign of it.

The famous villa built in 1897/98 by Franz von Stuck (1863–1928) (p. 83) was also traditional, albeit in a very candid way. Self- confidence and natural vitality enabled this progressive farmer's son to become a remarkable dilettante. An architect with years of study behind him would probably have done everything quite differently, without Stuck's immediacy or sumptuousness. Stuck dealt casually with details, but he created a magnificent overall form in the cubic design of the exterior, in the unconventional ground-plan and the linearity of the interior, coloured consistently in gold, brown and blue. Stuck was familiar with the gods of antiquity and had them appear all over the house, even in the bathroom. His aim was not so much to provide an artistic profession of faith as to create an apt setting for himself; the juxtaposition of Empire-style salons and Renaissance rooms is evidence of this. He made no attempt to achieve a single new stylistic unity, but the house is probably his greatest work. His furniture in antique style won him a gold medal at the Paris World Exhibition of 1900.

It was not unusual at the time for artists to build their own houses. Van de

<u>Bruno Paul,</u> cartoon in "Simplicissimus": "D'you think you can insult my girlfriend, you dirty Prussian you!" Munich 1899.

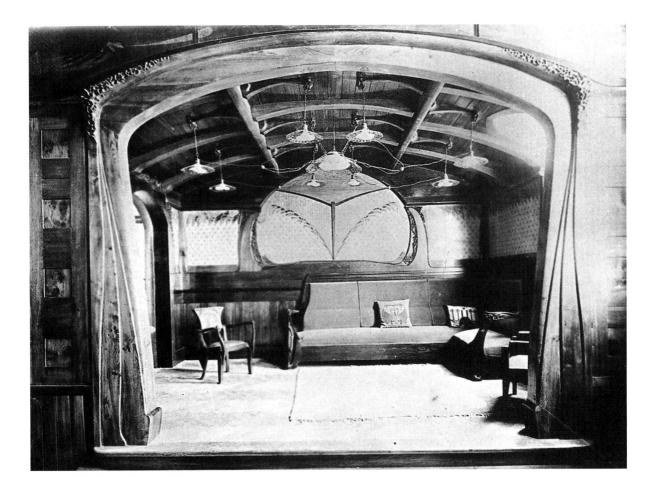

Velde had done it in 1895 on the outskirts of Brussels, and the artists' colony in Darmstadt in 1901 was inspired by a similar idea. There was almost an obligation for an artist to become his own amateur architect. This was the best proof that one was master of all disciplines and was nearing the proclaimed ideal of the Gesamtkunstwerk, the "total work of art". For some painters the new challenge became the only one; they committed themselves entirely to "applied art". This was true not only of Henry van de Velde and Peter Behrens, but also of Richard Riemerschmid, who in 1896 built himself an unassuming farm-style house in Pasing, just outside Munich. Even literary artists were affected. In 1901 the publisher, writer and hero of a book ("Prince Cuckoo"), Alfred Walter von Heymel, designed his beautiful neo-Biedermeier apartment on the Leopoldstrasse with the help of Rudolf Alexander Schröder, a sought-after interior designer. A third party to this undertaking was the architect Paul Ludwig Troost, who in 1934 inflicted on Munich the neoclassical Haus der Deutschen Kunst (House of German Art). Apollo was present in Heymel's apartment, too, as a life-size cast in the centre of one of the rooms.

Measured against such cultural gentility, the new departures at the turn

Bernhard Pankok, a smoking-room shown at the Paris World Exhibition in 1900.

<u>Richard Riemerschmid</u>, stoneware jar with pewter lid, Munich 1900, Villeroy & Boch, Mettlach, 16.5 cm high. Private collection, Munich

<u>Bernhard Pankok,</u> chair, Munich, 1898, mahogany. Württembergisches Landesmuseum, Stuttgart

of the century must have seemed positively barbaric. August Endell sounded the battle cry when he alarmed Munich in 1897 with his Elvira photographic studio (pp. 13, 95, 96), which was not only daring but totally lacking in respect for its surroundings. A new notion of form was asserting itself. A dramatic confrontation ensued on the recently completed Via Triumphalis, the Prinzregentenstrasse. While the lower end was subjected to the nearby facade of the Elvira studio, striking terror into the hearts of stalwart citizens, at the other end, on a hill on the far side of the river lsar, the Stuck villa provided serene reassurance. The two ends of the Prinzregentenstrasse were linked by Theodor Fischer's elegant bridge built in 1901 (p. 82), and crowned by the Friedensengel monument of 1899 in antique style. The free-spirited writer Frank Wedekind lived close to the river for a time, and beyond the Stuck villa was the Prinzregententheater, built in 1900 in the style of the Bayreuth opera house as a means of ensuring that Richard Wagner, driven out of the town in his actual lifetime, would at least be a posthumous visitor. All

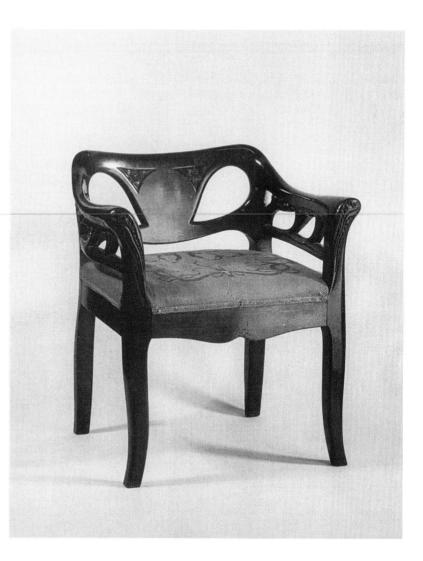

<u>Bruno Paul</u>, cartoon in "Simplicissimus": "Schorschi, d'you see the fly there?" "What fly?" "That fly!" "I can't see any fly" "Me neither!" "Foreman, we're stopping work, we can't see anymore." Munich, 1901.

styles were represented, and as if to secure the reconciliation of opposing forces, the Bavarian National Museum with all its spoils stood at the road's centre.

Although it might seem that the moderate forces held the balance in Munich, *Jugendstil* had more vitality, and more power to initiate change. It was first in evidence in 1897 in an exhibition crammed, as so often, into the Crystal Palace. In this 7th International Exhibition there was an obscure corner where almost all those artists were represented who were to provide the true innovations of the years that followed. In a room designed by Theodor Fischer, visitors to the exhibition could see paintings by Richard Riemerschmid, plaster frieze and tapestry by August Endell and a chair by Bernhard Pankok. A poor picture suggests that the room was dark and too full, and the overall impression is traditional rather than revolutionary; yet there are some very unusual details, above all in

<u>Thomas Theodor Heine</u>, poster for "Simplicissimus", Munich, 1896. Private collection, Munich

<u>Thomas Theodor Heine,</u> bronze saytr, Munich 1902, 41cm high. Private collection, Munich Endell's abstract ornamentation, which foreshadows the most important embodiment of Munich *Jugendstil*, the Elvira façade.

It was the first sign of things to come. Beneath Munich's neo-classical surface a subversive spirit was appearing which was soon to make itself felt not only in the applied arts, but also in literature, cabaret and music. Journals such as "Dekorative Kunst", which was published by Bruckmann in Munich from 1899 onwards, and which was better than the Darmstadt "Deutsche Kunst und Dekoration", ensured that the new spirit became known to the public. Munich's voice was heard most distinctly in "Jugend" and "Simplicissimus". The former, although in fact a rather conservative paper, gave *Jugendstil* its name, while the latter entertained with its exquisite satirical drawings (pp. 84, 87). Its anti-Prussian line brought out the best in Bavarian qualities. Simpleton Prussian Junkers, officials and officers confronted in "Simplicissimus" homespun Bavarians whose lack of sophistication did not escape satire, but whose all-too-human features were nonetheless drawn with affection. This was the

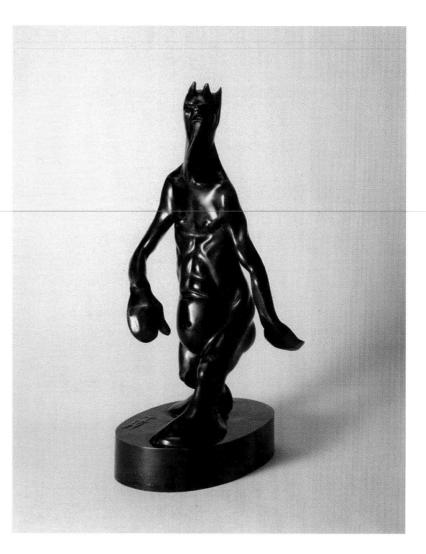

<u>Bruno Paul,</u> cartoon in "Simplicissimus"; "The angels, they call it heavenly; the devils, they call it hellish; the people, they call it lo...o...ve." Munich, 1901.

Hermann Obrist, 1862-1927

Originally from Switzerland, he came to Weimar in 1876, where his mother lived in a villa near Goethe's former garden pavillon. Experienced visions from early youth. Extensive travel from 1886 onwards, 1890 in Paris, and in Munich from 1895. Built his own house, with furniture by Bernhard Pankok. Founded a school with Wilhelm von Debschitz, from which he subsequently withdrew. In 1914 he provided the sculptural decoration of the theatre built by Henry van de Velde for the Cologne Werkbund Exhibition.

<u>Hermann Obrist,</u> model for a fountain, Munich, c. 1900, plaster, 43 cm high. Kunstgewerbemuseum, Zurich clearest expression of antagonism towards the north; subversion elsewhere was stylised or indirect. Bavaria called a spade a spade, for which authors and editors were frequently prosecuted, especially when the Kaiser was the target of their merciless lampoons. Restrictions were also imposed in the home province: Bavaria was by no means so liberal as it might seem in retrospect. In 1900, for example, censorship in theatres was intensified. Nevertheless, Munich was capable of holding its own against Berlin. Since its insubservience pervaded almost all areas of the arts with popular appeal, the movement did actually share some of the features of a revolt.

Bruno Paul was the most characteristic of the "Simplicissimus" cartoonists. Others were usually too concerned to illustrate the crucial point in the text, whereas Bruno Paul's boldly outlined figures are far more independent. Nobody else could sketch a serving-maid, a soldier, a farmer's daughter, an apprentice with so few strokes. He was so brilliant at conveying the physical characteristies of mountain folk – with gangling legs, big feet and clumsy hands – that one might be tempted to see in these figures the inspiration for the specific curves and the robustness of

<u>Bernhard Pankok,</u> flyleaf of the catalogue for the German section at the World Exhibition in Paris, Munich 1900. Bibliothek der Landesgewerbeanstalt, Nuremberg

Munich *Jugendstil*. The physiognomy of these figures is not so very different from the overall form of the room designed by Pankok for the Paris World Exhibition of 1900 (p. 85). Munich excelled in these complex modes of expression.

Even more sharp and uncompromising in rendition, although fussier in style, was the cartoonist Thomas Theodor Heine. His mischievous pen also had favourite targets – bulldogs, devils with cloven hoofs, simpering maidens, wives foaming at the mouth, two-tongued priests (pp. 8, 88). He liked to give an initial impression of bourgeois respectability, but his eye missed nothing, and his cynicism probably made more impact than Paul's more elegant humour. Closer to Paul in style, though a little later, was Olaf Gulbransson, although his drawings were finer and lacked the comic impact of work by Paul.

The incisive quality of all of Paul and Pankok's work was to become characteristic of Munich *Jugendstil* as a whole. Its powerful linearity

Peter Behrens, wallpaper design, c. 1900.

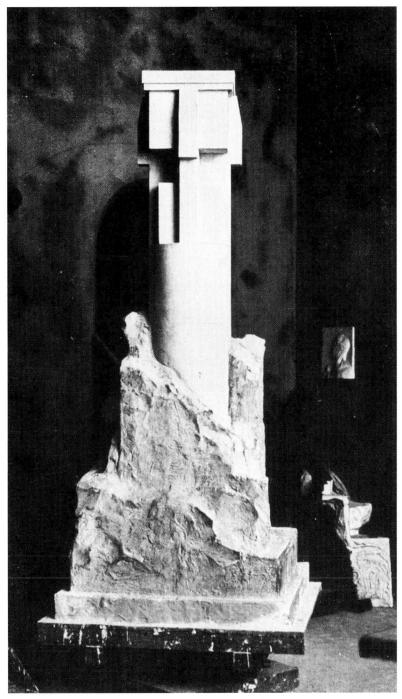

Hermann Obrist, design for a memorial, c. 1900.

<u>August Endell</u>, design for the boxes in the Buntes Theater in Berlin, 1901, from: Berliner Architekturwelt, 1902.

<u>August Endell,</u> the Elvira photographic Studio in Von-der-Tann-Strasse in Munich, 1896/97.

August Endell, 1871–1925

Studied philosophy and psychology in Tübingen from 1891. From 1892 to 1901 he lived in Munich, teaching himself craftwork designs and architecture. Went to Berlin in 1901, where he executed a number of building commissions. Founded a "Form school" in 1904, which existed until 1914. In 1918 he was called to succeed Hans Poelzig at the Breslau Akademie für Kunst und Kunstgewerbe.

Major works: Elvira Studio in Munich, 1897/98; "Buntes Theater" in Berlin, 1901; "Neumann'sche Festsäle", 1905/06; the trotting course in Mariendorf, 1911/12.

demanded three-dimensionality, and it was in this area that the most important work was produced. As early as 1896, the Swiss sculptor Hermann Obrist had made his mark in Munich with some unusual pieces. First in wall hangings, later in monumental masonry he developed a style of ornamentation which drew very freely on nature (pp. 12, 90, 93), sometimes strangely sinuous or tumid, sometimes soft and flowing, then abruptly ending in bizarre sharp-edged spikes, bone-like structures, foaming waves or crystals. Yet it was never quite any of these, but always something enigmatically strange, from another world. The artist on several occasions experienced visions, which he tried to reproduce in his work. The writings found among his possessions after his death are a testimony his desperate struggle to give material shape to his visionary experience. But he failed to make the transition to the abstraction he was clearly seeking in his art. His few known works display a compulsive inner movement, an urge to seek and to find. In spite of its freedom, his work followed its own laws so consistently that it served as model and stimulus for others. Most of the Munich Art Nouveau artists were influenced by Hermann Obrist.

This is most evident in the case of Endell. The one-time student of philosophy declared his unqualified enthusiasm for this source of inspiration when he decorated the façade of the Elvira studio in the spirit of Obrist – but he went even further. His gargantuan monster plunged this way and that, pouring scorn on everything that the city had seen up to that time.

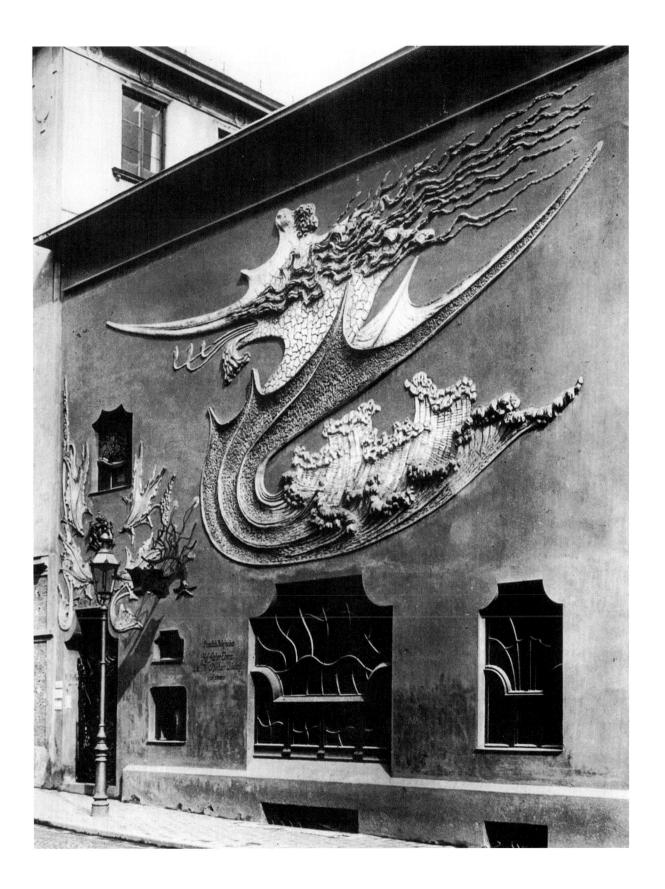

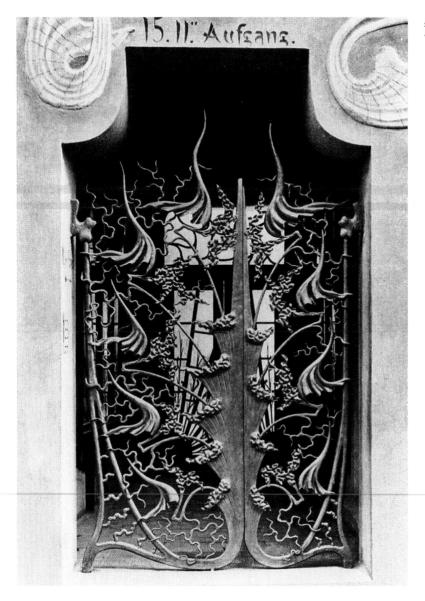

<u>August Endell, gate of the Elvira Studio in</u> Munich, 1896/97.

Like some herald of anarchy it was at once macabre and provocative in its vivid combination of colours, defying anyone to fathom its origins, unless it were a blend of Chinese dragon with Germanic fairy-tale. It beckoned others to follow its lead, and was greeted with rage and delight in equal measure.

What had come about was ornament for its own sake, free from every sense of purpose, except to fill an empty wall. On the other hand, the windowless surface may have been designed expressly to receive it; just because the studio on the upper floor could do without windows to the south was hardly a sufficient reason for so much effort. The reversal of priorities is clear: no longer is ornament ancillary to architecture, but architecture serves purely as a neutral background for ornamentation. Art Nouveau's origins are here clearly shown to lie in decoration. The audacities continued with the iron work door and, less successfully, in the interior, where gnarled roots and kraken shapes protruded from every corner. The courage of the two women who ran the studio still seems surprising today. Their photography was rather conventional, not at all attuned to the building's uncompromising exterior. Endell's original manner of ornamentation could be applied well to furniture, and harmonized fully with an ossiferous piece of a chair or with the plain boards of shelves and cases (p. 97). He created few pieces of furniture, and toed the Munich line only in early years; later on he tried to bring some order into his persistently bizarre ideas. The result was a more domesticated style of decoration, in spite of some lingering waywardness. In 1901 he went to Berlin and there he found the task for which he was best suited: he was invited to decorate the "Buntes Theater" (Multi-coloured Theatre) for Ernst von Wolzogen (p. 94). The wit of his designs was brilliant; the most original of all cabaret interiors was created at relatively low cost.

<u>August Endell,</u> upper end of a bookcase, Munich 1899.

<u>August Endell,</u> chair, Munich 1899, elm, upholstery by Richard Riemerschmid. Bayerisches Nationalmuseum, Munich

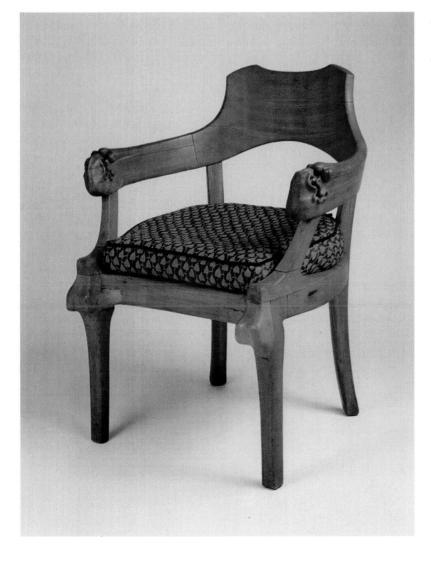

<u>Richard Riemerschmid</u>, design for a wall at the Paris World Exhibition of 1900. Architektursammlung der Technischen Hochschule, Munich

Richard Riemerschmid, 1868–1957

Studied painting at the Academy in his home town of Munich from 1888 to 1890. He was a founder member of the Munich Vereinigte Werkstätten für Kunst im Handwerk in 1897, and from 1903 onwards he worked for the Dresdner Werkstätten für Handwerkskunst (Dresden Workshops). He was director of the Munich Kunstgewerbeschule from 1912 to 1924, and director of the Cologne Werkschule from 1926 to 1931. Major works: the Kammerspiele at the Munich Schauspielhaus, 1901; Hellerau garden city, near Dresden, begun 1909. Unfortunately it existed only for a short time, and Endell never ventured to try anything of the sort again.

Less spectacular, and more notable for its architectural understanding, was the work of Riemerschmid. He became the most consistent representative of Munich Art Nouveau, almost synonymous with it. Initially relatively unadventurous as a painter, he rapidly developed a designer's mode of thought and sense of form, and from his workshop came numerous pieces of furniture which all had the virtue of being eminently usable. He had an engineer's instinct for such things, and no-one could match him in his effective and economical use of wood. The creative process could always be followed in his work; there was a logical sequence and only occasionally did he overstep the mark. This constructive orientation was a quality he shared with van de Velde, and van de Velde recognized him as a champion of the same cause and publicly expressed his admiration for him.

The year in which the first signs of *Jugendstil* appeared in Munich – 1897 – was also the date of a large arts and crafts exhibition in Dresden, which gave van de Velde his first and at the same time his decisive opportunity to show his work in Germany. Four décors which had not been well received in Paris in 1895/96 were exhibited again, together with a further salon interior, and were at once acclaimed with enthusiasm. The germ of

abstract Art Nouveau design had been injected into central Europe, launching the battle against every other trend, particularly against the soft, vegetal and purely decorative kind. It is impossible to determine the extent to which developments in Munich were influenced by what happened in Dresden; clearly there was an affinity between van de Velde and Riemerschmid from the start. Van de Velde repeated his success in Germany in Munich in 1899 with one of his most distinguished works, the study furnished with the large desk described above (p. 55). In the same year Riemerschmid achieved a comparable success in Dresden by exhibiting a music room that said as much about his aims and objectives as did the desk about van de Velde.

Riemerschmid, too, developed a philosophy of strongly articulated design embracing each single element in equal measure. A chair constructed for the music room may serve to illustrate Riemerschmid's force-

<u>Richard Riemerschmid,</u> table lamp, Munich 1899, 45 cm high. Kenneth Barlow Ltd., London

<u>Richard Riemerschmid,</u> chair, designed for a music room in 1899, oak and leather. Private collection, Munich

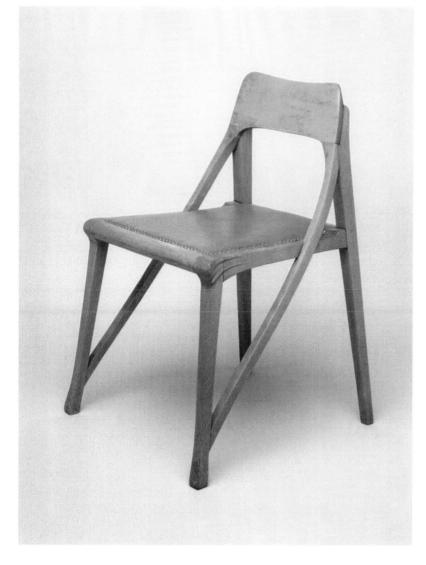

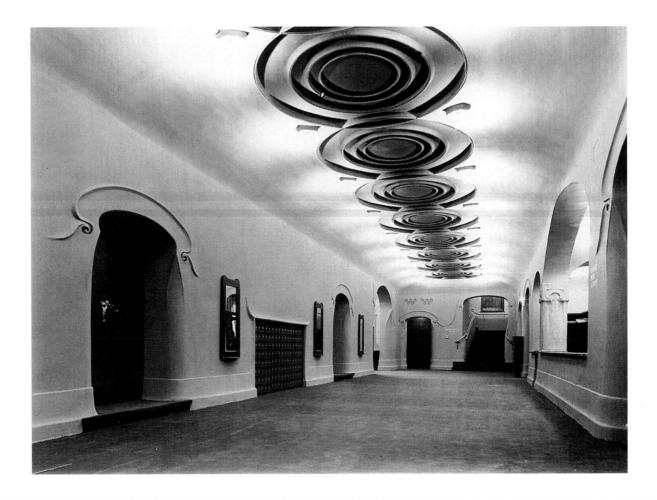

<u>Richard Riemerschmid,</u> the lower foyer of the Munich Kammerspiele, 1901. ful and economical style (p. 99). Ostensibly in order to give the musicians more freedom of movement, the designer did away with the usual arm rests but found another way of generating the necessary stability: diagonal struts gather up in one sweep all the important components of the frame. Starting from the back, they extend to the base of the legs in the front, and firmly clasp the feet. In passing they touch the seat, which appears lightly flexed and sprung in consequence. The link with the back feet provides similar stability. Viewed from the side the chair appears as two triangular configurations, inseperably linked by a common line – the diagonal strut. The intersection of seat and strut is the nub of the construction; any loss of cohesion here would shake the stability of the whole. Yet the rationality of the construction causes no loss of grace; on the contrary, the inner dynamics of the chair become almost visible and tangible through the organic sculpting and modelling.

There were other ways in which Munich artists were quick to learn. They saw, for instance, that it was advantageous to join forces for business purposes. In order to have their designs executed and then marketed, Obrist, Riemerschmid, Pankok, Paul and others founded the Vereinigte Werkstätten für Kunst im Handwerk (United Workshops for Artist Craftsmanship) in 1898. They modelled their undertaking on William Morris's

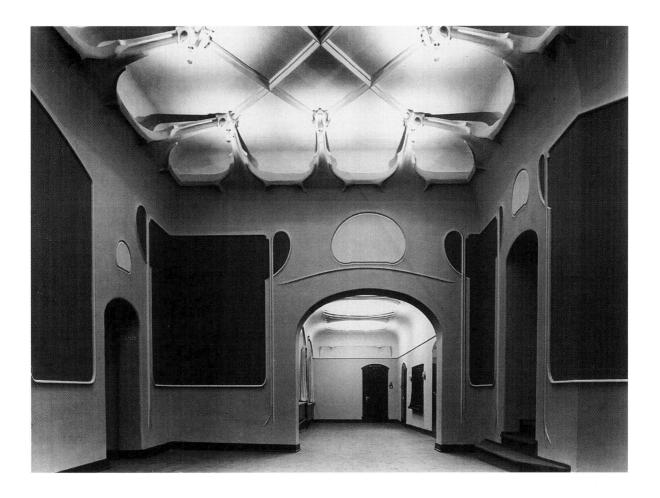

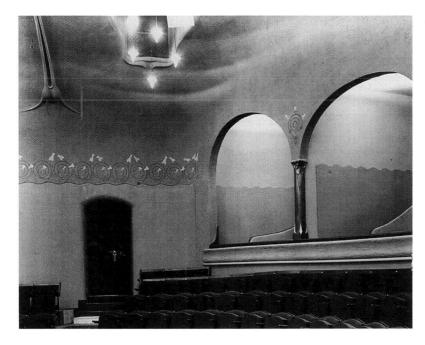

<u>Richard Riemerschmid, upper foyer and part of</u> the auditorium of the Munich Kammerspiele, 1901. <u>Richard Riemerschmid</u>, the Dresden Workshops' factory building in Hellerau near Dresden, 1908–1910.

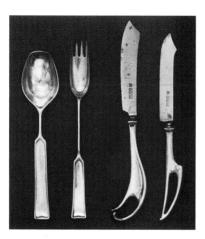

<u>Richard Riemerschmid,</u> cutlery, Munich 1899/ 1900, silver. Private collection

<u>Richard Riemerschmid</u>, chair, Dresden Workshops, 1905, oak with upholstery by the designer. Private collection, Munich

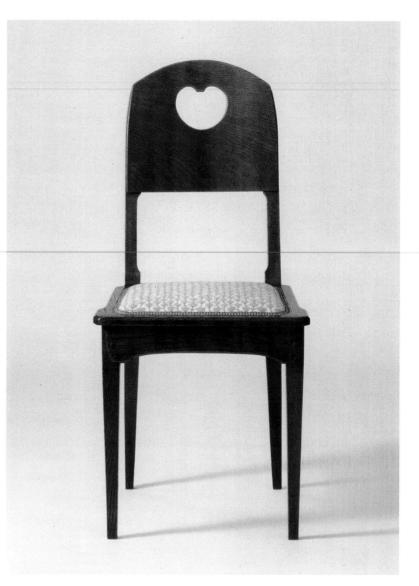

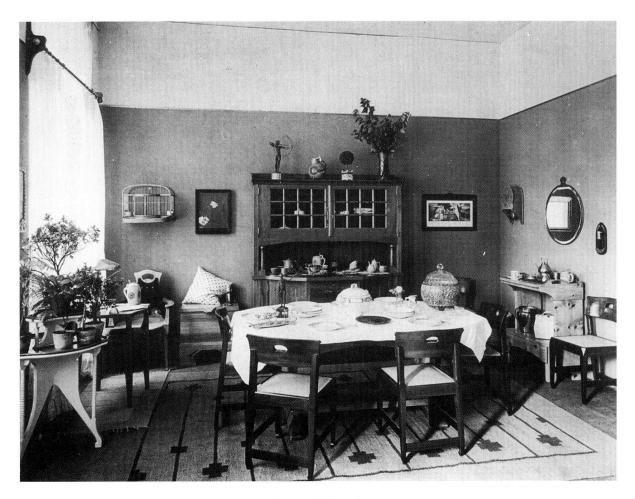

<u>Richard Riemerschmid,</u> a model room by the Dresden Workshops, with furniture and ceramic tableware by the designer, c. 1905.

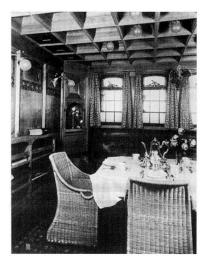

workshops, with the artist as entrepreneur on his own behalf. This worked well in Munich, and their progress was rewarded by an invitation to take part in the Paris World Exhibition of 1900. Of course they could not share the space allocated to the official "German House", which took its place alongside the other national displays on the banks of the Seine, since this had turned out to be entirely in the spirit of Wilhelm II – cheap and flashy. Instead the Munich group was accommodated in a remote corner, in the quarters of the German cultural commissioner on the Esplanade des Invalides.

The largest of the three rooms put at their disposal was given over largely to single pieces – furniture, fountains, tapestry and so on. Riemerschmid tried to introduce a sense of unity by means of a strand of woven ornamentation extending right round the room, which dominated the assembled objects in a satisfying way. The two remaining rooms were unspectacular, but at least each was consistent in plan. One was desig-

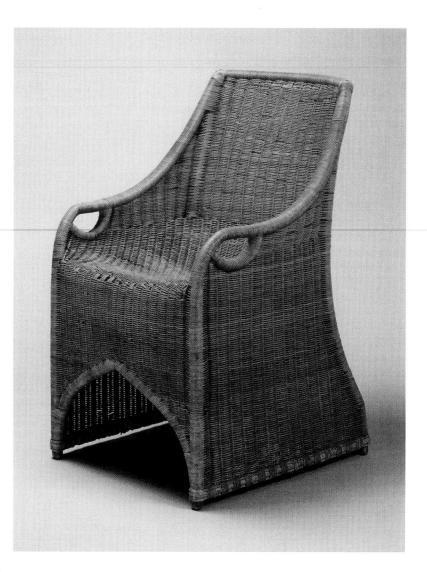

<u>Richard Riemerschmid</u>, cabin on the steamer "Kronprinzessin Cecilie", 1906.

<u>Richard Riemerschmid,</u> rattan cane chair, Dresden, 1904–1906. Münchner Stadtmuseum, Munich

<u>Richard Riemerschmid</u>, a model room by the Dresden Workshops, with the designer's furniture, Dresden 1905.

<u>Richard Riemerschmid,</u> chair, 1905, mahogany with upholstery, Dresden Workshops. Private collection, Munich

<u>J. J. Scharvogel und W. Magnussen,</u> stoneware jar with pewter lid, Munich c. 1900, 35 cm high. Private collection, Munich

<u>Richard Riemerschmid</u>, stoneware jug, Munich 1902, Reinhold Merkelbach, Grenzhausen, 22 cm high. Private collection, Munich nated as a smoking room, and Pankok panelled the walls impressively with wood (p. 85), making it seem like an old-style cabin on board ship that might at any moment have started rocking on the deep, with creaking timbers, and lamps dangling to and fro from the ceiling. Here and there a homely knot embellished the wood. The dilated wooden shapes beside the door through to the next room gave a feeling of stalwart solidity.

The third room was by Paul and was intended as a huntsman's room in rustic style, positively Bavarian in feel. Paris was left in no doubt as to the provenance of the Munich contribution. The metropolis was not shocked by this Bavarian intrusion – exhibitions of this sort often hosted folk-lore in the entertainment sector – but as an artistic contribution it was a daring display nonetheless. The Finnish offering was in a similar spirit; in their pavilion the Finns displayed stylized modern art rich in their own regional traditions. It was a success.

Riemerschmid followed this with a masterly design for one of the smaller Munich theatres, in which he was helped by family connections. The construction of the Kammerspiele was a stroke of luck for the movement as a whole (pp. 100, 101), comparable in extent and artistic merit to the Folkwang Museum in Hagen which van de Velde was completing at the same time, 1900/1901 (pp. 36, 37). The conditions were ideal in both

cases; van de Velde had a patron who could be persuaded to extend a welcome to modern art, and Riemerschmid was building for a theatre that championed modern drama. The size and the design of the interior were shaped with this in mind, entering into a kind of intimacy and even conspiracy with the regular patrons. Like van de Velde, Riemerschmid had to cope with an outer shell that was already more or less finished; insted of being a disadvantage, this stimulated his inventive creativity.

His ingenuity and his fertile imagination are specially evident in the diverse ceilings. In the auditorium he fitted all the lamps into boatshaped hollows spanning the whole width of the room. In the foyers he worked either with interlacing circle patterns or with a network of ribbing, lighting providing them with a functional, and not purely aesthetic, role. What might have been bleak rooms were enlivened by an abundance of movement. Pleasantry and wit are everywhere, supported by corresponding colours, with a successful contrast between the greyviolet and blue of the aquarium-like foyer and the rather more sober brown, grey and brass-yellow of the upper level. In the auditorium the dominant colours are red and intense blue-green. Altogether the theatre was in its time rather too brightly coloured for the taste of Henrik Ibsen and Gerhart Hauptmann. Riemerschmid, who tended to keep a firm hold <u>Friedrich Adler</u>, coffee service, Munich, shortly after 1900, pewter; coffee pot 24 cm high. Private collection, Munich

<u>Theodor Fischer</u>, elementary school in the Haimhauserstrasse in Munich, 1895–1898.

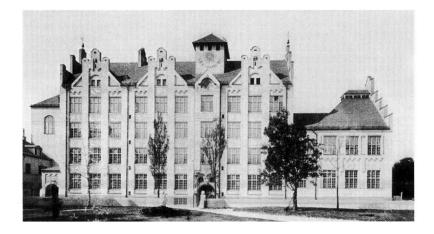

<u>Theodor Fischer</u>, door in the Haimhauserstrasse school in Munich, 1898.

on himself, showed just how versatile he could be when he related his inhibitions.

He was given another lavish task when he was asked to decorate the rooms of a large restaurant in Berlin. His approach to this was similar to his approach to the theatre. He was also able to build several houses, in spite of never having studied architecture, but his real passion – as has been mentioned – was designing furniture (pp. 102–105). Others were designing furniture at the time – van de Velde, Behrens and Hoffmann – but none with the same programmatic strategy. His aim, developed over a period of many years, was to set standards and to find broad-ranging solutions. As early as 1901 he had won a competition for his design of a model, low-cost interior for a worker's apartment. He was pursuing the same line of thought when he turned to the Dresdner Werkstätten für Handwerkskunst (Dresden Workshops for Artist Craftsmanship), with their interest in inexpensive traditional objects, in preference to the more exclusive ambience of the Munich Workshops, of which he had been a co-founder. These were the leading workshops of their kind in Germany at the time, but there were other smaller ones; they all showed how widespread the inclination was to offer "honest" goods at sensible prices. The ethical manufacturing ideals behind them prevented the products from being really cheap, but since they did not have to be

Theodor Fischer, entrance to the Haimhauserstrasse school in Munich, 1895–1898.

<u>Ludwig von Zumbusch,</u> front cover of "Jugend", Munich, 1896. Private collection, Munich

<u>Ferdinand Morave</u>, table clock, Munich 1903, wood and brass, 53 cm high, Vereinigte Werkstätten für Kunst im Handwerk. Private collection, Munich expensive either, the workshops went some way towards putting William Morris's ideas into practice.

Doubtless a curtailment of the artist's scope was involved, and in a sense Riemerschmid could not remain true to himself; but he seems to have accepted this. He was so engrossed in the work of the Dresden Workshops during the years that followed that he was largely responsible for the face of their output (pp. 102-105). The results were variable, but never inconsequential. But well-meant endeavour and the undisquised will to benefit other as felt in Riemerschmid's model interiors, can become overpowering. The comforts suggested by birdcage, high quality art-print and traditional china are all so stage-managed that the petit bourgeois for whom they were intended would have been no more eager to live in them than the Opel workers in the house built for them at the same time by Joseph Maria Olbrich in Darmstadt (p. 165). Behind all the honourable intentions there is a patronising streak; here were people who knew what would be most beneficial for the common man. It is hardly surprising that this attempt at reform proved as naïve as most others connected with Art Nouveau - from the very beginning the movement had been more than an artistic revolt. Those who bought the furniture tended to be those who took pleasure in inverted snobbery.

The results improved when technical considerations began to have more of a formative influence than stylistic predilections. The "machine furniture" on offer from 1906 onwards was composed of individual parts visibly screwed together. Taken to bits, they could easily be dispatched. Art Nouveau had clearly been a driving force in this development – as the identity of the designer shows – but it now also found useful application. Aesthetically, too, the visibility of bolts and joints added satisfaction of a new kind.

The ideas and spirit of the Dresden Workshops were re-confirmed by the founding of the Deutscher Werkbund in Munich in 1907. The Werkbund was an association of artists, manufacturers and writers, whose declared goal was a closer link between progressive designers and industry. As pragmatists the associates believed in mechanisation; they no longer pursued the handicraft ideals with which Art Nouveau had originally begun. This was in effect the real revolution, in contrast to the apparent revolution which had preceded it. The conscious decision to found the Werkbund – whose members included almost every artist mentioned so far – might be regarded as the most important outcome of the whole movement, were it not for the fact that it went against the very same movement and undermined many of its hopes and aims. Yet there could

<u>Otto Eckmann</u>, stoneware vase with bronze mount, Munich, shortly before 1900, 42 cm high. Private collection, Munich

<u>Otto Eckmann,</u> illustration from "Jugend", Munich 1899. Private collection, Munich

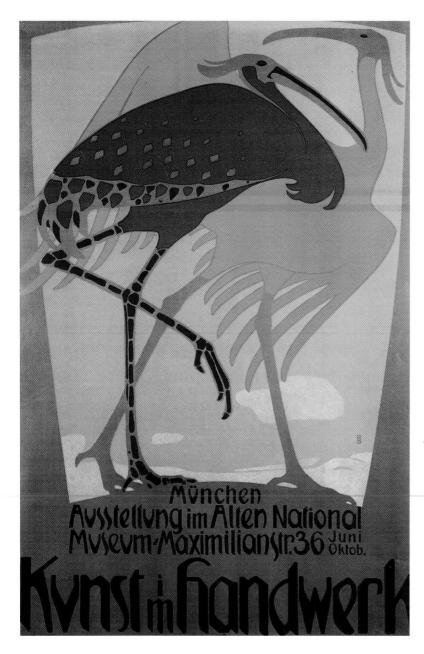

Bruno Paul, exhibition poster, Munich 1901. Münchner Stadtmuseum, Munich

Bruno Paul, 1874–1968

Studied at the Dresden Kunstgewerbeschule and later at the Munich Kunstakademie. He was a contributor to "Simplicissimus", for which he drew almost 500 cartoons. Began to design furniture under the influence of Henry van de Velde, and in 1898 was co-founder of the Vereinigte Werkstätten für Kunst im Handwerk in Munich. In 1907, director of the education department of the Berlin Kunstgewerbemuseum.

Major works: huntsman's room at the Paris World Exhibition of 1900, for which he won a "Grand Prix"; dining-room at the Exhibition for Decorative Art in Turin, 1902; study for the parliamentary president, Bayreuth, 1904; interior décor of the waiting room at Nuremberg, central station, 1905. be continuity and consistency even in reorientation. Riemerschmid was one of the key figures in this process.

In the years that followed, from 1909, the artist who worked most successfully in partnership with industry was Peter Behrens; he became artistic adviser to the electricity company AEG in Berlin, and had originally been a member of the Munich group, although less prominent there than others. It was not until his appointment to Darmstadt in 1900 that he began to attract altention. In Munich he had been chiefly employed as a in graphist (p. 114). In retrospect, it is easy to see that for him, coming from Hamburg in the north, Munich was not a place to stay for long; the southern German mentality was too limiting for someore of his talent and ambition. Otto Eckmann (p. 111) was another artist whose contribution was marginal; he died young, at the age of thirty-seven, in 1902. The weakness subsequently attributed to him by van de Velde, could actually be seen as a betrayal of all their high ideals. There was a certain self-

<u>Bruno Paul,</u> two views of a chair, Munich 1901, maplewood with leather. Private collection, Munich

<u>Peter Behrens,</u> frontispiece of "Der Bunte Vogel", Munich 1898. Private collection, Munich

<u>Bernhard Pankok,</u> wardrobe, Munich 1902, cherry verneer on oak. Westfälisches Landesmuseum für Kunst und Kulturgeschichte, Münster sufficiency in much of the work produced in Munich at the turn of the century; an unruffled lack of commitment tended to make itself felt in form and in attitudes, more so than in other places. Things were not taken quite so seriously as the occasion might demand. On the cover of "Jugend" the lettering might be excellent, the illustration, by contrast, conventional (p. 110). There was inconsistency; emotions often replaced true convictions.

This was not the case with the two artists mentioned earlier in this chapter – Bruno Paul and Bernhard Pankok. Their work, with that of Riemerschmid, made the greatest contribution to *Jugendstil* in Munich, indeed in Germany. In the wake of his activities as cartoonist for "Simplicissimus", Paul turned out to be capable of the most amazing muta-

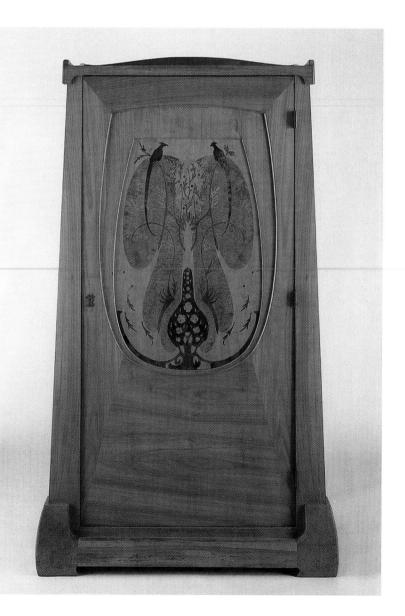

Bernhard Pankok, 1872–1943

The painter and designer Pankok studied at the Kunstakademie in Düsseldorf and in Berlin from 1889 onwards. He opened his own studio in Munich in 1892, and in 1897 was a co-founder of the Vereinigte Werkstätten für Kunst im Handwerk. He was appointed professor at the newly established Königliche Lehr- und Versuchswerkstätte in Stuttgart in 1901, which, under his direction, merged with the Kunstgewerbeschule in 1913.

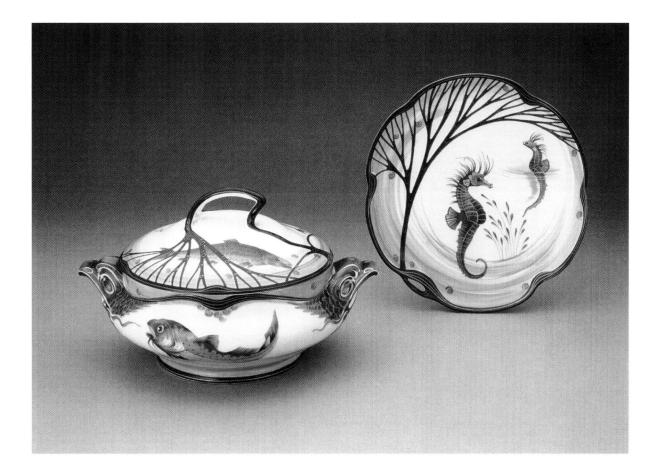

tions, even by the standards of the times, accustomed to rapid change. At extraordinary speed, the accomplished illustrator became the most rigorous and elegant designer of furniture, domestic décors and largescale interiors. His initial sureness of touch was never lost, but it did gradually take on a certain routine quality as one commission succeeded another. Yet the ability to present complex relationships in simple terms a quality discernible in his early caricatures - is a distinctive feature of the furniture he designed in the early 1900s. His chairs, whether plain or upholstered, were constructed with great precision and economical clarity of contour. Moreover, the overall design displayed great plasticity. Paul knew how to transfer his method of composition to whole rooms, as in the dining-room that he showed in 1902 at the exhibition of modern decorative art in Turin. He also designed one of the most elegant posters of the period (p. 112). Spurning illustrative blatancy, a pair of herons move across the picture, their relevance to "Kunst im Handwerk" - "art in craft" - remaining far from apparent - unless the viewer is supposed to see a certain affectation in both! Yet it is easy to see the connection when one observes how the herons' wings inspired the design of one of Paul's chairs (p. 113).

Other Munich artists drew inspiration from fauna, particularly Pankok, the most startling of all of them. Like Riemerschmid and Behrens, he had <u>Hermann Gradl</u>, fish service terrine and plate from the Nymphenburg porcelain factory, Munich 1899, dia. of plate: 23.5 cm Bröhan Museum, Berlin

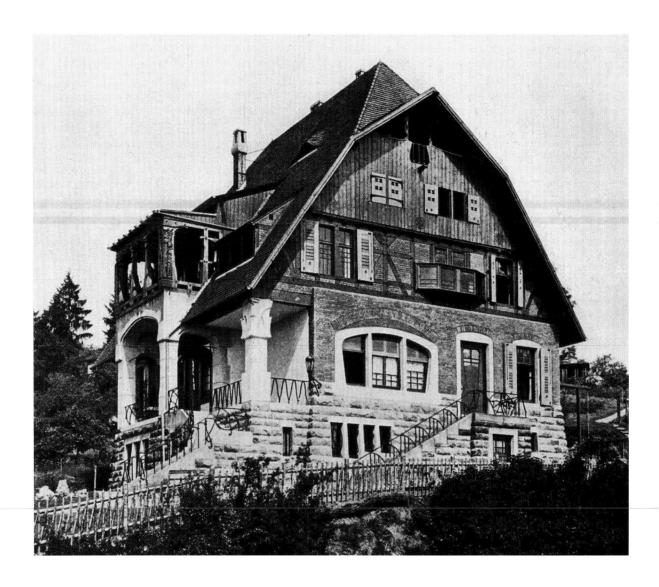

Bernhard Pankok, the Lange house in Tübingen, 1901/02.

started out as a painter; unlike the others, he never gave up painting. He later made a name for himself as a portrait painter, and as a stage and costume designer, at the same time as creating highly individual pieces of furniture of considerable sculptural merit. A wardrobe from a bedroom interior appears built on cloven hoofs, narrowing at the top to two pointed ears (p. 114). The door has a powerfully moulded two-part relief; the innermost area is playfully decorated with inlay work, and birds can be seen sitting on branches. But there seems to be a pair of lungs there, too giving the wardrobe the air of a living organism. The large swollen form in the centre might be interpreted as an active phallus. In 1900 Pankok had his first opportunity to build a house. Konrad Lange, a 45-year-old professor of art history in Tübingen, was courageous enough to have his house built by an untried architect. He had probably become acquainted with Pankok through the Munich Workshops. The outcome of their joint design was no more a revolution in architecture

Bernhard Pankok, living-room in the Lange house, Tübingen, 1902.

than were the villas and country houses built by Riemerschmid, but Lange's house has a freshness and ingenuousness that augured well for the future. The overall form is very much in the style of a large Black Forest farmhouse, but beneath and beside the hipped roof a series of details prevent any hint of heaviness or tediousness. The tension lies above all in the combination of the large with the deliberately small. In the design of loggias, bay windows, terrace steps, window and door surrounds, and above all in the support buttressing the front corner of the house, Pankok proved himself yet again to be an imaginative sculptor. The interior was a model example of a "German home", unimpeachably upright and respectable, idealogically sound, with not an artificial additive in sight. Yet the didactic element was more relaxed here than in Riemerschmid's hands. A close look reveals a whole range of imaginative embellishments: the stucco frieze below the ceiling, the amusing clock whose outline echoes the swing of the pendulum, the pretty little vignettes and the fluted panelling that seems to invite a sensuous caress. As if in confirmation of the conjecture that the purchasers of Riemerschmid's simple products were above all people who could have afforded to spend more, one of his jugs stands on the sideboard. A delicately slanted line can be discerned as a barely perceptible, unifying element of design in almost everything in the house. In the case of the chairs, as the owner noted, the graceful line was achieved at the expense of comfort.

Pankok's signature is unmistakable in the music room designed in 1904. The profusion of detail, strangely enough, is not confusing; it can rapidly be seen to match the large, fundamentally strict order of the panelling. The bizarre shoal of lamps playfully extends the design of the panels into the room, and suddenly you are under water, surrounded by algae, coral and all manner of rippling creatures, silently observed by hovering skates. This extravagantly luxuriant room, created for one of the last important exhibitions of the time, actually marked the end of the distinctive Munich version of Art Nouveau. Nothing comparable could be repeated, and interests now lay elsewhere. A particular shame in view of the unmistakable pinnacle this achievement attained. <u>Bernhard Pankok</u>, music-room shown at the St. Louis World Exhibition in 1904, and afterwards at the Stuttgart Landesgewerbeanstalt. Destroyed.

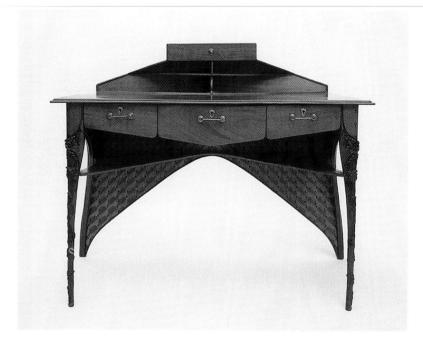

<u>Bernhard Pankok,</u> lady's desk, Munich 1900/01, mahogany and cherry. Geitel Gallery, Berlin

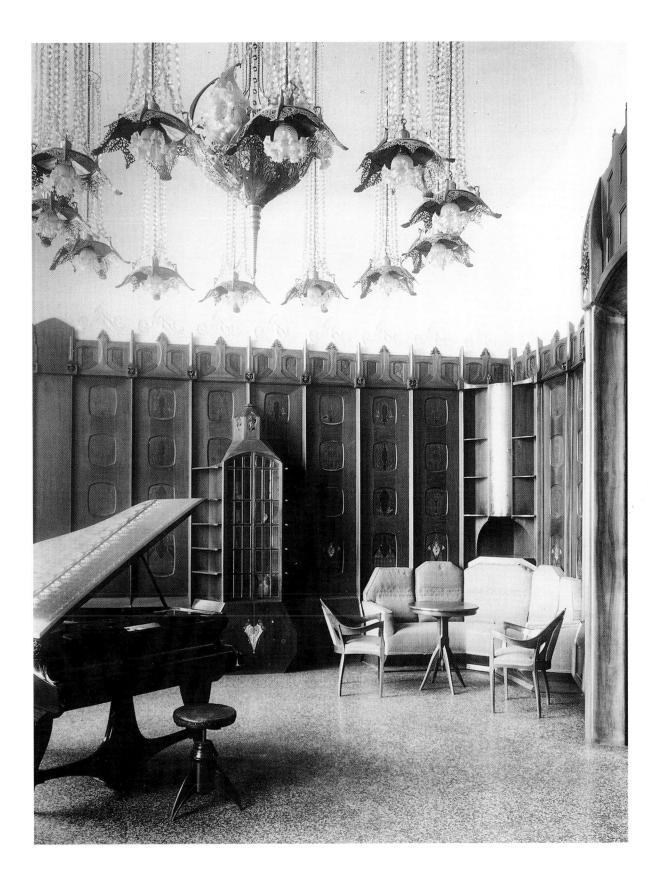

Weimar

Since the early nineteenth century the name of Weimar had had not only geographical but also cultural significance. Around 1800, under the rule of Duke Karl August, this quiet city, remarkable neither in politics nor in economy, awoke to become the German "Athens on the Ilm". Goethe, Schiller, Wieland, Herder and others lived here for varying lengths of time, ennobling the city and elevating it above the level of provincialism. The partition of Saxony in the seventeenth century had made Weimar the capital of the Thuringian duchy Saxony-Weimar-Eisenach, a heterogeneous area of unequal parts and one of the smallest of the small German states, yet in 1815 it became a grand duchy as a result of the Congress of Vienna. Economically it did not make great progress in spite of the impetus of industrialisation in the nineteenth century. It was lacking in mineral resources; raw materials and semi-finished goods had to be imported. Only trade and commerce were able to hold their own.

Weimar won new importance during the second half of the century under Grand Duke Karl Alexander, who ruled from 1853 to 1901. With a strong sense of his own rank, the Grand Duke laid claim to a privileged position among the Saxon dukedoms; he arranged for the Russian and Prussian consuls to be based in Weimar. Relatively liberal in politics, the Grand Duke initially steered a neutral course and kept his distance from Berlin. The disputes of 1866 he classed as "criminal civil war". After the founding of the empire he supported the Kaiser on the assumption that the influence of Prussia would be spread more widely and more moderately - an understandable, but in the event mistaken, hope. None the more powerful for all his loyalty to the empire, the Grand Duke turned his attention instead to promoting the cultural renown of Weimar, as the much younger Duke Ernst Ludwig was later to do for Darmstadt. A school of painting founded in 1860 was financed from his privy purse; at one time or another it numbered among its members well-known artists such as Wilhelm von Kaulbach, Max Liebermann and Arnold Böcklin. Weimar tended to be more open towards innovation, particularly coming from France, than did Berlin, Munich or Dresden.

Distinguished artists in other fields were pleased to show their esteem for the city. Franz Liszt and Friedrich Hebbel both spent time in Weimar. The seat of the muses seemed to have found new life, and memories of earlier Opposite page: portrait of Count Harry Kessler by Edvard Munch, Weimar 1904, private collection, and the opening of a Klinger Exhibition in Weimar, 1903. In the foreground: Grand Duke Wilhelm Ernst and his wife. Henry van de Velde was later added on the left by montage; in front of the light-coloured Count Harry Kessler.

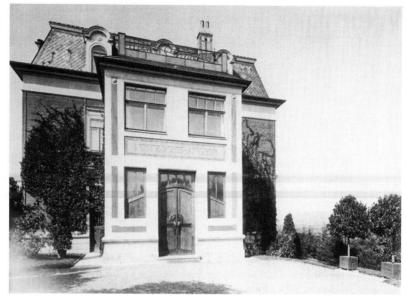

<u>Nicola Perscheid</u>, Elisabeth Förster-Nietzsche at the entrance to the Nietzsche Archive in Weimar, 1904; the door handle is by Henry van de Velde, as is the dress material.

<u>Henry van de Velde,</u> the redesigned entrance to the Nietzsche Archive in Weimar, 1903.

times were appreciated and nurtured: the Goethe-Schiller Archive, the first literary institute of this sort, was founded in 1889; from 1890 Weimar was the seat of the Schiller Foundation; the Shakespeare Society had already been in existence for some time. The modest charm and rich traditions of this old city, with a population of some 3000, were successfully retained, and disguised up to a point the relative lack of prosperity in the surrounding countryside, still predominantly agrarian.

The receptive atmosphere of the ducal court changed abruptly when Karl Alexander was succeeded in 1901 by his grandson – the ailing son and heir having pre-deceased his father. Wilhelm Ernst (p. 120) was a Prussian type, filled with the martial spirit of Rhineland students. He was considered arrogant and overbearing, with keen intelligence but lacking in feeling and tact. Hunting and automobile racing meant more to him than art. He upheld the traditions of his court out of a sense of duty, aware that there were obligations to be met.

In spite of this lack of enthusiasm, 1901 saw the launching of a "third Weimar". The situation was rather similar to that in Darmstadt, although the respective dukes had little in common. Wilhelm Ernst had few ideas of his own; initiatives were put forward by others who hoped to be able to influence the restless and choleric ruler. Harry Count Kessler (p. 120) was the most important of these, and should perhaps have taken heed of what he knew of the Grand Duke from their time together as duelling students. Initially there seems to have been some affinity between them, grounded either in hereditary loyalties or in the personality of the Count, who may have valued the duke's raw vitality and strength which contrasted with his own vulnerability.

Kessler was assisted by Elisabeth Förster-Nietzsche, sister of the philosopher and poet. She had looked after her brother during his deranged last years in Weimar and she considered herself his legitimate

heir; she did more than simply guard the heritage, at times she undertook improvements. Her personal ambition led to notable results: to splendid editions and to extension and reorganisation of the archive, which she kept under her own supervision and made a hive of activity. In all these undertakings she turned for help to the revered artist who determined the cultural physiognomy of Weimar in the years that followed: Henry van de Velde.

In Weimar, as in Darmstadt, economic realities also steered developments. Thuringian commercial enterprises and small businesses were technically well-equipped, and there was no shortage of skilled workers, but in order to survive in the increasingly competitive market there was a need for greater differentiation in taste. In accordance with the maxim that what commerce really needed was art, steps were taken to find a personality who could bring to the city an established reputation. Van de Velde's recent spectacular successes in Berlin justified the hope that Weimar would profit from his strength and influence and that lucrative commissions would be secured for local craftsmen. This was what Kessler had in mind when he nominated his friend for a position in Weimar. He himself took over in 1902 as director of the Karlsplatz Museum, also known as the art and crafts museum. Both he and van de Velde were received at court from this time.

Kessler and van de Velde had got to know each other well in Berlin. Both were fired with missionary zeal to bring art to their environment, the former as patron and initiator, the latter as artist and theoretician. Both felt drawn to the major cities of Europe, and yet both wanted to escape from city life in order to work with greater concentration in seclusion. Thus they embodied the artistic conflict of their age.

Weimar seemed to be a good place for reflection. Both men felt free to choose where they were going to live and work, both moved throughout

<u>Henry van de Velde,</u> design for a Nietzsche Stadium (never built) in Weimar, 1911/12.

Louis Held, Elisabeth Förster-Nietzsche with the deluxe edition of Nietzsche's "Also sprach Zarathustra", designed by Henry van de Velde and published in 1908, Weimar c. 1910.

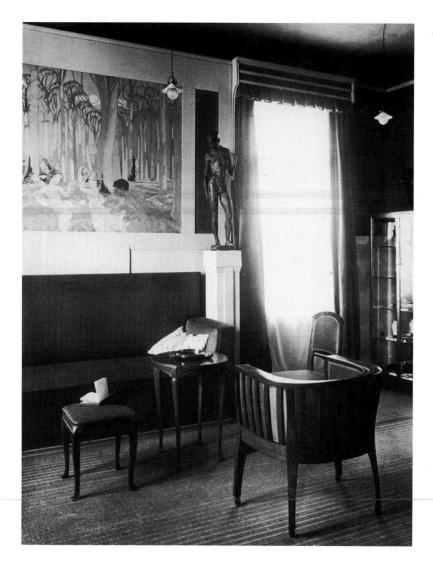

Henry van de Velde, seating in Count Harry Kessler's apartment in Weimar, 1902 and later, after the room and had been turned from a diningroom into a salon. The figure is by Aristide Maillol, the mural by Maurice Denis.

AMO

'AIME LES FLEURS QUI SONT LES

AIME LES FLEURS QUI SONT LES yeux de la Terre, qui s'ouvrent des qu'Elle se ré-vieux pour nous dire l'était des ajois, simple et en-dances et des sei des inssouvis, l'inonie des arcu-auté ou l'infinie douceur de sa bonté. "aine les arbres qui réusissent do nous avons é-choué et réalisent en beauté, sans l'intervention d'aucan bon sentiment, par le seul miracle de leur parrer et de leur silence, la lute et le choc des é-forts et de l'égoime qui sont parells à ceuxqui dé-cient de notre destinée. Pas un juge prosonce parmi eux le jugement hautain; pas un prêtre la promesse fai-ncieus de pardon de la faute commise contre le sa ures pardon de la faute commise contre les au-tres pas un docteur applique le remède, panse la plaie; pas un vois jase, colport le le blame ou la médiance ou louange chargée d'envie.

et sa stature, puise sans égards au sol qu'il a mis sous lui. Et le faible s'accommode, fixe son humilité sans honte

Et le faible s'accommode, fixe son humilité sans honte et sans plainte et sans revendication. aime les corps humains et ceux des animaux. Nos sens affolés ont tout dit du corps de la femme, de celui de l'homme. Le toucher s'illusionne qu'il caresse les plus beaux fruits, tandi que la vue détaille et découvre que chaque membre du corps humain ressemble aux choses les plus tentantes que son désir pourrait quérir sur Terre autant que dans le Paradis. L'odorat trahit les fleurs, la senteur des matins et des brouillards d'automne pour les parfums de la chair qui varient selon qu'elle est sans désirs ou ardente, folle ou mortifiée et qui détient ainsi des secrets que la nature lui envie.

mortine et qui deitent anns des secrets que la nature lui envie. L'ouïte a pour la voix humaine des extases telles qu'aucun des sons que la virtuosité arrache aux instruments divins n'en peut provoquer et on sait que le goût ne connaît rien qui envire plus surement que l'effleurement des lè-vres et l'eau des bouches.

Tandis que ces instincts ne dissimulent qu'imparfaite-

Henry van de Velde, two pages from his text "Amo", printed by Count Harry Kessler's Cranach Press in Weimar, 1909.

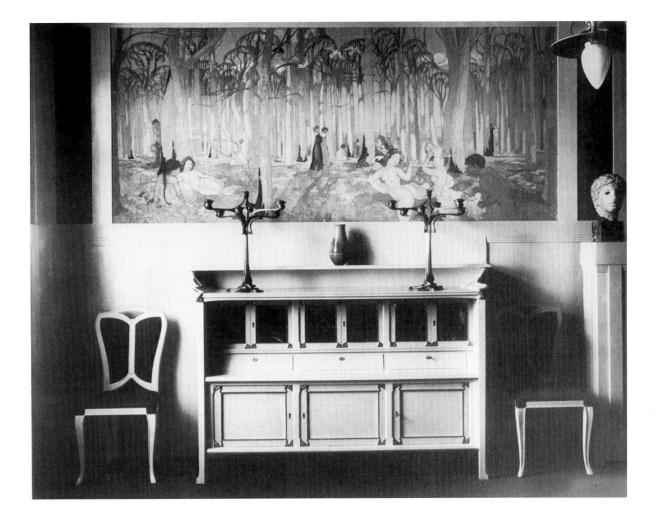

their lives from one country to another, from one intellectual and artistic climate to another. Although Kessler was of German descent, he had grown up in England. He owned an apartment in Berlin but he did not spend much time there until after the First World War. He felt himself just as much an alien in Wilhelmine Germany as did the Belgian van de Velde, who was also something of an anglophile, in search of a home which could not be his natural one. His rationalist theories had international validity; he could only live in a place where he felt, immediately and above all else, that he was understood. He had been searching for such a place all his life. Again, the two men were united in their predilection for France. The count was a connoisseur of Impressionist painting, which he tried to promote in Berlin, while Paris had provided the most important formative influence for van de Velde, as his vivid and commandingly colourful interiors attest. The way of life favoured by both men drew them west, but a keen sense of advantage and opportunity led them to maintain their links with Germany. The real chance for them to exert an influence was granted in Weimar, and that seemed to outweigh the alluring splendour of society life in crowded Paris.

<u>Henry van de Velde,</u> the same room in Count Harry Kessler's Weimar apartment as in the picture on the left, but before its conversion from dining-room to salon, 1902.

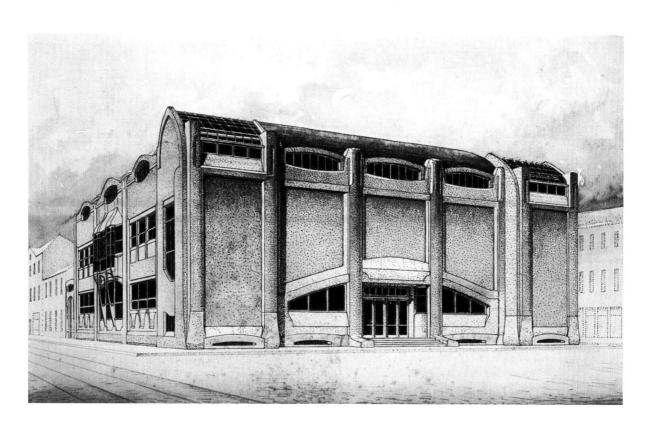

<u>Henry van de Velde,</u> design for a museum of applied arts in Weimar, 1903/04. La Combre Archive, Brussels In his memoirs van de Velde describes his friend in detail: "The relationship between Count Kessler and myself was at first cautious and distant. There seemed to be a deep and unbridgeable gap between us. Although we soon came to feel ourselves united by a friendship so close that nothing could come between us, yet the aloofness remained throughout the next forty years. Kessler's bearing was impeccable and he had a natural self-assurance and elegance. He was somewhat below average height, but well proportioned, without a trace of corpulence. His face was beautiful, his gaze keen, his eyes bright and without hardness; he could at times take on an air of authority. If one were to search in literature for comparable figures, one might pick Oscar Wilde's Dorian Gray, or Joris K. Huysman's Des Esseintes, the protagonist of his novel 'A Rebours' ..."

One of van de Velde's first tasks on arrival in Weimar was to decorate and furnish an apartment for Kessler. Having to be always in the public eye had weighed heavily on van de Velde's work in Berlin; now it was no longer necessary, and freed from the constraints of public inspection the design could be far more relaxed, yet at the same time finely attuned to the owner's personality. The main room served first as a dining-room, but later converted to a living-room (p. 124). The panelling, in which a picture by the French painter Maurice Denis was set, remained. The picture's Arcadian mood was taken up perfectly in the figure of a naked youth sculpted by another Frenchman, Aristide Maillol; the Grecian associations of the room are taken up in the fragment of Parthenon frieze on the opposite wall, above the fire-place. The sideboard, in white lacquer, was a variation on a type of furniture which van de Velde had designed in Berlin. It testifies most beautifully to the fact that Japanese influence on Art Nouveau around 1900 was not restricted to two-dimensional art. It is an exquisite paraphrase of Far Eastern models, and shows the utmost delicacy in its proportions, in the metal fastenings and in the sweep of its topmost shelf. The chairs, on the other hand, are an idiosyncratic variation on Chippendale.

The modern furniture in the room is even more rigorous in design, and shows that the artist had moved on, not only in a geographical sense. It may be that van de Velde was influenced in part by what he saw in Darmstadt when he visited the exhibition there with Kessler in 1901. In the Weimar apartment he honoured his undertaking to abstain from ornamentation for a while. Yet things still seem full of life, their animation now derived less from bold curvaciousness than from their functional logic. Many features contribute to the relaxed atmosphere of the room, among them the simple mats which provide floor covering throughout the apartment.

Van de Velde did not hesitate to extend his principles to architecture. He considered his theories all-embracing, but since he had scarcely any experience of building the results must have been awaited with particular interest. The design for a new building to house the museum of applied arts (p. 126) of which Kessler had just become director shows how daring and how dubious was the attempt to go straight from small-scale to

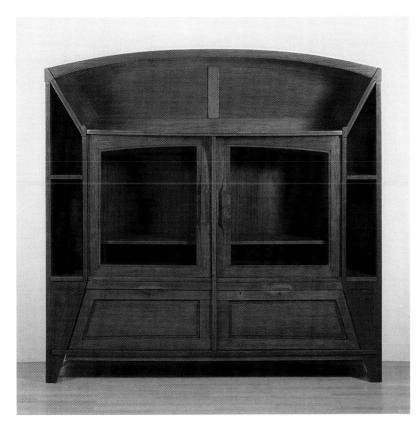

"Art Nouveau may have been my offspring, but I gave it a thorough hiding all the same!" Henry van de Velde, taken from: Oswalt von Nostitz, Muse und Weltkind. Das Leben der Helene von Nostitz, Munich 1991

<u>Henry van de Velde,</u> salon cupboard, Weimar, shortly after 1900, mahogany. Museum für Kunsthandwerk, Frankfurt/Main

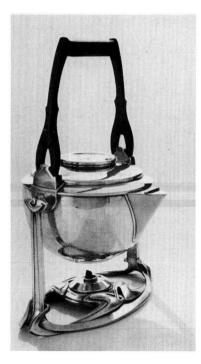

Henry van de Velde, samovar, Weimar, 1902 silver with ebony, 37cm high. Kunstgewerbemuseum, Zurich

<u>Henry van de Velde,</u> tea service, Weimar, 1905 silver with boxwood, tray length: 50 cm. Karl-Ernst-Osthaus Museum, Hagen/Westphalia

Henry van de Velde, plate from the Meissen porcelain service shown on page 129, dia.: 27cm. Private collection, Munich

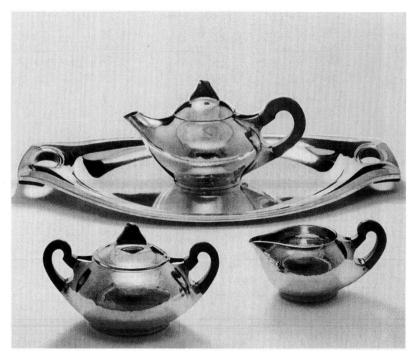

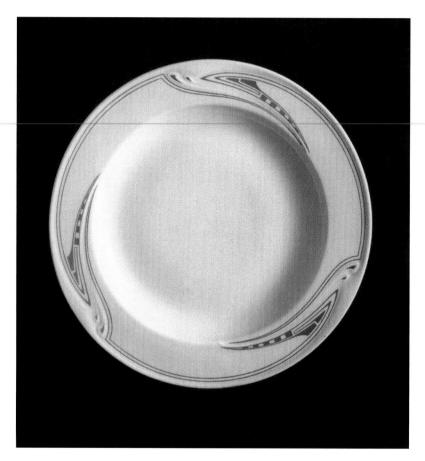

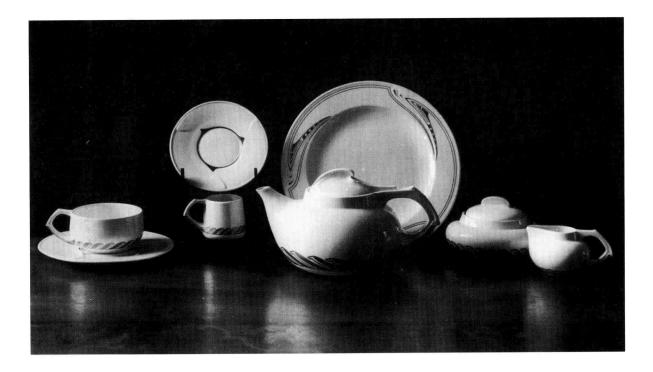

large-scale design. The avant-garde approach is evident in the unconventional flavour and rich plasticity – only a gifted amateur could broach architecture with such reckless spontaneity – but it is also clear that the plans are largely derived from furniture design. What had been successful for the one purpose was not necessarily going to succeed for the other. The somewhat overpowering character of the relatively small building results from the attempt to transpose and enlarge. The arch motif reappears, probably intended to introduce lightness, but hard to reconcile with the interior. At the same time it can be seen that the usual triangular gables, rectangular windows and sloping roof have been avoided. The new approach was at least comprehensive.

The project was discontinued, and thus numbers among Kessler and van de Velde's first disappointments in Weimar. There was compensation in the successful collaboration with local craftsmen. The jeweller Theodor Müller and the cabinet-making firm of Scheidemantel – both in Weimar – benefited visibly from the artist's presence. At last their skills were appreciated and encouraged. Business flourished not only because of contracts secured by van de Velde, but also through the sale of items manufactured to his designs. The same benefits accrued to wickerworkers in Tannroda, weavers in Weimar, potters in Bürgel, meerschaum-carvers in Ruhla and artistic locksmiths in Berka.

From 1902, the introduction of a handicrafts seminar helped to systematise the artistic reform process on a commercial basis. The aim was to convince craftsmen of the need to improve or even thoroughly rethink their products. In practice, the designers of factory goods submitted their plans and worked on them under van de Velde's supervision until they were considered ready to go into production. The artist even travelled

<u>Henry van de Velde,</u> parts of a Meissen porcelain service, c. 1905.

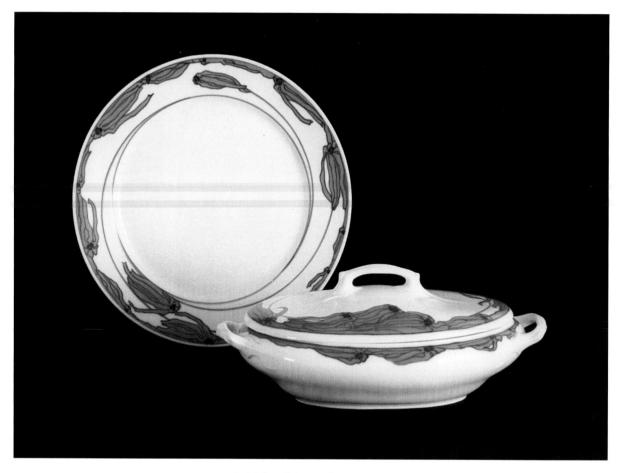

<u>Rudolf Hentschel</u>, parts of a Meissen porcelain service with arnica decoration, 1906, plate dia.: 25 cm. Private collection, Munich

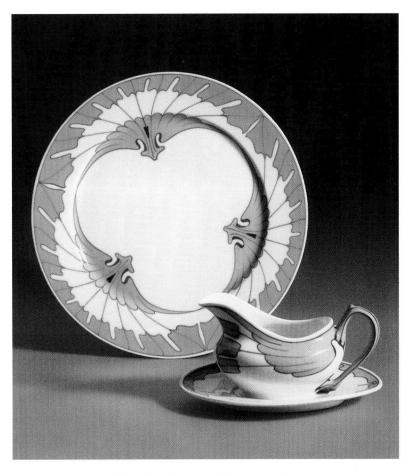

<u>Konrad Hentschel</u>, parts of a Meissen porcelain service with wing pattern, 1901, plate dia.: 26 cm. Private collection, Munich

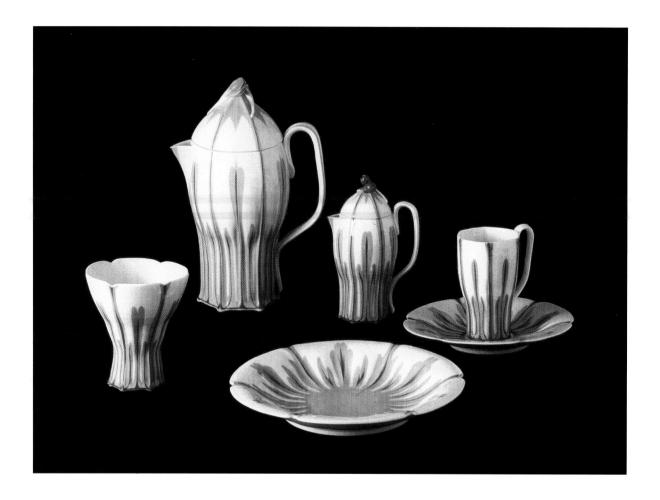

Konrad Hentschel, part of the "Crocus", Meissen service 1896, pot height: 20 cm. Private collection, Munich round the countryside, inspecting and advising, so that small firms should not be neglected. The laudable idea of an educational seminar was not new; a similar institution – the "Saxon Grand-Ducal Centre for Handicrafts" – had come into existence in 1882, but seems not to have lasted long.

The move to Weimar lost van de Velde his Berlin clientèle, but he was not restricted to Thuringia and Weimar. Commissions were forthcoming from neighbouring Saxony; he was well known in Dresden, where his career in Germany had actually begun in 1897. Four interiors which had aroused hostility in Paris in 1895/96 were all the more highly acclaimed when they were shown a year later at a large exhibition of applied arts in Dresden. It became apparent at this point, even before the breakthrough in Berlin, that van de Velde's specific gifts were best understood in Germany. The sequel to the earlier success was his 1905 interior design of the Galerie Arnold in Dresden (pp. 136, 137), which extended through several rooms and demonstrated very well the architect's emphatically constructive stance of the time. At about the same time the Meissen porcelain firm commissioned him to design a dinner service for them; they were among the first to incorporate modern art into their product range. <u>Henry van de Velde,</u> reading room in the Nietzsche Archive in Weimar, 1903.

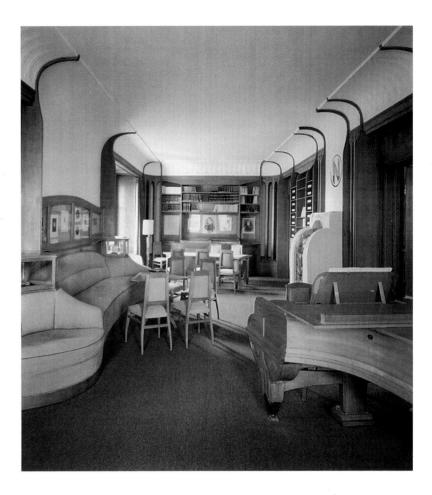

<u>Henry van de Velde,</u> two stoneware vases, Weimar 1902/04, Reinhold Merkelbach workshop, Höhr/Grenzhausen, 21.5 cm and 23.5 cm high. Private collection, Munich

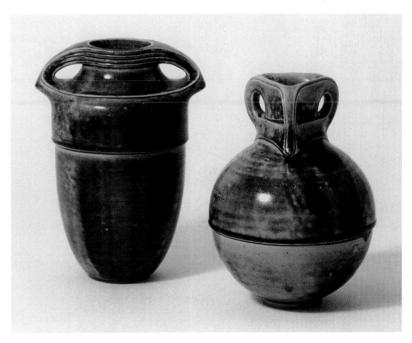

<u>Henry van de Velde,</u> silver jardinière, part of a large service presented to the Grand-Ducal couple by the province of Thuringia, Weimar, 1902. Missing.

<u>Henry van de Velde,</u> parts of a silver cutlery set, Weimar, 1903. Owned by various museums

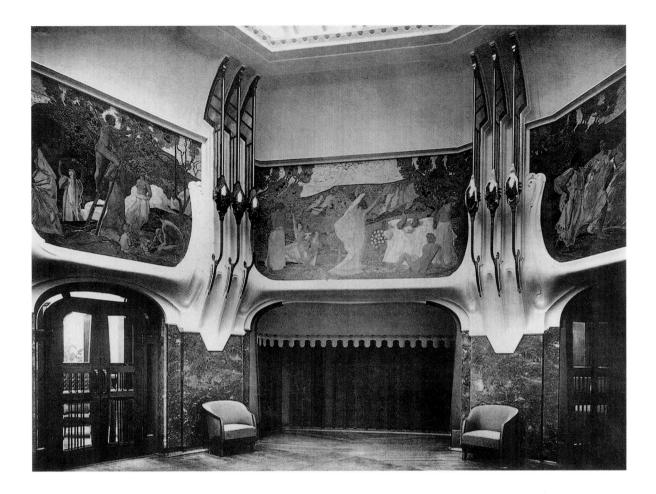

The elegant porcelain service designed for Meissen in 1905 (pp. 128, 129) is one of van de Velde's best works. There is unity in the softness of outline and ornament, each supplementing the other. With great care the ornamentation is suited to each individual piece, not generalised: the plates have a circling motif, the dishes an upright one, matching their functions. Differently applied, the signature is nevertheless the same, discretely linking each piece. The lid of the pot is hinged into the top of the handle – an aesthetically pleasing but also a useful idea, since it is secured in this way. Van de Velde designed a canteen of silver cutlery on similar principles (p. 134). The ornamentation is subsumed in the form of handle or haft, yet knife, fork and spoon are quite distinct from one another. Each has its own individual shape. On the other hand, the linear approach is the same in each.

However skilful and meaningful this kind of modelling might seem in small-scale products, the transposition of such techniques to architecture remained problematic. Van de Velde's philosophy led him to proceed in the same way, but the great Weimar museum hall which he constructed in 1906 on the occasion of an exhibition of applied arts in Dresden (p. 135), though full of lyrical and original features, was ultimately overloaded in its plasticity. Its vehemence recalls the somewhat florid retiring-room <u>Henry van de Velde,</u> museum hall at the Dresden Exhibition of Applied Arts in 1906; paintings by Ludwig von Hofmann.

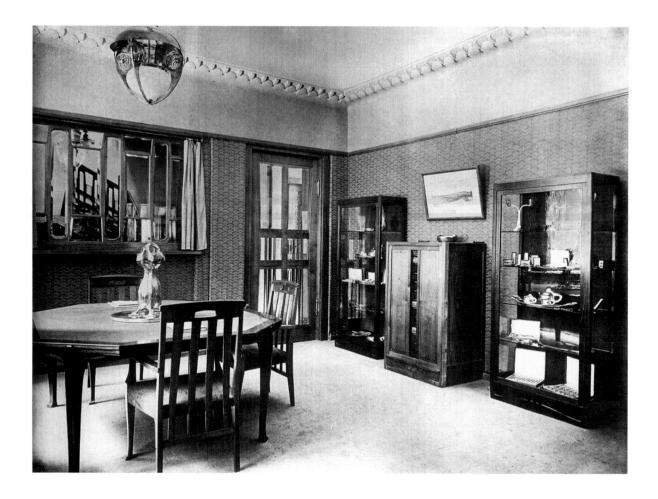

<u>Henry van de Velde,</u> exhibition room at the Galerie Arnold in Dresden, in which silverware by the designer is on display, ca. 1905. with which, along with the four rooms from Paris, van de Velde had made his Dresden début in 1897. But such extravagance and zeal were no longer necessary ten years on. The aesthetic logic still held good in part, but not the scale. A fundamental problem of Art Nouveau, the transition from handicraft to architecture, is manifested all too clearly.

Even in failure van de Velde was prototypical, and his importance to Weimar was not in question. The concern to boost the economy by means of education in art was bound to end in the founding of a training establishment. Only then would it possible to improve upon the ad hoc activities of the seminar. In 1907 a school of arts and crafts was opened under van de Velde's direction, and attendance was good in the years that followed. The building was one of his few public contracts (p. 138). Although relatively modest in size, it gave real scope to his engineering bent and precision, and it proved that he had now found his own direct approach to architecture. Nothing is lost of his individuality, the threequarter circle in the façade bears his distinctive stamp. It may well be that this building represents the best of Art Nouveau: an artistic and imaginative initiation into functional cohesion. The centre was mapped out as if with a pair of compasses, with van de Velde's own studio lit by the three gable windows, and energy flowing between the body of the house and the roof. Components are visibly interlinked, rendering indissoluble what might otherwise appear fragmentary. One of the achievements of these early years in Weimar was thus the acquisition of a powerful architectural language, confirmed by subsequent buildings.

Up to this point Kessler and van de Velde had met with indifference rather than appreciation on the part of the Grand Duke, but there was some hope that his lack of interest might be overcome by patience and persistence. Both men were untiring in their efforts, and Kessler succeeded in bringing important exhibitions to Weimar, particularly exhibitions of French art. It was largely owing to him that in 1903 the Deutscher Künstlerbund (German league of artists) was founded in Weimar, which had begun to enjoy a certain renown once more. The great tragic actress Louise Dumont contemplated bringing her own theatre to Weimar and van de Velde designed the plans, but in the event nothing came of it.

<u>Henry van de Velde,</u> silver candelabra, Weimar 1902 (the same can be seen in the picture on the left, inside the front cabinet). Kenneth Barlow Ltd., London

<u>Henry van de Velde,</u> cupboard for artists' materials from the Galerie Arnold in Dresden, 1905. Stanal Gallery, Munich

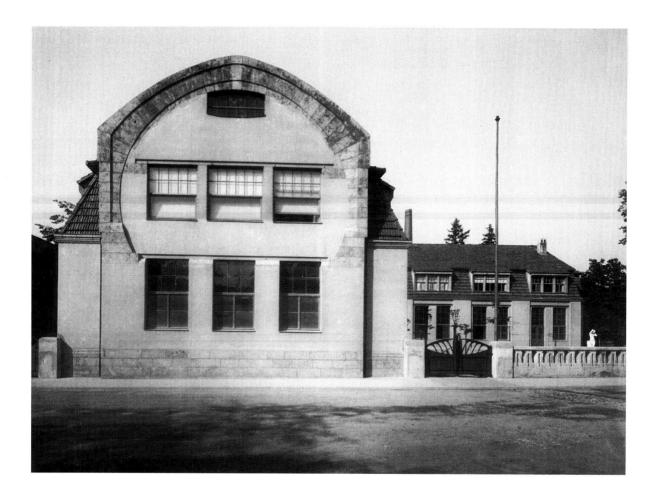

Henry van de Velde, the School of Applied Arts in Weimar, 1905/06. While hopes were still running high, van de Velde consulted the English theatrical reformer Edward Gordon Craig, who was just as glad to visit the city as André Gide and Hugo von Hofmannsthal, this latter coming on several occasions. Other guests were Rainer Maria Rilke, Gerhart Hauptmann, Max Reinhardt and Ferruccio Busoni. The list was impressive: the Athens on the IIm seemed to have risen once again.

Weimar remained more modest than Darmstadt, but there were great similarities between the two. In both cities an aristocrat and an artist came together as late fruits of an epoch in order to live out an ideal. It is impossible to gauge to what extent they were aware of being the last to be privileged in this way. Kessler may have borne some resemblance to the Grand Duke of Hesse, but Grand Duke Wilhelm Ernst of Weimar was very different. When the civilising influence of his wife ended following her early death, the atmosphere at court underwent a noticeable change. His increasing disaffection finally led in 1906 to a ridiculous and widely publicised fracas: Kessler had persuaded the sculptor Auguste Rodin to dedicate a nude drawing to the regent, probably on the assumption that it would find favour. The opposite was the case, and when the Grand Duke returned from a journey to India he ostentatiously slighted Kessler, causing him to tender his resignation. This was the end of Weimar's new awakening. Although Kessler and van de Velde both remained there, there was no further scope for their active partnership. Van de Velde found some satisfaction in working in Hagen, where the non-aristocratic but energetic and ambitious Karl Ernst Osthaus secured numerous contracts for him; but his later work in Weimar shows how shaken he was by the loss of confidence and trust. His attempt of 1911 to conjure up the spirits of the past, by means of a design for a stadium in honour of Friedrich Nietzsche, was unsuccessful. Not until 1919 did Weimar's fortunes rise once more, for a brief spell, with the founding of the Bauhaus, which grew in part out of van de Velde's School of Applied Arts.

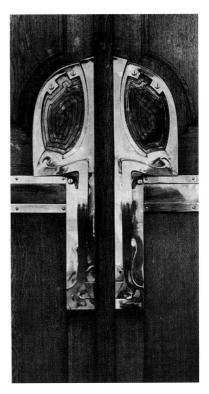

<u>Henry van de Velde,</u> door handles in the Weimar Nietzsche Archive, 1903.

<u>Henry van de Velde,</u> rocking-chair, Weimar 1904, mahogany with leather uhpolstery. Museum für Kunsthandwerk, Frankfurt/Main

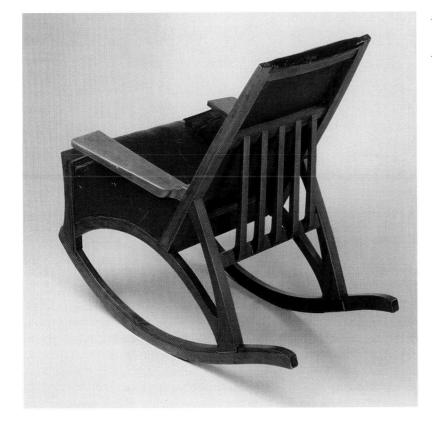

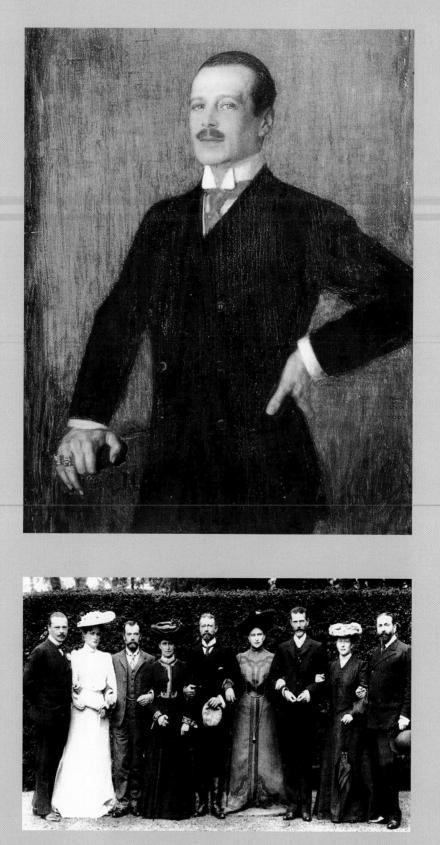

Darmstadt

Once upon a time there lived a nobleman who had wisdom, courage and a sense of style, and who was very favourably disposed towards the arts. Not only was he a patron of the arts in his own city, he was himself something of an artist. In order to help his country to become prosperous and renowned, he ensured that worthwhile commissions promoted crafts and trade. He chose young artists to help him, and so that all the world might hear of his intentions, he invited it to a magnificent celebration.

A fairy-tale, but one that seems to have come true in Darmstadt in 1901 when Grand Duke Ernst Ludwig opened the exhibition that he had encouraged, and indeed devised - "A Document of German Art". The title sounds too cold and impersonal for the reality: an artists' colony constructed entirely in the new style. The site was the Mathildenhöhe, a gentle rise not far from the town centre; the architectural nucleus was a spacious studio building, with seven dwellings loosely grouped around it. There was a pleasant air of informality, but with most of the buildings designed by the same architect there was also stylistic unity. Today the selection of the seven artists who were to sustain the whole, as a kind of living inventory, seems less convincing. The two painters and two sculptors had estimable talent, but nothing more. A young interior designer invited to join them was overshadowed by the far more experienced Joseph Maria Olbrich, who had already made a name for himself in Vienna and was well on the way to becoming a star in Darmstadt. Olbrich was particularly close to the Grand Duke, and indeed resembled him in some respects; he was also a most remarkable virtuoso, and the only trained architect in the aroup. Only the seventh member could compete with him, the painter, designer and graphic artist Peter Behrens, who had been summoned from Munich to join them. He was the secret winner of this artistic gamble, although Olbrich set the tone and knew how to maintain his position in Darmstadt in the years that followed. In style they were poles apart.

Originally the houses were supposed to be occupied only by the artists, but since not all of them had the means to build on the land put at their disposal, two of the already completed homes were purchased by a furniture manufacturer who was then able to display the products he had supplied as prime examples of his talents, since on the occasion of the

Opposite page: portrait of the Grand Duke Ernst Ludwig von Hessen und bei Rhein by Franz von Stuck, 1904, Schlossmuseum Darmstadt; also the Grand Duke with his Russian and English relatives; Czar Nicholas II, is third from the left, Darmstadt 1905.

Joseph Maria Olbrich, poster for the opening of the Darmstadt artists' colony, 1901. Museum Künstlerkolonie Darmstadt

Joseph Maria Olbrich, House for Decorative Art, erected for the exhibition by the Darmstadt artists' colony in 1901.

Joseph Maria Olbrich, 1867-1908

Studied at the Vienna Kunstakademie from 1890 to 1893. Before joining Otto Wagner's office he travelled to Italy and North Africa on a "Prix de Rome" scholarship. Olbrich stayed with Wagner four years, during which time he helped in the planning of the Stadtbahn railstations and designed the Secession building in Vienna. At the invitation of Grand Duke Ernst Ludwig von Hessen, he moved to Darmstadt in 1899, and spent eight years supervising the construction of the artists' colony on the Mathildenhöhe. Major works: Wiener Secession building, 1898; houses on the Mathildenhöhe in Darmstadt, 1900 –1908; Tietz department store in Düsseldorf, 1906–1908.

exhibition all the buildings were opened to the public. Nor was the whole undertaking entirely selfless, since the noble initiator's interests lay not in the latest developments in art and industry alone, but in their combination with the active promotion of the local economy. The commercial factor was discreetly concealed behind the aesthetic. The absence of the artificial staging involved in most previous exhibitions put complex reality directly on show. Although there were instances of ceremony, particularly on the occasion of the opening, there was for the most part an air of cheerful naturalness. This was not at all in accord with the usual pattern of public events in imperial Germany. It seemed to be a case of premeditated rebellion: Ernst Ludwig was clearly intent on presenting an image diametrically opposed to German ponderousness and Wilhelmine pathos. The naming of the exhibition showed that he was not unpatriotic; his commitment to the nation was simply different from what was expected in Berlin – as different, as he was himself. Cosmopolitan by upbringing, and related to the English royal family on his mother's side. he had been exposed to very different influences. The English ingredient could be observed in his reserved bearing and in his attitudes towards the possible tasks of nobleman and ruler.

Largely excluded from the national decision-making process by the high-handed Kaiser, he focused his attention all the more on his own province, and tried to make it culturally significant in its own right. The provincial capital benefited most. Since the middle of the nineteenth century, Darmstadt had developed from a quiet garrison town to an industrial city featuring mechanical engineering, chemical works and furniture production. The urban architecture had been upgraded by Georg Moller, appointed by an earlier duke, and Ernst Ludwig intended to make a comparable appointment. One of the first decisions of the

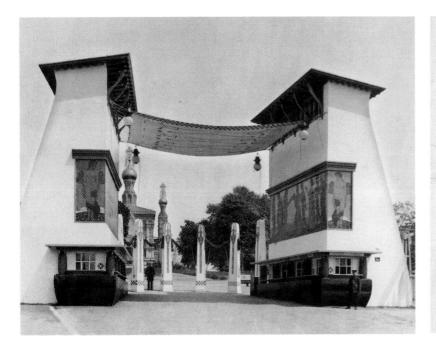

twenty-three-year-old Grand Duke on his succession was to commission Alfred Messel – unknown at the time, all the more renowned in later years – to build Hesse's new regional museum in Darmstadt. Ernst Ludwig trusted his own judgement. A great admirer of Wagner, he sometimes even tried his hand as opera director.

Certainly there was also something English in the notion of using the private house to present the art manifesto of 1901. Here was a selfless patron intent on procuring the well-being of others, and if the exhibition also contributed to his own happiness and renown, it was only in an indirect way. Moreover, he was taking an enormous risk. With artistic aims in the foreground, it was not surprising that short-sighted critics reviewed the aesthetic angle of the event, while the political statement was hardly noticed. Impartial reactions were perhaps not to be expected; anything that was so obviously supported "from above" was bound to meet with a negative response. The crucial difference was overlooked, in spite of the efforts of the exhibition's official author -Georg Fuchs – to make plain the contrary positions of the Grand Duke's Darmstadt and the metropolises, Munich and Berlin, of Kaiser Wilhelm: "It was a courageous act on the part of the founder of the artists' colony, to give his city of Darmstadt independent status despite the imperiousness of the metropolis in matters of taste, to place it as far as possible beyond the reach of the arbitrary and often catastrophic influences which continuously lower the great, glorify the trite and nourish the mediocre."*

What was achieved in Darmstadt in 1901 was architecture in a provincial setting, but not in itself provincial. It was an advantage that the site was not too large; novelty could develop here more freely than in grander locations. By the same token, the potential for grand achievement was

<u>Joseph Maria Olbrich</u>, entrance pavilion erected for the exhibition by the Darmstadt artists' colony in 1901; in the backround the Russian chapel for the Grand Duke's relatives.

<u>Paul Bürck</u>, invitation to the opening of the artists' colony in Darmstadt, 15 May 1901. Museum Künstlerkolonie Darmstadt

* Georg Fuchs: Ein Dokument deutscher Kunst, in: Alexander Koch (ed.): Ernst Ludwig und die Ausstellung der Künstlerkolonie in Darmstadt Mai bis Oktober 1901, Darmstadt 1901

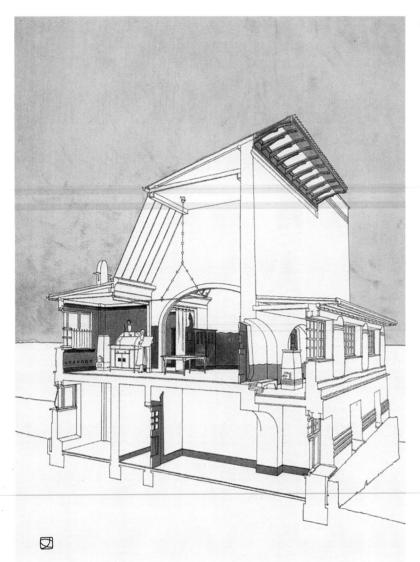

Joseph Maria Olbrich, sectional view of the Ernst-Ludwig-House in Darmstadt, and (right) the entrance to the Studio building, with the figures "Strength" and "Beauty" by Ludwig Habich, 1901.

limited. The pleasing exterior characterising all the houses Olbrich built contained within itself both promise and limitation. A hopeful beginnig in overall terms, too rapid a development when examined more closely. Mannerism, discernible in Olbrich's work from an early date, was in evidence in Darmstadt too. The most original part of the complex is still the studio building, housing eight individual studios in a row, each lit by high sloping glass ceilings. Since the main façade faces south, it featured very few windows. In front of the plain and functional façade is a lavish portal, a three-quarter circle flanked by two monumental figures. Strictly speaking, the arch is too large, as are the two statues, and yet there is an extraordinary sense of equilibrium, brought about less by the architecture than by the figures. Erstwhile caryatids, they have escaped their bonds to lift their heads and dominate the building. All strength is theirs, while the rest seems delicate, even thin, an impression intensified by the

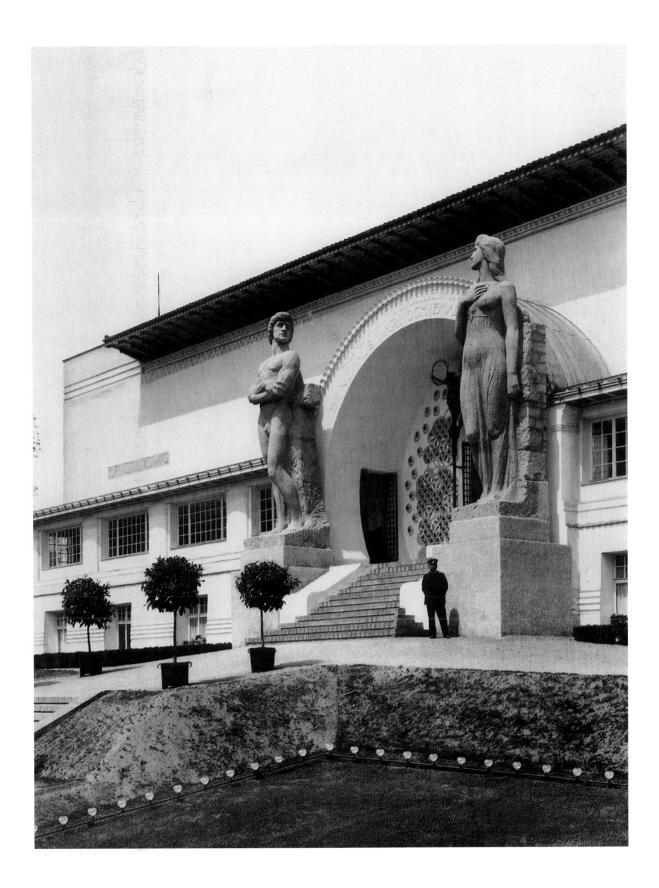

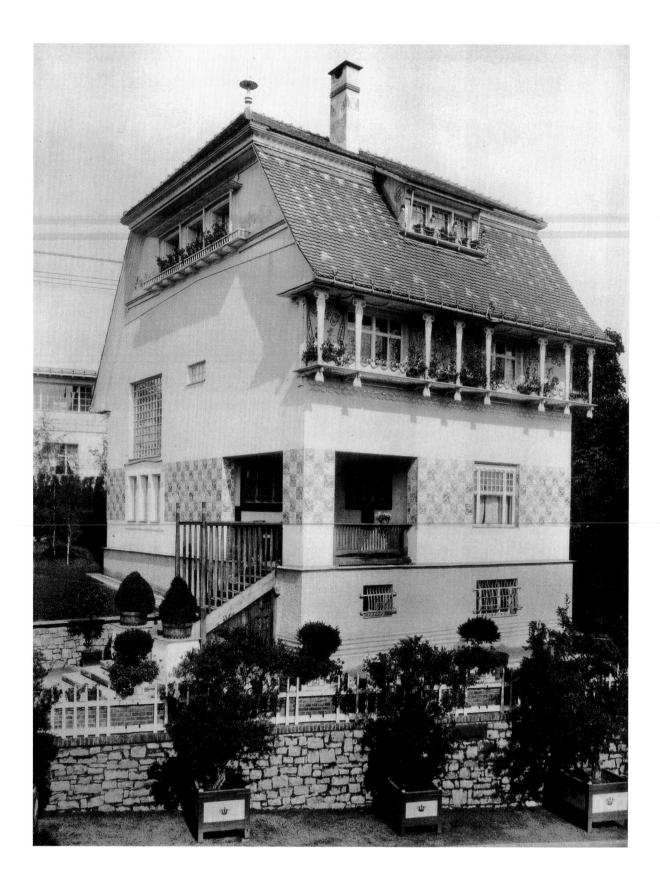

Joseph Maria Olbrich, overall view of the architect's house and (right) the entrance, Darmstadt, 1901.

rough surface and in part unfinished elements of the sculptures; they are clearly distinguishable from the smooth skin of the building.

A number of reversals have here taken place: what was once fixed now seems fleeting, what was fleeting has strength; decoration supports the house, instead of being supported by it; the massive seems vulnerable, while the vulnerable abounds in vigour. The impression is not unlike that created by the Wiener Secession exhibition building which made Olbrich's name in 1899. There massive blocks of stone seemed to have paper-thin sides, and the layers seemed so lightly joined that they might slip at any moment. There is something impermanent about architecture of this sort, as if it has simply been provisionally thrown together. The entrance pavilions and the exhibition hall for decorative art (pp. 142,

143), a short distance down the hill from the studio building, were indeed

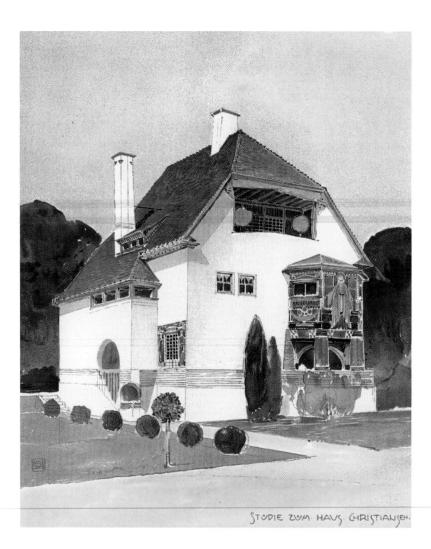

only temporary. While the gates recall something of the fairground, the hall was reminiscent of an upturned galley. The lateral supports served no functional purpose, but assured the effect of rows of oars. The daring and highly original arch of the roof gave an illusion of depth to the building: what looked like one end was in fact its full length. Olbrich continued to favour contours of this sort in his later work.

Less spectacular than the studio building and the exhibition hall are the sit villas, also by Olbrich. They are variations on traditional housing types, but veiling this under a wealth of ornamentation. Playfully designed and configurated windows help to make the houses seem more original than in fact they are. This applies above all to the architect's own house (pp. 146, 147) and to that of the painter Hans Christiansen. By contrast, structural features are more in evidence than inventive decoration in the house built for the sculptor Ludwig Habich (p. 150), and in the smaller of the two houses bought by the furniture manufacturer Glückert (p. 151). In both of these, the basic cube form was either broken, extended and then crowned, or accentuated by means of a half-barrel-

Joseph Maria Olbrich, design for the Christiansen house in Darmstadt, c. 1900.

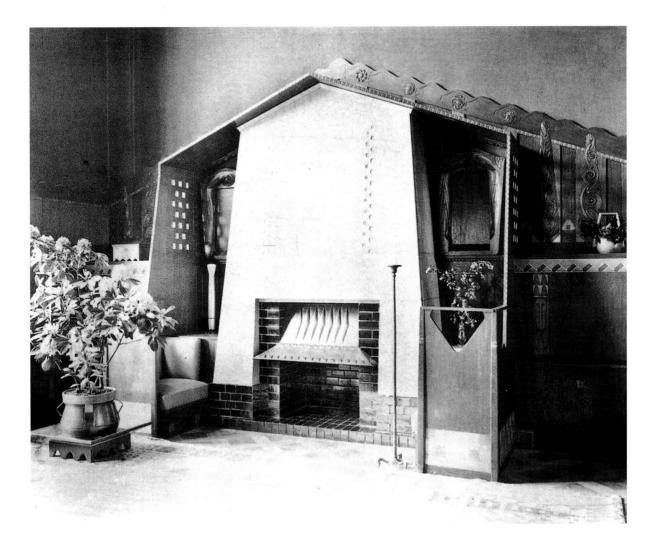

shaped superstructure. The first is very cleverly terraced to match the hillside, and the entirely flat roof is unusual. There is no sense of front or back or side; the exterior seems to open and close alternately in a manner determined entirely from within. The result is a striking anarchy of smooth surfaces and assorted windows. Although the observer can hardly tell what is what, there is a feeling that equilibrium has just been maintained. Architecture was here exhibited as virtuoso exercise, its brief both to startle and to animate. This effect is heightened by the mediterranean quality of the houses as a whole.

The interior was for the most part designed in such a way that a twostorey hall formed the centre (p. 152). The spaciousness of the hall gave Olbrich an opportunity to give full rein to the decorative talent which he kept strictly under control outside. Tectonic cohesion gave way to a relentless proliferation of decorative surfaces, frenzied and unexpected after the villa's exterior calm. The decorator had got the better of the architect, and yet since both were still visibly one and the same, there is a sense of split personality about the whole. Most of the criticism was Joseph Maria Olbrich, the fireplace in his own house, Darmstadt, 1901.

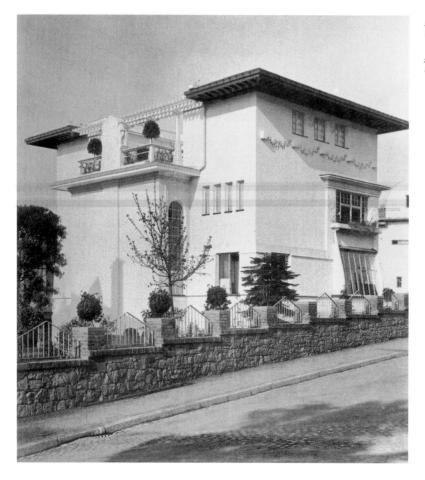

derived this problem; it inspired van de Velde to declare that he himself would design no decoration for the next two years – a salutary resolution! The mannerism which had been effective and stimulating in the studio building's exterior was employed inside to no apparent purpose, as an end in itself. We can sense even today that Olbrich did not have enough time for the project, and that he succumbed to the temptation of attempting too much. The thin partition-like quality of the interiors betrays the haste with which they were constructed. This was to change later, at the expense of the attractive recklessness of the initial venture.

There was a dramatic contrast between Olbrich's architecture and the house which the artist Peter Behrens, not trained as an architect, built for himself (p. 155). Precise forms rather than freedom, definition rather than ambiguity. Striking coloured pilaster strips at the corners of the house both frame and emphasize its parts. The more flowing elements of moulded gable and lattice are fitted within this framework, and yet have strength enough to counterbalance it. Tension is maintained by strength and not, as with Olbrich, by ambivalence. Coquetry was not in Behrens' nature, either then or later.

The distinction of his achievement was quickly grasped and acknowledged. The perceptive critic Karl Scheffler, not prone to exaggeration, Joseph Maria Olbrich, Habich villa in Darmstadt, 1901.

Joseph Maria Olbrich, the small Glückert house in Darmstadt, 1901.

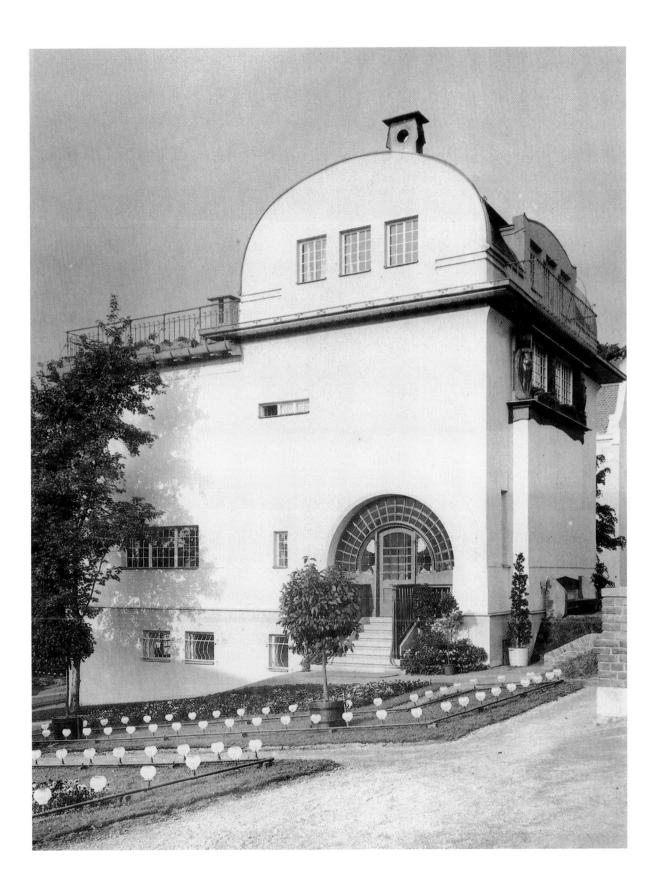

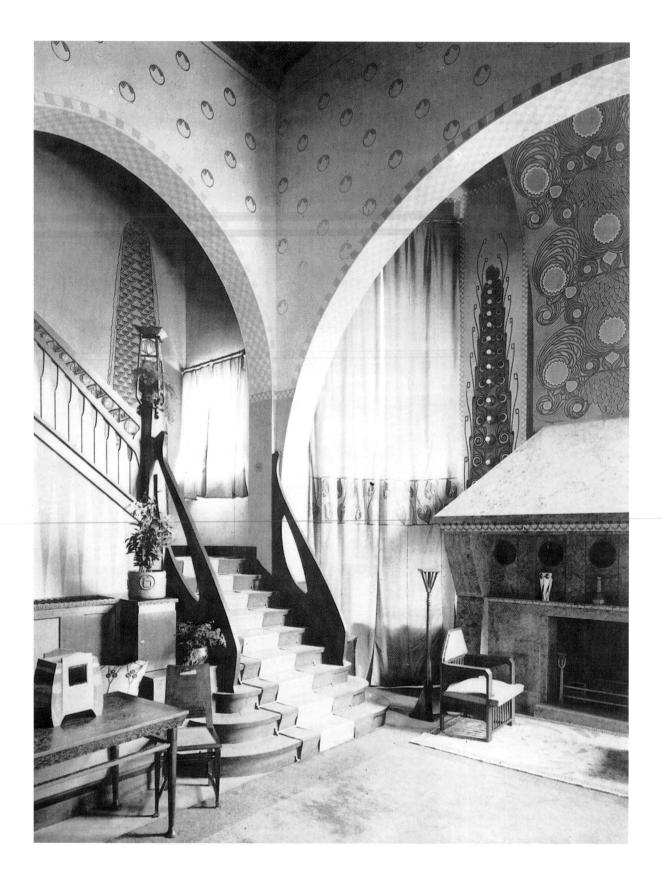

Joseph Maria Olbrich, hall in the large Glückert house in Darmstadt, 1901.

Joseph Maria Olbrich, entrance to the large Glückert house in Darmstadt, 1901.

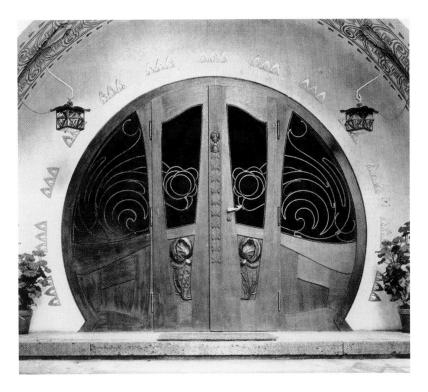

observed in it a quality associated with modern literature: "We therefore see in the house on the Mathildenhöhe a home for the man of the future, elevated by the life-work of his ancestors above the choking oppressiveness of the fight for survival, which will rescue from religious scepticism and social need, a new form of society – from science, beauty." Visitors will have felt much the same, and will not have been surprised by the interior, where the severity of the exterior yields to festive intensity. Dark, heavy forms fill music room, study and boudoir, with the exception only of the dining-room, which is decorated in white, red and silver (p. 154). However different they may have been in other ways, there were similarities in the Germanic nature of the interiors designed by Olbrich and Behrens. In their houses as in their innermost hearts, they both took very seriously the declared purpose of the exhibition, to create a "Document of German Art."

Behrens' house was a milestone, and it ensured the exhibition was taken seriously by the critics. It thus achieved a result beyond its original intention by proving that a new style of architecture was possible. Moreover, it did so unaggressively within the framework of friendly rivalry. The idealistic and indeed successful community made up by the seven artists did not survive for long: its numbers declined, but were regularly replenished. In 1903 Behrens took up an appointment in Düsseldorf, and in the years that followed he was able to indulge his partiality for refined sensibility and elevated feeling on several occasions – whether in small items, as in the lamp designed for the Grand Duke (p. 159), or on a large scale, as in the Hamburg hall at the Turin exhibition of 1902 (p. 158). Like most artists of his generation, he was not concerned

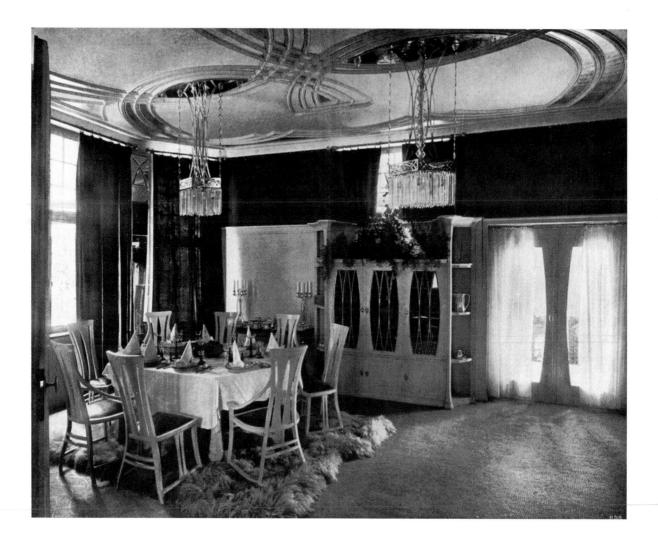

<u>Peter Behrens,</u> dining-room of his own house in Darmstadt, 1901.

Peter Behrens, 1868-1940

Originally from Hamburg, he studied painting in Karlsruhe and Düsseldorf and lived in Munich from 1890. He was co-founder of the Munich Secession in 1892, and foundermember of the Vereinigte Werkstätten für Kunst im Handwerk in 1897. From 1899 to the end of 1903 he worked at the Darmstadt artists' colony, and afterwards became director of the Düsseldorf Kunstgewerbeschule. In 1907 Emil Rathenau employed him as artistic advisor to the AEG electricity company in Berlin. From 1922 he was professor of the School of Architecture at the Vienna Academy, and took over the deparment of architecture at the Berlin Akademie der Künste in 1936.

Major works: his own house in Darmstadt, 1901; AEG turbine factory in Berlin, 1908/09; German embassy in St. Petersburg, 1911/12. about any distinction between art and architecture, although at times he seemed to confuse the two and to want to make everything into some kind of memorial.

Behrens was the most versatile of the young artists setting out to make a name for themselves around 1900. Like van de Velde and Riemerschmid, he had begun as a painter and turned to handicraft design later on, in Munich. Darmstadt was the watershed; at the first attempt he showed himself to be a precise and clear-thinking architect. Both the precision and breadth of his vision can be seen in his dining-room, where a rigorous linearity recurs in every element, starting with the ceiling and running through lamps, door panels and chair-backs (p. 154). This comes very close to van de Velde and the notion of the total work of art; it is clear that a room of such intensity will have an effect on everything that happens in it.

It was not to be expected that Darmstadt would be more than a temporary residence for so sure an artist – he was bound to make a rapid career in Germany. He went on to Düsseldorf, Hagen and Berlin, but also to the Peter Behrens, his own house in Darmstadt, 1901.

<u>Peter Behrens,</u> illustration of his own house in Darmstadt, 1901.

industrial areas of the Rhine and Ruhr. He was one of the few to move from the periphery directly to the centre. He clearly did not share other people's scruples, and his achievements were undeniably considerable. He becars architect to the powerful AEG electricity company in Berlin in 1909, working on designs not only for their buildings but also for their products. This was a very significant step, which went a long way towards realising the link between art and industry. A representative of *Jugendstil* was granted access to the boardroom.

This made Behrens into the "grand artist", directing a whole design empire; but the abundance of commissions, for private residences, factories, exhibitions, even for the German embassy in St Petersburg, meant that his signature became less and less distinct. Most of what went under his name at this point was fairly schematic. He had probably done no more than take a brief look at it, since he could rely entirely on his highly talented staff. Two of the best representatives of the new generation of architects – Ludwig Mies van der Rohe and Walter Gropius – worked for him for a time.

<u>Peter Behrens, entrance door to his own house in</u> Darmstadt, 1901.

<u>Peter Behrens</u>, parts of porcelain service designed for his own dining-room; Weiden porcelain factory, Bauscher Bros., dia. of largest plate: 25 cm. Germanisches Nationalmuseum, Nuremberg

Behrens was very much a German artist. This is discernible in the Wagnerian tone that he displayed in his early years, and in the hymnic phrases that authors used to praise him. Of the "vestibule of the house of strength and beauty" – meaning the lavish display at the Turin exhibition (p. 158) – Georg Fuchs, cited above for his comments on the Darmstadt exhibition, wrote: "'Enter, stranger, this is the German Empire; see its power, and rejoice!' Words such as these should be engraved over the entrance, for what is silently manifested in this hall is power, the power of Kaiser Wilhelm's empire, ripened ready and resolved, equal in entitlement, equal in ownership, equal in authority and claiming its place among the great powers of the world when the globe is divided anew, as the destiny of nations has irreversibly decreed." Occupation was effected and the avantgarde swallowed up with terrifying swiftness. The writer was correct in sensing that Behrens was a conformist, ready to comply with

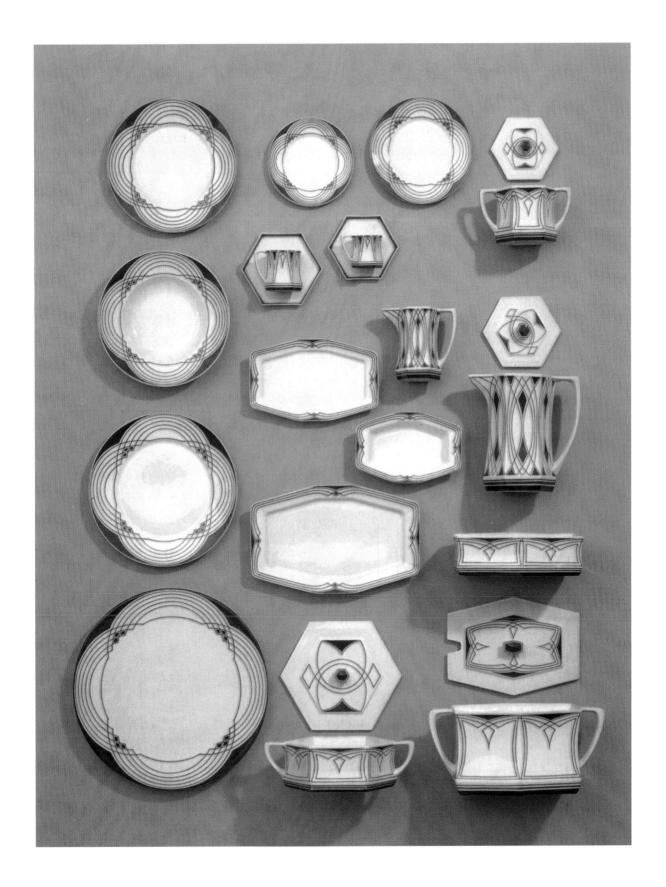

<u>Peter Behrens,</u> "Hamburg Hall" at the large Turin exhibiton of modern decorative art, 1902. almost anything. It was as if he felt himself under some kind of duty to obey; since the moderate modern art which he came to represent in the early years of the century was easily accessible, he reaped success from it.

One of his patrons in Darmstadt had been the publisher Alexander Koch, editor since 1890 of the journal "Innendekoration", which was followed some years later by "Deutsche Kunst und Dekoration". This influential but by no means impartial man claimed some of the credit for the exhibition of 1901, but he played a more important part in the same year in initiating a competition for the design of an "art-lover's house." One of the prizes was won by the Englishman Baillie Scott, who had designed some rooms for the Grand-Duke in very British style at the end of the previous century. But the real triumph in this spectacular undertaking went to Charles Rennie Mackintosh from Scotland. The only reason why he was not awarded the first prize was that his submission was not complete. Although his designs were not executed at the time in Darmstadt or elsewhere – in fact not until 1990, in Glasgow – a flash of genius had touched the city.

Unlike the others, who came and went or did not come at all, Olbrich remained in Darmstadt, and this was because Ernst Ludwig trusted him and was wise and courageous enough to keep him. There were further

<u>Peter Behrens,</u> table lamp, Darmstadt 1902, bronze and coloured glass, 70 cm high. Private collection of the Grand Duke of Hesse exhibitions in 1904, 1908, and 1914, and they resembled the first in their emphasis on architecture, interior decoration and artist craftsmanship. New houses were built and given model interiors, but the greatest marvel of all was the unwavering support of the Grand-Duke. The main achievement of 1904 was the three-house group (p. 161) which enabled Olbrich to demonstrate his ability to give a more disciplined face to his imagination. With no less originality than before, he imbued the various components of the whole with strength and structurally-founded plasticity. It seems that Olbrich was intelligent enough to learn from Behrens' example. At the same time, the increasing solidity is accompanied by traces of a new classicism, a return to axis and symmetry, discernible beneath the wealth of inventive detail. Olbrich's later buildings show this even more clearly.

The extent of the urge to improve the quality of life is attested most convincingly in Olbrich's designs for workers' housing in Darmstadt (p. 165). This was not entirely new – a model for artisan housing had been displayed at the 1851 Great Exhibition in London – but it was surprising that the theme should be taken up again in the context of Darmstadt, which was often regarded as refined, if not positively aestheticist. The first group of semi-detached houses was reminiscent of English models, while the example built in 1908 struck an unfortunate tone of false

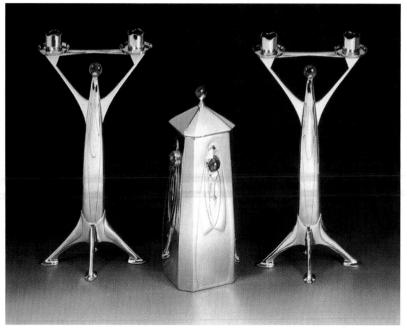

<u>Joseph Maria Olbrich</u>, white-wine glass, Darmstadt c. 1900, G. Bakalowits & Sons, Vienna, 25 cm high. Private collection, Munich

<u>Joseph Maria Olbrich</u>, spoon, Darmstadt c. 1900, white metal, silverplated, Christofle & Cie., Paris, 23 cm long. Museum Künstlerkolonie Darmstadt

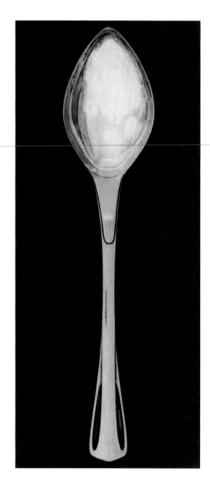

Joseph Maria Olbrich, pair of candelabra and tea-caddy, Darmstadt c. 1900, silver with amethysts, P. Bruckmann & Sons, Heilbronn, candelabra height: 35 cm. Private collection

<u>Joseph Maria Olbrich</u>, Preacher's house, part of the group of three buildings erected in 1903/04 for the second exhibition by the Darmstadt artists' colony.

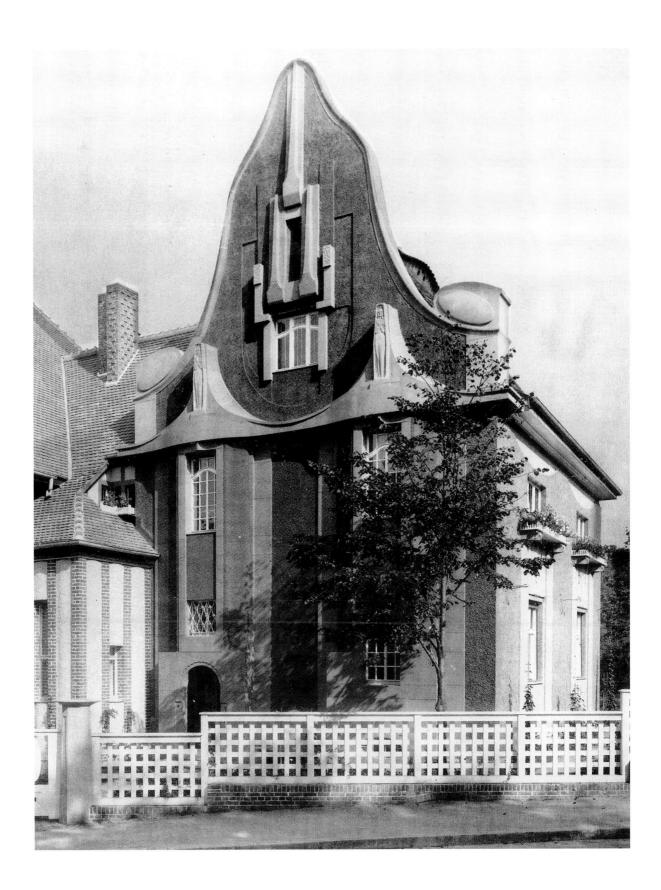

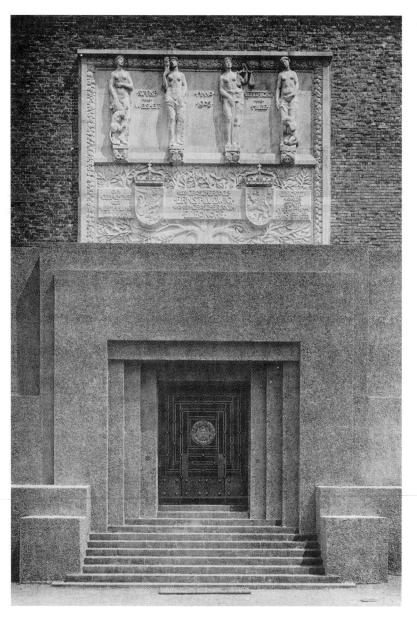

Joseph Maria Olbrich, entrance to the "Wedding Tower" in Darmstadt, 1908.

amiability (p. 164). Their residents would have needed to be very good sorts to be able to live up to their homes.

The first beginnings of new civic architecture in 1901 were hesitant, but by 1907 there was extensive new building, most notably at the top of the hill above the artists' colony. Previously there had been nothing there but a reservoir, which now formed the basis for a spacious exhibition hall and an asymetrically-adjoining tower (pp. 162, 163). It was the town's official gift on the occasion of the Grand Duke's remarriage, and it was thanks to him that the Mathildenhöhe became a concept in itself. The Hochzeitsturm (Wedding Tower) was popularly seen as signifying a hand raised in solemn promise, and it formed a beacon linking the hillside with the

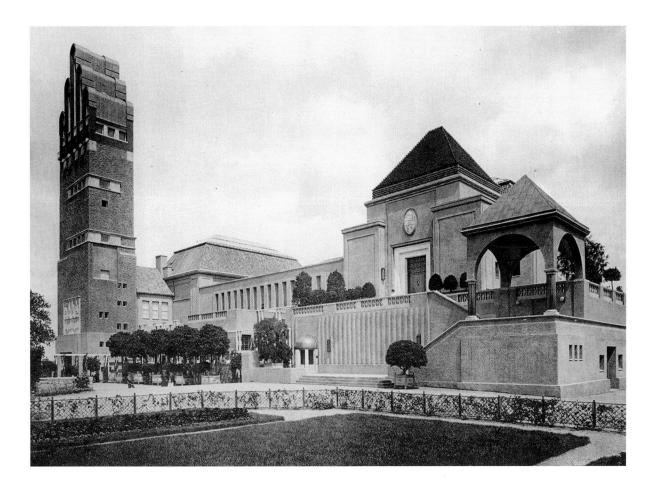

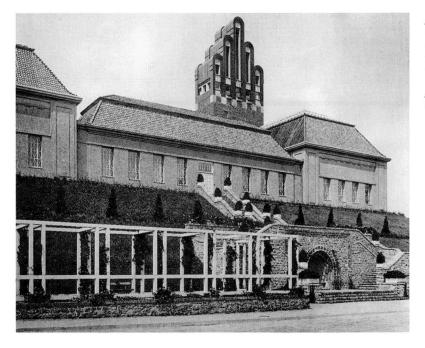

<u>Joseph Maria Olbrich</u>, the city-facing side of the exhibition building on the Mathildenhöhe in Darmstadt. To the left, the "Wedding Tower" erected 1905–1908 by the city in celebration of the Grand Duke's second marriage.

Joseph Maria Olbrich, rear view of the exhibition building on the Mathildenhöhe in Darmstadt, with an austere stone pergola in the foreground.

<u>Joseph Maria Olbrich</u>, exterior and interior of a worker's home, erected for the Opel Works in Darmstadt, 1907/08.

Joseph Maria Olbrich, design for workers' housing, Darmstadt c. 1900.

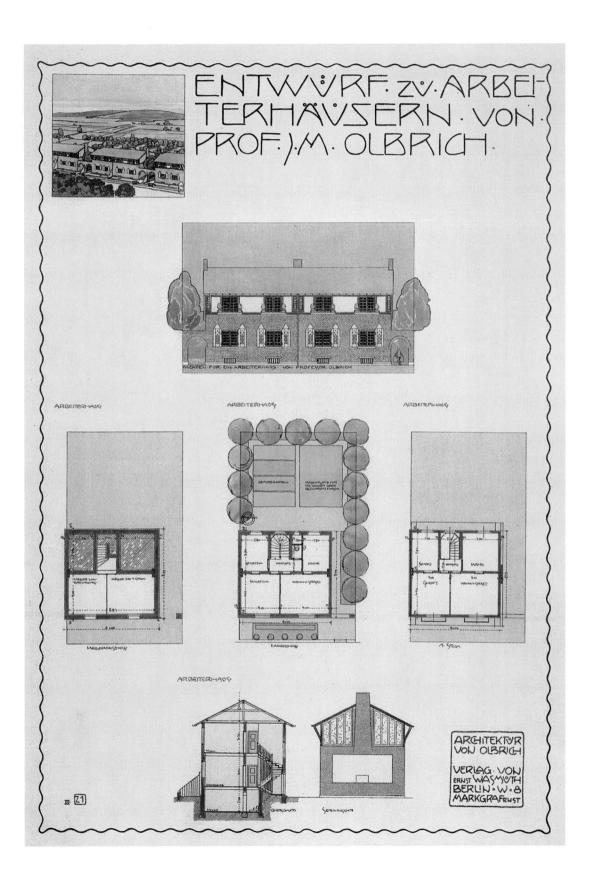

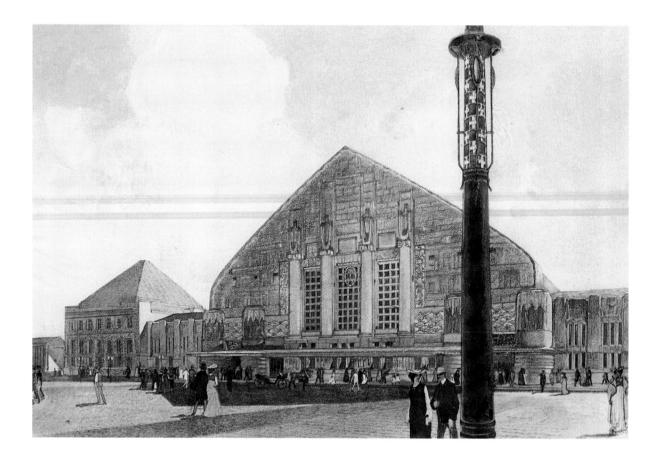

Joseph Maria Olbrich, design for the central station, Basle, 1903.

centre of the town. This line of communication was reinforced by a road axis leading directly to the exhibition building, via the little Russian orthodox chapel built in 1899 for the Grand Duke's imperial relations (p. 143). The building was not of architectural value, but arresting nonetheless with its colourfulness. The new configuration put the artists' colony somewhat in the shade, but the studio building continued to be a centre of attention.

The exhibition building is constructed symmetrically with three wings enclosing a central courtyard, but to this basic symmetry is appended the complexity of all that is displayed on the west side – steps, terraces, a pavilion, and the upward-thrusting tower. Olbrich showed himself here as the complete rather than the sporadic master. The construction is once more very relaxed, almost playful, but most ingeniously balanced and measured. In fact it is not unlike the construction of the studio building, but this time it is the tower, and not a pair of statues, that hold up the complex. Although the buildings are joined, yet there are distinctions between them: the symmetry of the main building contrasts with that of the tower and its angled windows; the tower's rough brick surface contrasts with the smooth plaster of the rest. One might see the whole as an encounter between two different epochs, the mediaeval and the classical, but this would be to intellectualise its freedom and originality. The building repeatedly contravenes the canon, creates a sense of provi-

dentially random chance, and conveys also that familiar ambivalence which marks the best of Olbrich's work.

These buildings on the Mathildenhöhe were the architect's farewell to Darmstadt; he had outgrown the town. New tasks lay ahead in the Rhineland, culminating in a last pinnacle of achievement before the early death that claims so many highly gifted men. He died in 1908. What he left behind him in Darmstadt was unique. Nowhere else had an artist had the chance to develop so fully, and nowhere else had the possibilities and dangers of the new style been so excessively demonstrated. A small but vital beginning had been made, drawing strength from its isolation, from the feeling that success could be achieved only in opposition to official currency. Nothing of the sort could have happened in Berlin. Politics and art were movingly united in Darmstadt, and generated together a strength which neither could have had alone. The special potential of the times, with the beginning and end they contained, was recognised and grasped. The Hessian capital took its place alongside the far greater cities of Paris, Brussels and Vienna as Germany's first important centre of the new style, with all the concomitant political implications.

Olbrich's early death prevented him from seeing the completion of his major work; he died halfway through the decoration of the interior of the great Tietz department store in Düsseldorf. This was one of the most spectacular commissions of the time, and his plans were brilliant and <u>Friedrich Pützer</u>, side-wing of the central station in Darmstadt, c. 1910.

Joseph Maria Olbrich, Tietz department store on the Königsallee in Düsseldorf; exterior view and large shopping hall, 1907/08. individual; he was in no way daunted by the earlier work of Alfred Messel in Berlin. The sweeping gables above the entrances and in the roof zone give the building a dignity and yet lightness which go far beyond pure functionality, and which only Olbrich could achieve. Late, but not too late, *Jugendstil* achieved a symbiosis of technical construction and aesthetic modelling. Both components retained their strength, and instead of competing, complemented one another. The long years of experimentation in Darmstadt had led to a convincing conclusion. None but Olbrich himself could have taken things further; no sooner was the new door opened than it was closed.

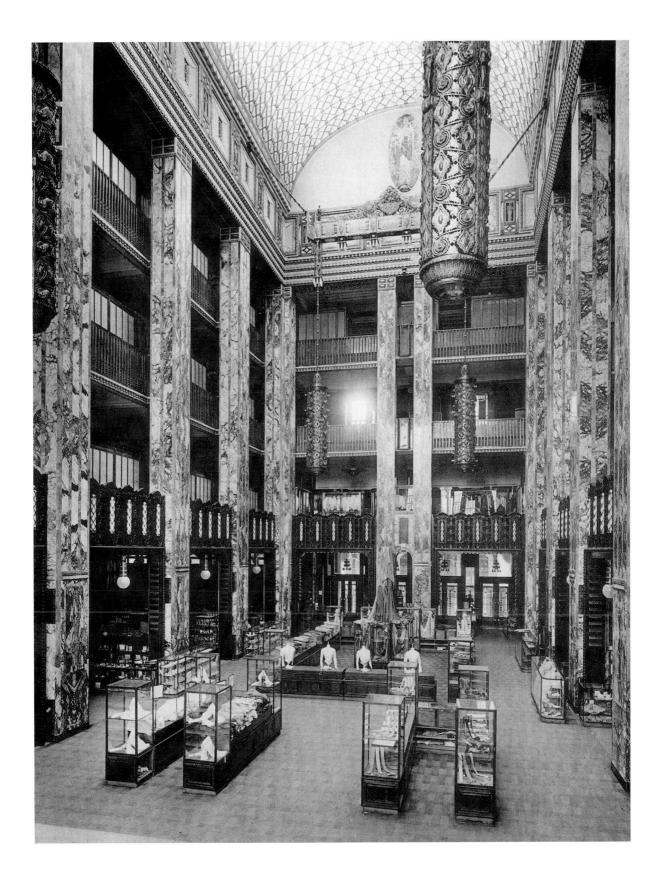

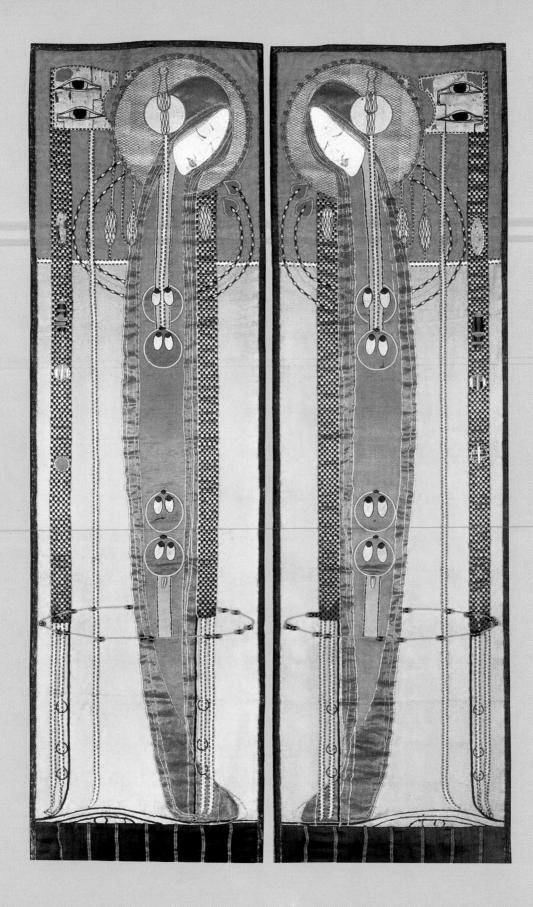

Glasgow

Glasgow is the prime example of a place to which industrial development brought wealth, but also a dubious reputation. Not rich in history in earlier times, the city grew in size and in importance during the nineteenth century, initially because of the cotton mills which enabled Glasgow to compete with even Manchester. From 1860 heavy industry became increasingly important, and by the last decade of the century the townscape was dominated by steel, coal and engineering works. Glasgow led the whole of Europe in the construction of steam engines and railway equipment. Ship-building was another important branch of industry, and around 1900 Glasgow was delivering steamers to as far afield as the Pacific region.

Manufacture offered great opportunities, but so did merchant shipping. Trade flourished with other sea-ports in England and Ireland, and also with America. In 1908 almost twice the number of ships docked in Glasgow – the largest port in Scotland – as had done so ten years earlier. Three railway stations in the city centre facilitated transport to and from the surrounding areas. The population increased four-fold between 1840 and 1914. Edinburgh, the administrative centre and actual capital of Scotland, was outstripped by Glasgow, which in economic terms was second only to London.

The exciting pace of change encouraged confidence and selfassertiveness. Unification with England, opposed for so many centuries, had been accepted because of its patent benefits, but around the middle of the nineteenth century there were new moves towards autonomy. The National Association for the Defence of Scottish Rights founded in 1853 pursued separatist aims; from 1880 the association's demands were voiced with increasing vehemence at its meetings.

In the last quarter of the century the city's reputation was nevertheless poor: it was prosperous, but its riches were newly acquired and it lacked taste. It was considered ugly, partly because of the inescapable poverty which had followed from rapid industrialisation. The Gorbals, providing sparse accommodation for large numbers of people, were notorious. Yet with a streak of cynicism, perhaps, they were also seen as a symbol of vitality, as was the widespread problem of alcoholism – not merely confined to the proletariat, as is shown by the life of the artist Charles

Opposite page: Margaret Macdonald-Mackintosh, embroidered textile panels for the Scottish Room at the Eighth Secession Exhibition in Vienna, 1900. Glasgow School of Art, Mackintosh Collection

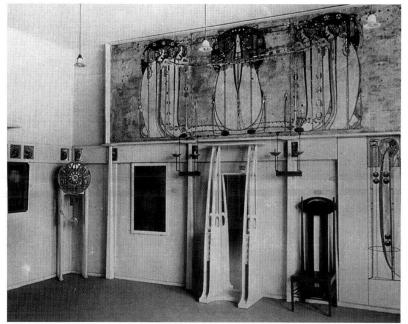

<u>Charles Rennie Mackintosh,</u> cupboard in the room shown at the Eighth Secession Exhibiton, Vienna, 1900.

<u>Charles Rennie Mackintosh,</u> room shown at the Eighth Secession Exhibition in Vienna, 1900.

Charles Rennie Mackintosh, 1868–1928

Attended the Alan Glen High School from 1877 to 1884, and afterwards evening classes at the Glasgow School of Art. Apprenticeship with the architect John Hutchinson, and draughtsman for the firm of John Honeyman & Keppie in Glasgow from 1889, becoming a partner in 1904. Married Margaret Macdonald in 1900, a graduate of the Glasgow School of Art, with whom he worked closely. Concentrated mainly on painting from 1923 onwards.

Major works: the new buildings for the Glasgow School of Art, 1897–1909; Hill House in Helensburgh, 1903; tea-rooms in Glasgow, 1897–1911. Rennie Mackintosh, who gave a certain polish and brilliance to the city at the turn of the century. None of Glasgow's citizens escaped entirely unscathed. Tea-rooms and football clubs were founded with the explicit purpose of diverting people from drink, but such measures were ineffective, and carousing was often the order of the day until failure of the economy took its sobering toll. Armaments for the First World War brought a last flurry of activity, but after that the decline began. The negative image was not helped by the fact that there was no architecture of note to be seen in Glasgow; it was simply a typical Victorian town – enterprising, ruthless, lively, ugly.

One result of trade with foreign parts was that unusual goods were sometimes brought ashore. An influx of exotic items brought unaccustomed colour to the drab greyness of the city. The key country of origin was Japan, which had established early contact with Glasgow; contacts increased as Japan grew more open to the West. In 1876 Christopher Dresser, who later designed remarkably useful items of amazing simplicity, accompanied a delivery of British products destined for the Imperial museum in Tokyo on the voyage from Glasgow to Japan. He stayed there for a whole year, and returned with a wealth of furniture, woodcuts and everyday utensils. No sooner had he returned home than he encouraged his son to go into business as an international art dealer in Japan. The connection between the rugged Scottish town and the exotic delicacy of the Far East may seem far-fetched, but it made good sense in view of the late nineteenth century spirit of adventure. It was not confined to aesthetic objects. The destroyers and cruisers which decided the Russo-Japanese war some years later were built in Glasgow. Interests were thus mutual.

The Far East was a mediator in another quite different area – it helped to

focus attention on the French Impressionists, who were quickly acclaimed by Glasgow's new élite in their search to transcend commercial preoccupations. It is also worth mentioning that James McNeill Whistler bequeathed his entire estate to Glasgow as a token of gratitude to the public collection which had been the first institution to purchase one of his paintings in Japanese style.

In this way the ground was prepared for the artist who succeeded in uniting Japan and Scotland in his works, creating a symbiosis in which the latter was almost subsumed in the former, and yet retained its identity. In considering Glasgow's contribution to Art Nouveau it is right to mention the three artists with whom he often appeared before the public, and yet it is appropriate, given restrictions of time and space, to concentrate above all on the man himself: Charles Rennie Mackintosh. He, and his wife Margaret Macdonald, her sister and her sister's husband Herbert MacNair, were well suited to work together as a team; their interests and styles coincided at many points, and the director of the Glasgow School of Art, where they had all been students, recommended collaboration early on.

Later Francis Newbery became a useful acquaintance, and he played a particularly significant part in 1897 when he helped to secure Mackin-

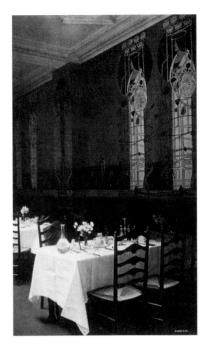

Charles Rennie Mackintosh, Glasgow tea-room, 1891–1893. Interior décor by the architect George Walton, stencils on the walls by Mackintosh.

<u>Charles Rennie Mackintosh,</u> cupboard of painted wood with enamel and coloured glass inlay work, Glasgow, c. 1900.

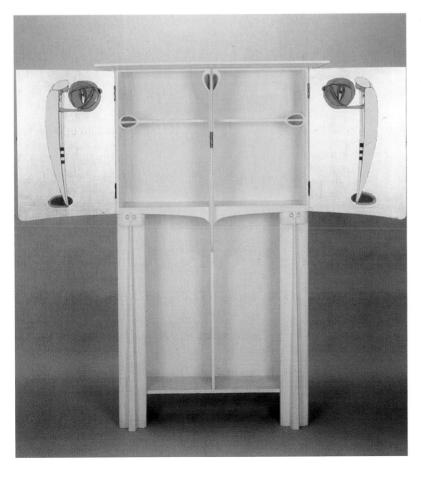

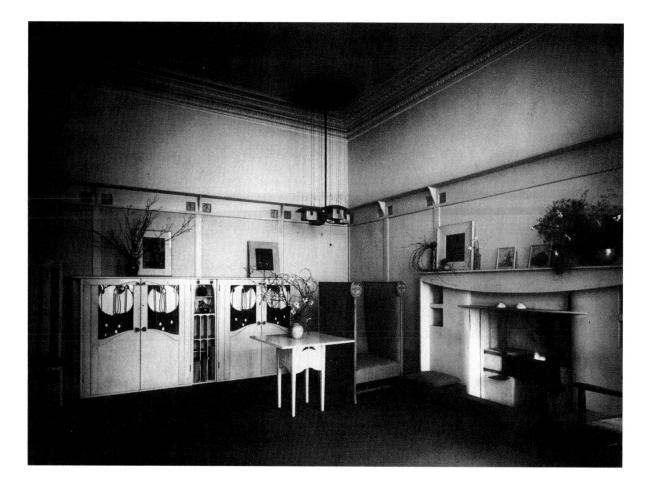

Charles Rennie Mackintosh, drawing-room in own house on Mains Street in Glasgow, 1900.

tosh's most important commission: the design of a new building for the School of Art from which he had himself graduated (p. 179). Basically, the two women, with their more privileged background, were more involved in the decorative aspects of the collaborative enterprise, while the men were responsible for construction. While differentiating in this way, however, it is important also to point out that it is the very interpenetration of both areas that gives the Glasgow style its distinctive quality. The delicately extended limbs, small heads and bloodless figures that wafted across the sisters' canvases, or silk or enamel, were late progeny, or even parody, of Pre-Raphaelite mythical beings. At times Aubrey Beardsley also felt he was being plagiarised by the two sisters, of whom Frances was considered to be more gifted than Margaret. The symbolism of these figures may for the most part escape us, but the decorative element becomes all the more interesting; in most cases predominant, it leads smoothly into the furniture and décor of which it is usually a part. The arcs and circles flitting through the pictures are taken up in the sweeping curves of edging, chairback, moulding. Rosebud clusters reappear singly as ornamental joints in chairs or cupboards. Yet all these wonderful flights of fancy would have lacked cohesion had they not been

integrated firmly in an architectural setting. Alone they achieved little, in combination the effect was considerable.

Mackintosh is without doubt the least fathomable of the important turnof-the-century artists. Did he know what he was doing, or was he just a conjuror whose supply of tricks ran out? The virtuosity of his oeuvre is at once admirable and unsettling: on what foundations was all this constructed, where was the aesthetic point of reference? Reflections on the brevity of his career are bound to have an affect on our assessment of it, and one is tempted to unravel the mystery backwards from the end. Perhaps it was his especial misfortune not to die so young as, say, Joseph Maria Olbrich, to whom he was in many respects very similar – above all in wealth of talent and in the reckless use of it. An early death would have relieved him of the problem of finding a transition to the humdrum

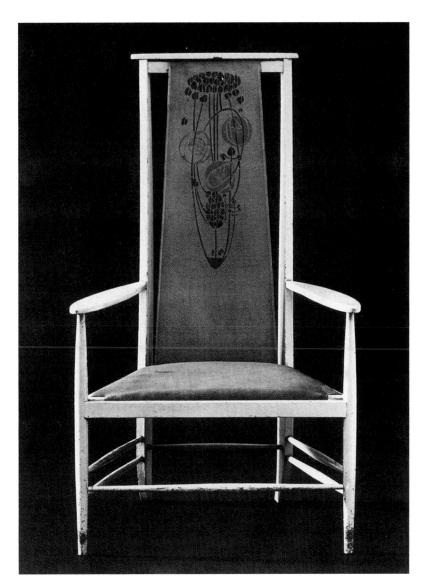

Charles Rennie Mackintosh, chair, Glasgow 1902, painted wood and painted silk upholstery.

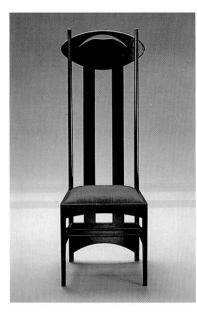

<u>Charles Rennie Mackintosh, modern reproduc-</u> tion of a chair designed in 1897. Cassina, Meda/Milan

<u>Charles Rennie Mackintosh, bureau, Glasgow</u> 1904, painted wood, glass and metal. Musée d'Orsay, Paris realities of life after the excitement of high hopes held and encouraged in youth. A photograph of Mackintosh aged about thirty-five shows the face of a rather ordinary bohemian artist, features good but casual, with unstarched open collar and cravat, revealing a trace of mockery but also something of the effete, not a fighter. Does this perhaps help to explain why he is usually thought of as a member of a group, as part of an artists' community? Margaret Macdonald was some years older and may well have helped to provide stability. A photograph taken at much the same time shows her as a positive and energetic character; it would certainly be a mistake to identify her with the ethereal figures she painted. She would perhaps have liked to be a mother.

The bitter truth of the matter is that, after his brilliant early success, Mackintosh soon faded into the background, and scarcely worked at all after 1908. In part this may be attributed to external circumstances – Glasgow provided too limited a financial basis for his work – but there was also the fact of the lack of potential for further development. There was a personal problem, too: alcohol addiction. From the very beginning Mackintosh's reputation was greater on the Continent than in Bri-

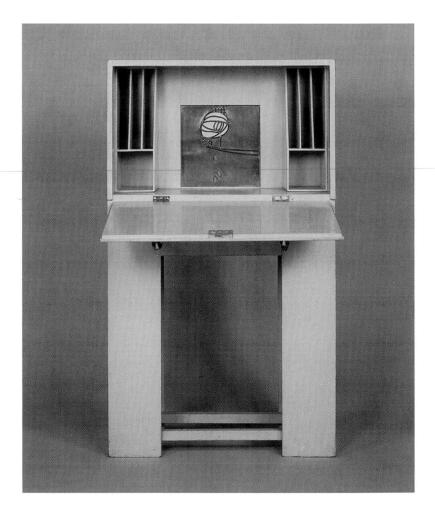

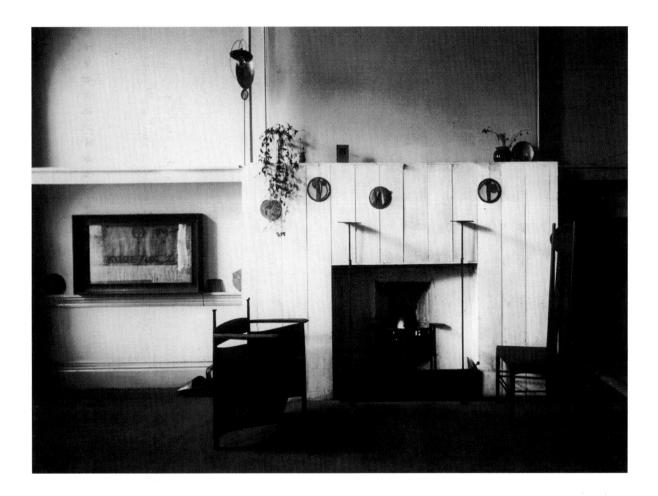

tain; there were early publications in the leading journal "The Studio", but in fact this excellent journal was also more highly regarded abroad than at home.

Prior to 1900, artists looked to England for their models, but this changed with the emergence of Art Nouveau as a new constant. The altered perspective, which consigned Britain to the periphery, was unfortunate for the few artists there who were intent on sharing in the development of the new style. People knew of the four artists in Glasgow, but what were they doing up there? The centres of art lay elsewhere – in Vienna, Turin, Munich, Darmstadt, even Dresden – in all these places Mackintosh was in evidence, either in person or in spirit. This was most clearly the case in the Austrian capital, where he was seen as a kind of saviour. The room shown there in 1900 as part of the eighth Secession exhibition was highly acclaimed (p. 172), but Vienna was already rich in tradition and had no need of artistic awakening. What happened there is simply indicative of what could be achieved by a well-judged appearance at the right exhibition. Van de Velde's breakthrough came with the 1897 exhibition in Dresden, which laid the foundation for his subsequent career in Germany, and just as Olbrich first became well-known in Darmstadt, so Mackintosh had his chance in Vienna. The only immediate result, howCharles Rennie Mackintosh, fireplace in the Studio of his own apartment on Mains Street in Glasgow, 1900.

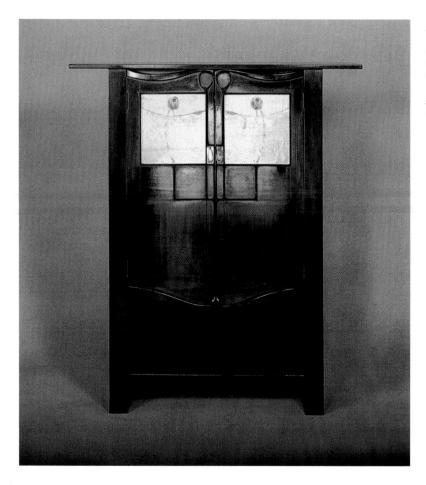

Charles Rennie Mackintosh, secretaire, Glasgow 1901, stained and polished maple, panels by Margaret Macdonald. Österreichisches Museum für Angewandte Kunst, Vienna

Charles Rennie Mackintosh, the older section of the Glasgow School of Art, 1898.

ever, was a music room commissioned by Fritz Waerndorfer, later cofounder of the Wiener Werkstätte (Vienna Workshops).

But there were other encouragements to relocate: although others won the prizes in the 1901 competition for the original design of an ideal "artlover's house" advertised by the editor of the journal "Innendekoration" in Darmstadt, yet Mackintosh was acknowledged as the real winner with his elegant submission worked out in the finest detail (p. 181). It may well have been the most inspired of all his designs - a point which can be better judged now that the City of Glasgow has decided on a belated execution of his plans. The alleged reason for his not winning first prize was that his entry was incomplete, although the plans were nevertheless purchased. It was also known that Alexander Koch, the man behind the competition, did not share his regent's taste for Olbrich's work - the artists' colony had just been introduced to Darmstadt – and it may well be that he was not prepared to give the prize to anyone associated with the Viennese style, as Mackintosh was. His drawings were nevertheless lavishly published with a commentary by the architect and England connaisseur Hermann Muthesius. This was perhaps more valuable than practical implementation of the designs would have been, and in the

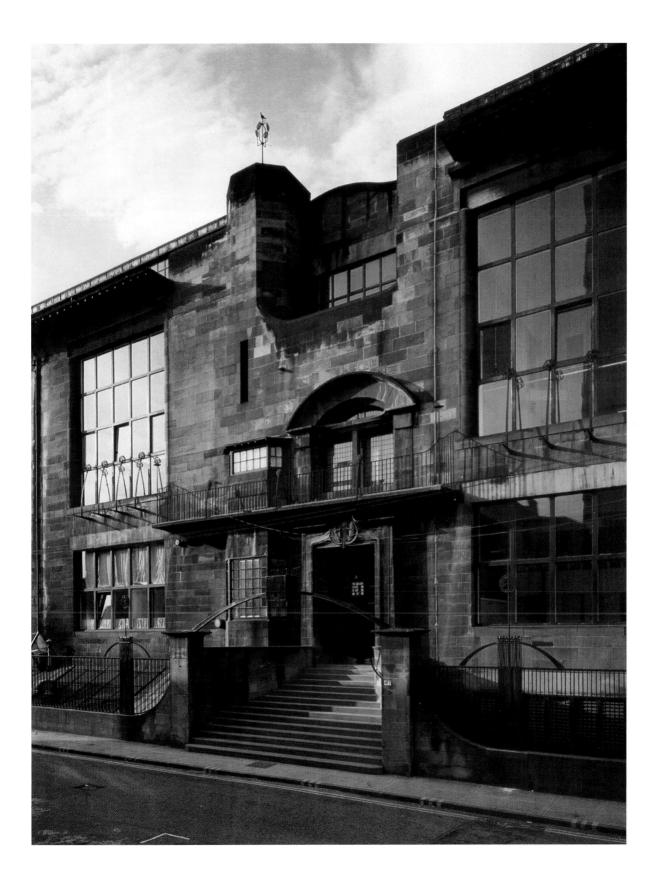

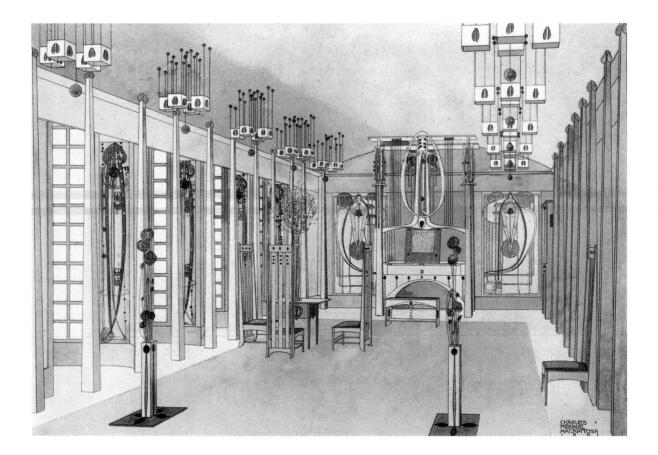

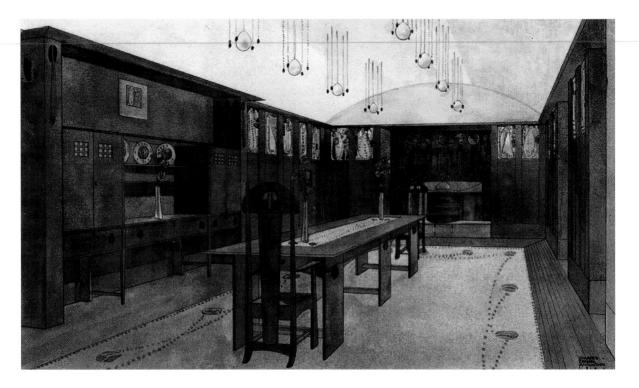

<u>Charles Rennie Mackintosh</u>, three designs for the "Haus eines Kunstfreundes" ("art-lover's house"): reception room, dining-room and entrance; also the cover of the portfolio in which the designs were published, 1901.

event none of the plans submitted for the competition ever came to fruition in Germany.

Mackintosh achieved international renown a third time with his contribution to the large exhibition of modern decorative art in Turin in 1902. This event marked the beginning of the end of Art Nouveau's heyday; Behrens' efforts (p. 158) and the brilliant follies of Carlo Bugatti served only to highlight the scale of the imminent crisis. Mackintosh remained true to himself – an indication of difficulty at this time.

At home he was still very successful. The first phase of his important work for the Glasgow School of Art had been completed between 1897 and 1899 (p. 179). The building had to be erected on a donated site sloping steeply to the south. Since it was essential both to have the studios facing north and to provide at least four storeys, the designer was obliged to make the rear rise straight up from the ground, defeating his imagination and remaining relentlessly unadorned. The most successful component of the first phase of construction, at least; part of the building was only completed later - was undoubtedly the north side, with a souterrain cleverly built into the ground and the top floor set back, so that the size, as viewed from the front, is reduced. This front view is dominated by the unusually large and simple windows. The pillar-like sections of wall between them provide stability and an anchor for the eye. A projecting cornice at the top harmoniously completes the composition. This "work form" is counterpoised, not quite symmetrically, by the "art form" of the entrance axis in deliberate contrast to the rest of the building: it is massive and heavy, sculptural and imaginatively ornamented. The modern functionality of the building is thereby given an element of tradition, in a paraphrase of Scottish castle architecture. There is nothing disturbing in the contrast; on the contrary, each part forms an outstanding complement to the other. The interplay of vertical and horizontal lines, and of one level of the building with another, is most successful. A rather

mundane need led to a remarkable result: the iron catwalks for the window cleaners are drawn like a delicate web across the imposing façade, at once poetical and purposeful.

The counterplay of the graceful and the solid is a distinctive feature of all of Mackintosh's work: small windows in thick walls, thin edgings to broad cupboards, high chairbacks against simple walls, tiny pieces of ornamentation almost lost within extensive surfaces. The catwalks were integral components of the overall design and therefore had the right proportions, but transposed to the limited dimensions of an interior such obsessional detail could become irritating. The most extreme result of this approach can be seen in the Mackintoshes' apartment (p. 174), which reflects their attitudes in excessively stylised, but remarkably consistent, form. Close inspection reveals that no detail is without purpose.

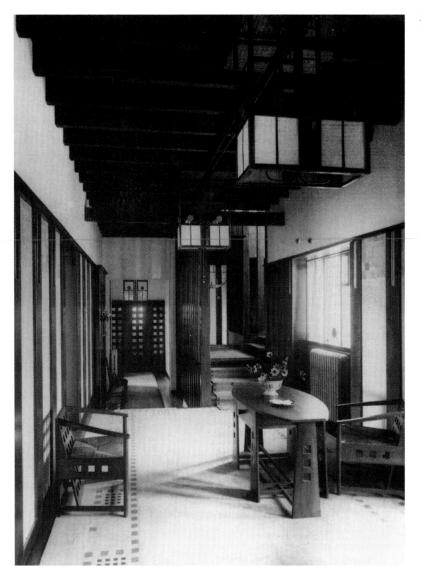

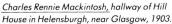

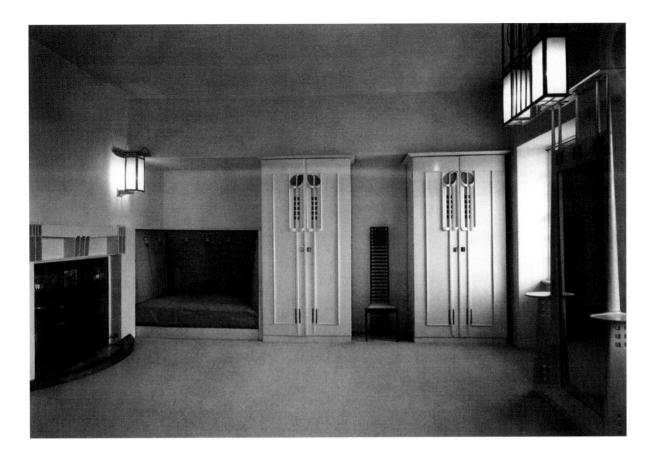

The chairs nevertheless look uncomfortable. The electric leads become an ornamental feature of the ceiling – it was evidently not possible to put the wiring under plaster in the rented apartment – and there are various projecting ledges and cornices, which weave together the different elements of the room as into a web, simultaneously light and binding. Like a fairy-tale setting where both innocence and black magic are in the air. An enigma we want to accept but we cannot trust. Once within, will we find our way out?

That, to a degree, was the dilemma of its creators. The décors that followed were a little more down-to-earth and robust, but they never quite abandoned their ceremonial character. The most direct line of succession would have been in the rooms in the "art-lover's house" (p. 180), where high-backed chairs were to confront one another at a long dining-room table "rigid as partakers in first communion". A few years later Frank Lloyd Wright was sufficiently daring to construct something of the sort in Chicago. When an opportunity arose for Mackintosh to build two houses in the Scottish countryside between 1900 and 1904 (pp. 182, 183), the results were noticeably more secular. The beautifully sensuous arches and languid curves had given way to sharper contours, the architect was more in evidence. On the outside these houses gave little Charles Rennie Mackintosh, bedroom at Hill House, Helensburgh, near Glasgow, 1903.

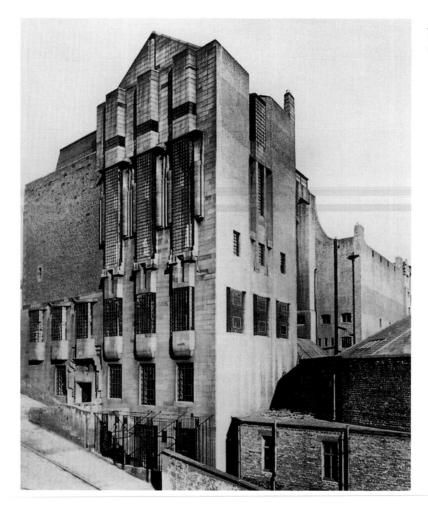

Charles Rennie Mackintosh, the younger section of the Glasgow School of Art: view from the south-west and reading-room, 1907–1909.

away, conforming to regional traditions, but inside there is a greater discipline and confidence, suggesting that Mackintosh's notions had a future.

Definitive proof of this is to be found in the second phase of building for the Glasgow School of Art, undertaken between 1907 and 1909. Here his art of multi-layered relief moulding, of projection from surface into space, is expressed in tighter, almost expressively unconditional terms, both in the extended, organ-pipe bay windows and in the interior of the reading-room, where the network of structural elements is not confined to the edges of the room, but spreads jungle-like right through it. As if he had followed his path to the end and reached his ultimate goal, the artist at this point chose to withdraw – or was obliged to. Subsequent occasional pieces are of little consequence.

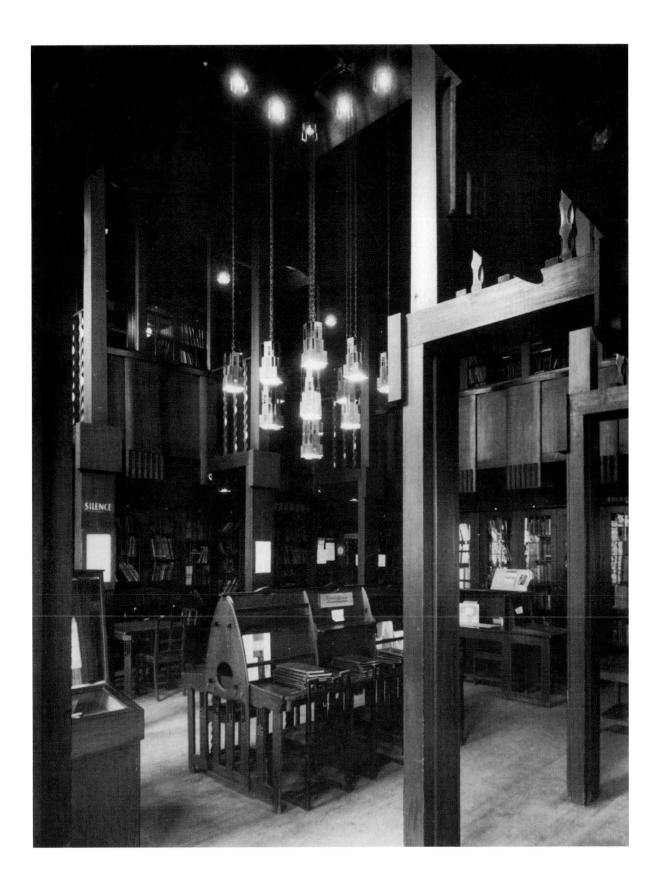

Helsinki

Nowhere else in Europe was the reform movement such an expression of national consciousness as in the Russian province of Finland. The very individual form taken by the new style in Finland can only be understood in the context of the nationalist power that sustained and shaped it. This caused some surprise at the time, since Finland had for a long time remained silent in politics and culture, but certain events changed matters very quickly.

For several centuries, what is now Finland had been watched over by other powers, ruled first by Sweden and from 1809 – as the result of a war – by Russia. Conditions had been bearable, and had even improved during the nineteenth century, thanks above all to Alexander I, who accorded the country far-reaching privileges. In fact the connection with Russia resided entirely in his person; as Czar he was also Grand Duke of Finland, with the undertaking to rule the land within the terms of its ancient constitution and to acknowledge the pre-eminence of the Lutheran faith. This all meant that Finland was treated largely as an independent nation, like a state within a state, and it even had its own army.

Its autonomy was such that it was able to extend more or less open hospitality to political refugees from Russia. Maxim Gorky was once in hiding there, and Lenin resorted to Finland at least ten times during periods of exile.

Towards the end of the nineteenth century, however, the country's independence conflicted with the Pan-Slav movement which was gaining in importance in Russia with its call for "one empire, one language, one religion". Within a few years these unexpectedly imperialistic sentiments drove Finland to resolute opposition, which quite nullified the former relationship and trust. At the very end of the century the situation became increasingly tense, and reached a climax in 1899 when Czar Nicholas II, who like his predecessors had undertaken to respect the country's rights and laws, suspended its privileges. The "February Manifesto" was a turning-point in Finnish history. From the Russian point of view this may have seemed of marginal significance, but for Finland the decree amounted to a breach of oath, and the fundamental interests of the country were at stake. Russian was to be the official language, the Finnish army was to be under Russian command. Arbitrary arrests took

Opposite page: demonstrations against Russian hegemony in Finland. Above: demonstration in front of the St. Nicholas cathedral in Helsinki on 13 March 1899. Below: mass meeting in front of the newly - erected National Theatre in Helsinki, 1905.

<u>Herman Gesellius, Armas Lindgren, Eliel Saarinen, Finnish pavilion at the Paris World Exhibition, 1900.</u>

<u>Eliel Saarinen</u>, design – not executed in this form – for the parliamentary buildings, Helsinki, 1908.

Eliel Saarinen, 1873–1950

Studied painting and architecture in Helsinki. Worked as a freelance architect in Helsinki from 1896 to 1923; partnership with Armas Lindgren until 1905, and with Herman Gesellius until 1907. Emigrated to the United States in 1923, was a teacher at the University of Michigan in Ann Arbor from 1924, later in partnership with his son Eero.

Major works: Finnish pavilion at the Paris World Exhibition, 1900; Hvitträsk Studio building in Kirkkonummi, near Helsinki, 1902; Helsinki Central Station, 1904, 1909–1914; second prize in the competition for the Chicago Tribune building, 1922; Cranbrook Academy of Art in Bloomfield Hills, 1926–1943. place and Finnish national leaders were sent into exile. One repercussion of this blatant infringement of Finnish rights was a European protest, signed in 1899 by more than a thousand noted personalities, including Emile Zola, Anatole France, Rudolf Virchow, Ernst Haeckel, Theodor Mommsen, Otto Harnack and Florence Nightingale. No immediate result was achieved, but Finland was suddenly at the centre of the contemporary scene, assured of sympathy and interest.

Since 1898 the Russian Bobrikov had been in office as governor, and his autocratic tendencies increased from 1903. After the failure of passive resistance by the populace and non-cooperation of civil servants, small groups turned to open aggression. Attacks became more frequent, and bombs exploded with increasing frequency outside Russian offices in Helsinki. On 16 June 1904 the senatorial employee Eugen Schaumann shot the hated Bobrikov. In the aftermath of the Russo-Japanese war there were uprisings and attempted coups throughout the czarist realm. and unrest intensified in Finland. In 1905 a general strike was called, in consequence of which the country's privileges were at least temporarily restored, and there was a breathing-space. But in the meantime it had become apparent that there was a threat of internal civil strife. Class distinctions had become more marked, the workers began to demand their rights. In 1899 they had formed their own party, and in 1903 they were re-named social democrats; they steered a more extreme course than affiliated parties in other parts of Scandinavia. Their political weight was sufficient for them to win eighty of the two hundred seats in the first elections for the one-chamber Finnish parliament in 1907. During the First World War they achieved an absolute majority.

Yet the introduction of truly democratic measures, including female suffrage (Finland was the first country in Europe and the second in the world to accord women the vote), was doomed as long as the Czar did not promulgate the laws which had been passed. In 1909 a new wave of oppression broke over the country; the Russians took advantage of the

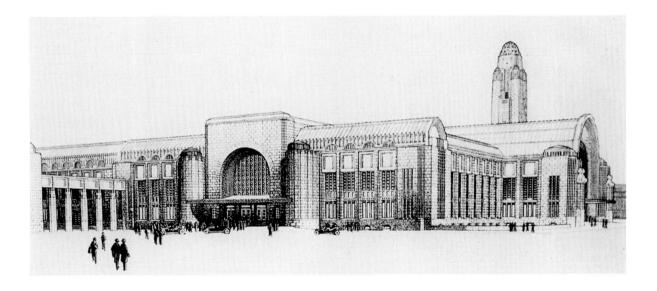

country's internal conflict to seize a measure of governmental control. In 1914 Finland was in a state of crisis on all fronts, precipitated on the one hand by the question of its legal status, on the other by internal disputes about equal rights for workers and the residual strength of an – in part, propertyless – rural population. At the same time the pressure from Russia was maintained. The slogan "Finis Finlandiae" with which the Pan-Slav movement had been launched in 1910 seemed likely to become a reality. Not until 1917 was the situation resolved; in that year the country gained independence.

Since 1812, the capital of the Finnish grand duchy had been Helsinki, pleasantly situated around a natural harbour. A series of excellent buildings in classical style, built by the German architect Carl Ludwig Engel from 1820 onwards, gave the city centre the distinctive character which it still retains today. During the nineteenth century it became the centre of administration, education and science, and around 1900 it was also the country's main centre of trade. Finland had been slow to accede to industrialisation, but the wood working and paper manufacturing industries had grown in importance. Access to the international timber trade extended contacts with foreign countries beyond Russia to Sweden, England and Germany. By 1900 the city was a metropolis of modest proportions, well kept and with a high general level of prosperity. The population of the whole country was a mere 2.7 million; by 1914 it had arown to 3.5 million.

Even after the defeat of the Swedish in 1809, the influence of Sweden remained strong for a long time and was at no stage replaced by a comparable influence of Russian culture. There was a conscious attempt to counterbalance outside influence by means of a deliberate fostering of everything Finnish. As in other countries, a prime focus of attention was the native language, which came to be used in numerous situations where previously Swedish had prevailed. Nevertheless, in 1910 half of the population of Helsinki still spoke Swedish, and the city continued to Eliel Saarinen, Helsinki Central Station, designed in 1904, built 1909–1914. be known abroad as Helsingfors. The revival of the native language was largely motivated by a spirit of National Romanticism, and among the most significant outcomes were written recordings of old sagas and stories – above all the *Kalevala* epic – which had previously been handed down by oral tradition only. The revival led to "Karelianism": artists of all types roamed the Finnish and Russian parts of Karelia in search of their roots in the depths of the forest. Scarcely anyone of artistic or intellectual standing escaped the trend.

A second decisive feature was the lively contact between artists, the bringing together of kindred spirits. Thus the swan of Tuoneala, familiar from Finnish mythology, now reappeared in the music of Jean Sibelius, in a play by the lyric author Eino Leino and in a painting by Akseli Gallén-Kallela, who was not only an important Finnish painter but also a leading figure among those seeking to mould their environment according to their principles. The house which he built for himself in an inaccessible

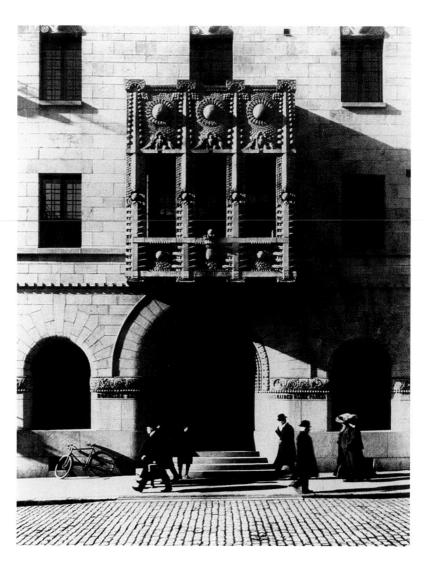

Herman Gesellius, Armas Lindgren, Eliel Saarinen, the Nordic Incorporated Bank in Helsinki, 1903/04. Herman Gesellius, Armas Lindgren, Eliel Saarinen, design for a country home in Kirkkonummi, 1902.

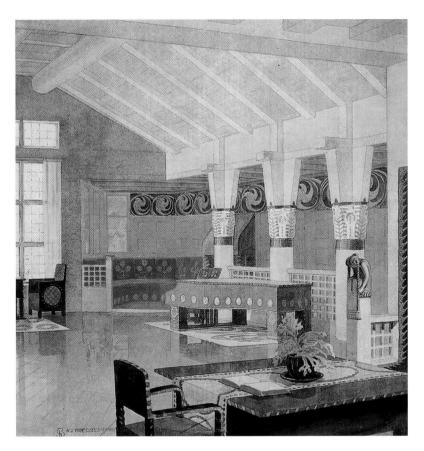

region in central Finland was constructed of wood in the traditional local manner and was, like van de Velde's "Bloemenwerf" house, a manifesto transcending fashion and style. At the same time it marked the beginning of the National Romanticism which pervaded all Finnish art in the era that followed.

The distinguishing characteristics of this movement were most happily illustrated by Finland's pavilion at the Paris World Exhibition of 1900 (p. 188). Its unusually free use of traditional motifs, its powerfully evocative character and astonishing freshness were immediately acknowledged. Its effect was thereby similar to that of the contribution by their - intellectually kindred - Munich colleagues, but the Finnish display caused a more resounding echo. The pavilion became a demonstration of Finland's independent spirit, a response to the Russian attempts at oppression, of which there had been ample evidence in the preceding year. From this time on, building became a manifestation of Finland's will to achieve self-determination; architecture was enrolled in support of the nation's claims. The significance of this process at the time was far greater than any art historical examination of individual buildings can convey: its aims were pursued not only by the new Central Station in Helsinki (p. 189) and in various public buildings and churches, but also by whole districts of new residential areas. The unmistakably Finnish style combined aesthetic value with a profession of faith. Today it is still

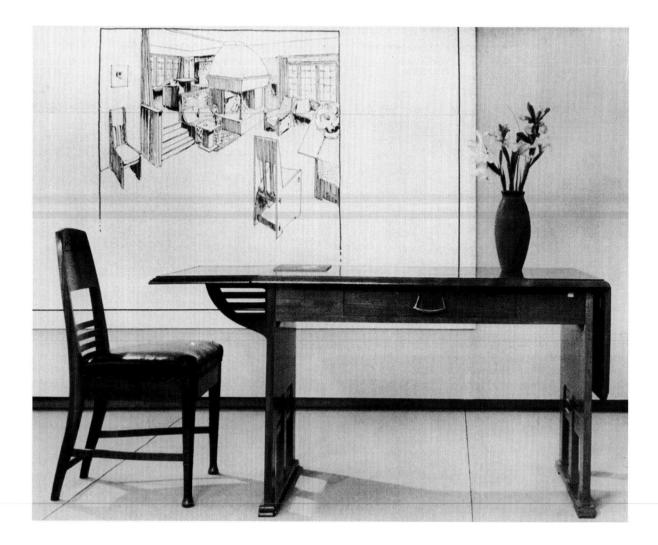

Louis Sparre, table and chair of mahogany, 1902/03, Louis Sparre's joinery workshop

easy for the careful observer to stroll through Helsinki and to appreciate the combination of civic pride and formal precision in its architecture. Such cohesion can only be interpreted as a deliberate proclamation of unity. Most of the buildings were inspired by the houses built around 1910 by Herman Gesellius, Armas Lindgren and Eliel Saarinen, prize-winners in the competition set up in 1898 for the Finnish pavilion. Abroad they came to represent Finnish architecture in its entirety; this was an unwarranted simplification, but understandable. They were certainly leaders and models. Their style tended to be weighty, highly charged with sentiment, solidly imposing, distinctive in contour, simple in ornamentation. The interiors show occasional links with the work of Joseph Maria Olbrich, Peter Behrens and Hermann Billing. In the exterior design of the numerous buildings that the Finnish architects were able to erect in a time which, though restless, was not impoverished, there is a blend of simple structural strength with restrained yet all the more emphatic ornamentation, which not only proves and reinforces the link with Art Nouveau, but even goes beyond it. In the work of Eliel Saarinen in particular it is possible to trace the unbroken line of transition to the Modernism of the post-war era.

The best-known Finnish building of the time, Helsinki's central railway station, whose design was the subject of a competition in 1904, was subject to alterations during planning, owing to conflicting pressures. Alongside the rather introspective belief that the nation's own heritage was the new salvation, there was an increasing drive to confront National Romanticism with European Modernism. This movement saw itself as more progressive and attached more importance to functional considerations than to those of sentiment. Its most consistent spokesman was the architect Sigurd Frosterus who had visited van de Velde several times in Weimar in the years 1903 and 1904, where he had been introduced to a whole new way of thinking. Although he did not have much opportunity to build in Finland, his critical influence was considerable. The influence of the final, tighter version of the railway station was to reverberate on drawing-boards far from Helsinki; Finnish architecture proved powerful enough to gain an international following.

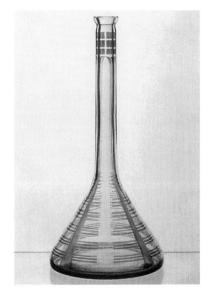

Wärtsilä-Nuutajärvi Glass-blowing Workshop, hand-painted vase, 20 cm high, c. 1900.

<u>Eliel Saarinen</u>, chair, oak with leather, 1902. Gerda und Salomon Wuorio Foundation, Hvitträsk

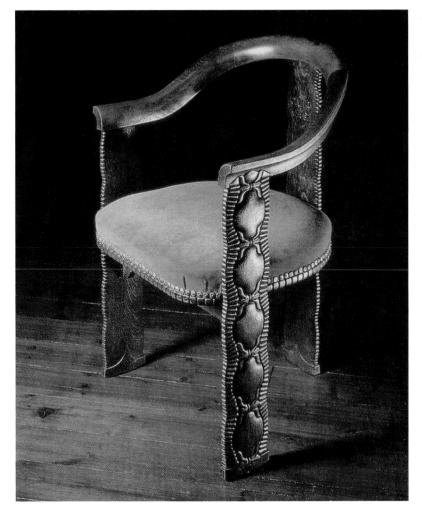

Chicago

There was no need for the Modern Style to be brought to Chicago in 1900: it was already there – at least in architecture. Building had played a major role in this city since the destruction of large parts of it by fire in 1871; several people had been shrewd enough to grasp the opportunities offered by the catastrophe. Pragmatism in architecture was felt to be a satisfactory expression of the unmistakable Chicago mentality.

What in 1830 had still been a village with twelve houses and seventy inhabitants, grew by the end of the century to become the second largest city of America. Until 1860, the city flourished largely because of its favourable location alongside the Great Lakes, which made Chicago an ideal handling point for the products of the vast Midwest. With the end of the Civil War, trade war joined by industry; the earliest tended, naturally enough, to involve processing of agricultural products, but rich coal and ore deposits in the surrounding area encouraged heavy industry and mechanical engineering. Large companies settled in the area, including Pullman, manufacturing rolling stock, and McCormick with harvesting machines.

By 1900 Chicago was the undisputed centre of the Midwest. Located at the meeting-point of four federal states – Illinois, Michigan, Minnesota and Wisconsin – it offered excellent transportation facilities both by water and, from 1850, by rail. Incredible – like so much about this city – in view of its situation in the heart of the country, Chicago had direct connections with the whole world: with New York and the whole East Coast via the Erie Canal, with Europe via the Great Lakes, the St. Lawrence river and the Atlantic, with the south via the Michigan Canal to the Mississippi and the Gulf of Mexico, and later from the Gulf via the Panama Canal with the Pacific Ocean and the West Coast. As turn-table between the American West and the Atlantic it enjoyed a virtual monopoly. By 1880 more than forty major railwaylines met in the city; in 1905 one-sixth of the world's railway tracks led to its centre, with ten thousand goods waggons passing through its stations every day.

The most important factor in the economy continued to be the handling of grain and cattle, with the city's famous slaughterhouses achieving almost mythical status. Every day some twenty thousand pigs, five thousand head of cattle and eight thousand sheep were slaughtered, dismemOpposite page: an exhibition featuring works by Frank Lloyd Wright in the Art Institute of Chicago, 1907. The installation is evidently a reconstruction of the architect's study; particularly characteristic are the metal chair in the foreground (1904), the plaster model of the Larkin Building in Chicago (1905) on the pedestal on the left, the window beside it and the vases on the desk.

<u>Holabird and Roche,</u> Tacoma Building in Chicago, 1887–89.

Louis H. Sullivan, Carson Pirie Scott & Co. department store, Chicago, 1899–1904. bered, loaded and dispatched. The meat-processing industry provided almost one third of the city's profits.

Chicago was the city of superlatives. It was the USA's largest producer of iron and steel, harvesting machines, furniture, even organs and pianos, and it was the largest railway junction and inland port in the country. It had the largest grain turnover of any city in the world, the largest cattle market, the largest timber market, not to mention the largest department store. The population had, of course, expanded with the economy, from 300,000 in 1870 to 1,700,000 in 1900. Immigrants from Europe contributed greatly to this expansion, the German colony being the largest.

The city's fame had spread rapidly, sometimes will gruesome distortions, particularly in the Old World. Bismarck regretted that he had not seen it, and many visitors did actually make the journey to the World Exposition held there in 1893, and experienced its rough and opportunist character as something unmistakably American. Rudyard Kipling recorded reactions of this sort in later writings, and Sarah Bernhardt saw the pig-slaughtering as a terrible and magnificent drama – she had gone and seen it all the same. The difference between this and europeanised New York must indeed have been most striking.

For a city oriented so strongly towards growth and constant innovation, a

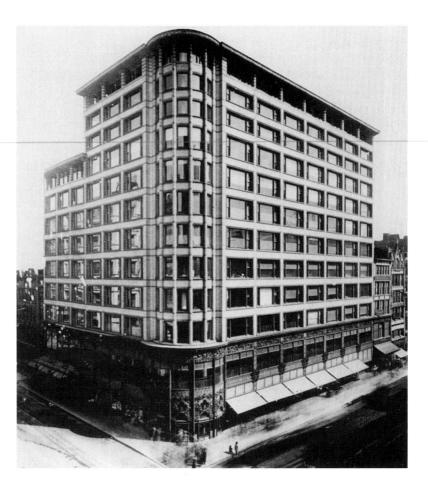

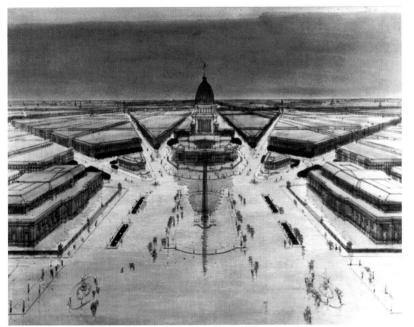

catastrophe could turn out to be a stimulating rather than an inhibiting factor. The great fire of 1871 had destroyed one third of it, but had thereby razed much that was old and overgrown. In retrospect, it seems clear that the disaster paved the way for a phase of cool, unsentimental planning. Chicago became the cradle of a specifically American style of architecture; its driving force was something that was still a distant hope as far as Europe was concerned, namely the engineering spirit. Pragmatic questions concerning the durability of multi-storeyed houses, their internal design, the supply of utilities, the fire-resistant covering of steel frames and the like determined an experimental and unprejudiced approach which led to an entirely new kind of architecture. Houses were built in response to a particular challenge, not according to earlier stylistic models. Historical reminiscences were found only in ornamentation, and even there they were subject to uncommon liberties.

New buildings typically now either used simple masonry or were reduced to a skeletal structures, which employed huge windows in an attempt to make even the innermost areas usable. There was no set orthodoxy. With the Monadnock Building, for instance, a particularly powerful effect was achieved through the combination of traditional load-bearing masonry for the exterior, despite its sixteen storeys, with a light cast-iron frame at its core. The upward tapered base allowed a simple curve in the vertical members.

The World Exposition of 1893 actually made a considerable profit for the city – by no means a foregone conclusion. The official character of this ambitious event resulted in a return to the conventional architecture of the Beaux-Arts tradition. The golden age of the Chicago School was provisionally over, but it was continued with some ambivalence by an

Daniel H. Burnham, plan for urban expansion, Chicago, 1909.

Daniel H. Burnham and John W. Root, Monadnock Building in Chicago, 1884–1890.

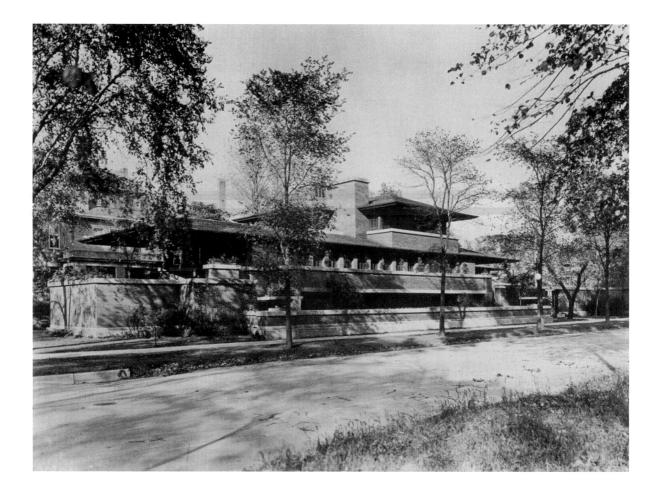

Frank Lloyd Wright, the Robie House in Chicago, 1906–1909.

<u>Frank Lloyd Wright,</u> entrance of the Heurtley House in Oak Park, near Chicago, 1901.

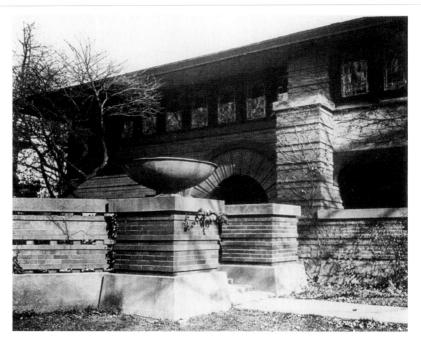

architect who had not submitted to the official attitude imposed on the exhibition: Louis H. Sullivan. He represented a younger generation that bore the stamp of the new tradition recently interrupted, but also looked beyond it, sought new challenges, and was not without internal contradictions. Although Sullivan was a little older than the architects setting the trend in Europe in the early years of the twentieth century, his ideas and his work make him part of the Art Nouveau movement. He extended the purely pragmatic premiss into an approach which, with its inclusion of a strong decorative element, came very close to the "total work of art". He was not averse to lofty sentiment; purist exclusivism did not appeal to him. He was striving for a sensual transfiguration of the strictly functional, not unlike his contemporaries in Europe, but in free and independent form. He came closest to Otto Wagner in Vienna. The large department store that he built in Chicago between 1899 and 1904 (p. 196) demonstrates a very successful combination of rigorous overall structure and clustered explosions of ornament, not strictly rational in utilitarian terms, but thoroughly convincing as art. There was scarcely any justification for the bizarre creepers ornamenting the two lower storeys, not even as incitement to potential buyers. Sullivan effectively contradicted all the theories, and seemed to be making nonsense of the tenet that ornament could be assigned a particular order. In this way he declared himself once more to be an artist-architect, rather than an engineer-architect as his predecessors in Chicago had been. To European eyes that would later appear a retrograde step, but in the years around 1900 Sullivan thereby produced his most outstanding works. He combined flawless clarity of construction with the attributes claimed by art, but repudiated the illusion that they could merge into one; in this he was perhaps more far-sighted than the rest.

Sullivan's artistic mission seems to have been fulfilled at this point; tragically, perhaps, his later works were of no more than marginal significance. But the ground had been prepared for the development of something very different. Again – as so often – this was concentrated upon the work of a single individual. Frank Lloyd Wright was a true contemporary of Olbrich, Hoffmann, Behrens and Mackintosh in Europe, but provided with exceptional training and given an excellent start by Sullivan and his partner Dankmar Adler. In 1894, at the early age of twenty-five, he set up on his own, built himself a house and studio in Oak Park, a suburb of Chicago, and immediately became a successful architect, specialising in lavish private houses. He thus entered architectural history shortly after the World Exposition, at much the same time as Victor Horta and Henry van de Velde in Brussels.

The appeal of his new style was its crystallization of both social and architectural emancipation. Wright would not have been able to build his sumptuous villas and country houses had it not been for his clients' specific life-style, which was new, unconventional in American fashion, but demanding and with clear expectations regarding the usefulness and practical value of things. Healthily- developed self-assurance required a fitting environment. The architect's own ideas were certainly likely to foster such attitudes, but in Chicago he could be fairly sure of finding them.

Frank Lloyd Wright, view of the Hardy House in Racine, Wisconsin, c. 1900.

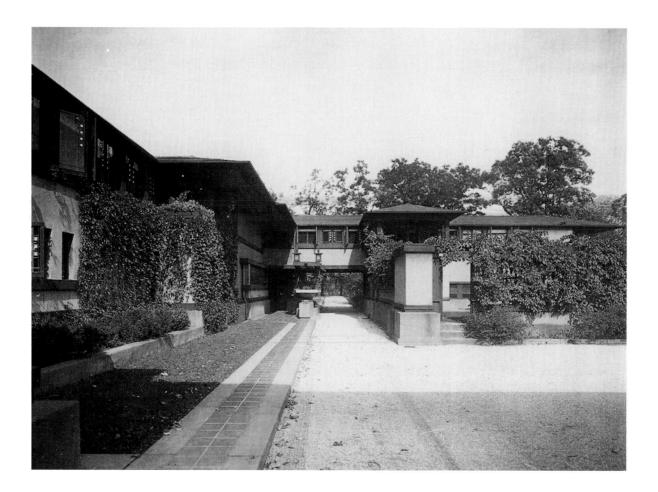

Frank Lloyd Wright, rear entrance to the Coonley House in Riverside, Illinois, 1907/08.

Frank Lloyd Wright, 1867–1959

After two years studying engineering at Wisconsin University in Madison, Wright worked in Louis Sullivan's architectural office from 1888 to 1893. During this time he built a number of houses independently, and established his own studio in Oak Park, a wealthy Chicago suburb. Here he later worked on his "Prairie Houses". He travelled to Europe in 1909, and came to exert an important influence on architects such as Gropius and Ludwig Mies van der Rohe through his exhibition in Berlin and his book "Completed

The congruence of life-style and architecture began with the groundlevel design of the houses, close to the generous space available outside. Terraces, ponds and the flat stone bowls so characteristic of Wright related the interior imperceptibly to its surroundings, entirely avoiding the hierarchical terracing of European villas. People wanted to feel the newness of the land on which they trod. Closeness to the ground spread right through the extensive ground-plans, which were cruciform rather than centripetal in design. This multiplied the number of outside walls, therefore also of openings. The focal point was usually a massive fireplace, giving a firm point of reference to the other more lightly-constructed parts - almost as if Wright had derived inspiration from photographs of Chicago destroyed by fire, where nothing could be seen of the old buildings except their chimneys. But more important is the pioneer mentality that looks first of all to what is most essential, the hearth, and lets everything else follow after. The different sections of the ground-plan allowed for the customary separation of areas – a central living area, with separate wings for domestic purposes, for study and office, and for bedrooms.

Closeness to the earth was maintained in the vertical axes by keeping the

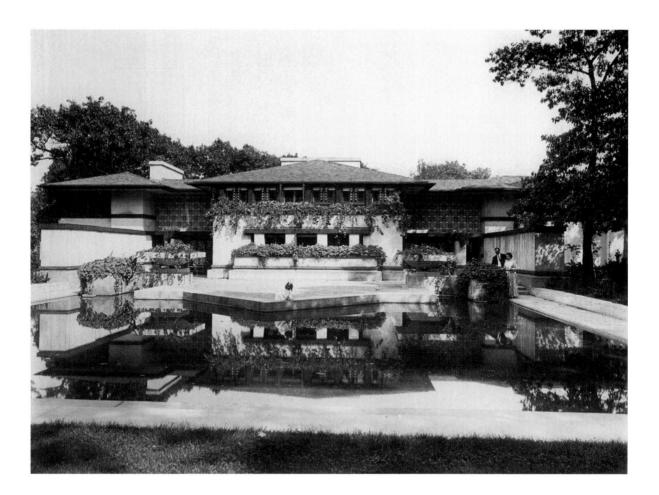

storeys – of which there were usually no more than two – low and by extending the flat – sloping roofing down as far as possible. A further visual reduction in height was achieved by the layered effect of the exterior, itself the result of emphasis upon all the horizontal elements of eaves, balustrades, sills and windows, these last typically aligned in bands. Large areas of projecting roof further overshadowed the solid building below, reducing its impact.

The interior revealed more of the brief history of the land, in which one could now at last live with a certain sense of security. The central hall of the Coonley House, for instance, in which the ceiling arches over the whole area, is reminiscent of a tent. But the most powerful expression of an entirely new awareness of life is the open communication between the different rooms, which makes the whole of the central area affear a single whole. As a rule, entrance hall, living-room and stairs were designed as a continuum extending right through the centre of the house. The fire-place as the focal point for the various axes and vistas created intimacy within the play of open spaces.

This detailed description is necessary in order to convey just how unusual Wright's notion of architecture was. It might be labelled extrovert when Frank Lloyd Wright, garden view of the Coonley House in Riverside, Illinois, 1907/08.

Works and Designs". After his return to the United States in 1911 he founded the Spring Green Co-operative in Wisconsin, and his own house, Taliesin, became an architectural school. Major works: the Coonley House in Riverside, Illinois, 1907–1909; the Larkin Building in Buffalo, 1904; the Kaufmann House (Fallingwater), Bear Run, Pennsylvania, 1936; the administration building of S. C. Johnson & Sons in Racine, Wisconsin, 1936–1939; Solomon R. Guggenheim Museum in New York, 1943–1946 and 1956–1959.

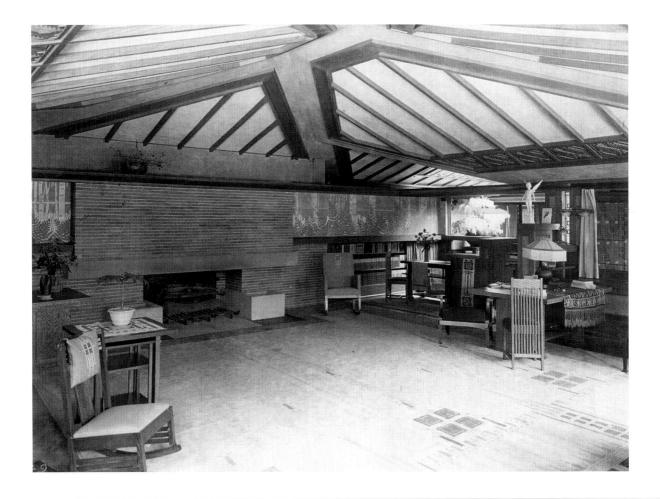

Frank Lloyd Wright, large living-room in the Coonley House in Riverside, Illinois, 1907/08.

compared with that of some of his contemporaries. Putting houses together was like completing a puzzle in which individual elements were combined according to prescription, whereby appropriateness of the inner organism and clear and easy functionality were fundamental, whereas the exterior was open to negotiation. Of course this was not entirely the case – the structured and carefully-organised composition of his houses is evident – but since his multi-layered technique created sufficient visual cohesion, he did not need to spend time working on façades. This procedure went against all the usual ideas, which inevitably required a clearly defined outer form: it might be interrupted, supplemented, extended, but overall it had to convey hermetic. For the architectural foundation provided by geometrical shapes Wright substituted his own interplay of closed and open spaces: brick walls reached out into the surrounding area, roofs cast shadows, long bands of windows dissolved the spatial boundaries of the interior.

Wright developed his "prairie style" at a time when even the most daring architects in Europe were still struggling simply to give the still conventional shape of their houses a new face – Olbrich with ornament and moulding, van de Velde with suggestively dynamic elements, Behrens <u>Frank Lloyd Wright</u>, design for a building for the City National Bank in Mason City, Iowa, 1909.

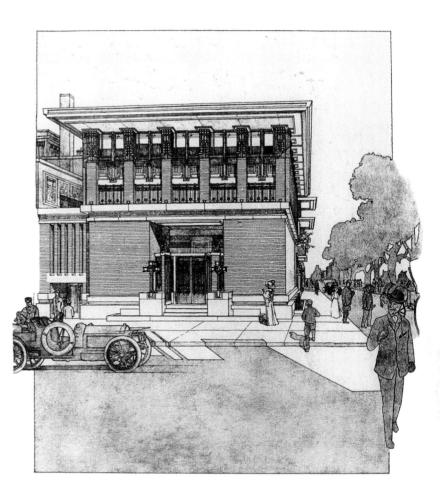

with sharpening of edges. When a comprehensive portfolio of drawings of Wright's most important buildings was published in Germany in 1910, it prompted lively response; but by this time architecture had moved on to a new wave of classicism, exactly the opposite of the American's vision. Only in a few isolated cases was his example followed.

The fronts were shifting – not for the first time in the wake of Art Nouveau. There was a certain appropriateness about the fact that the best new architecture was being developed in America, and there was a certain logic, too, in the focal point being not in europeanised New York, but in a provincial city which had strength, freedom and space enough to encourage innovation over many years – in an initially somewhat aggressive, but later highly civilised manner.

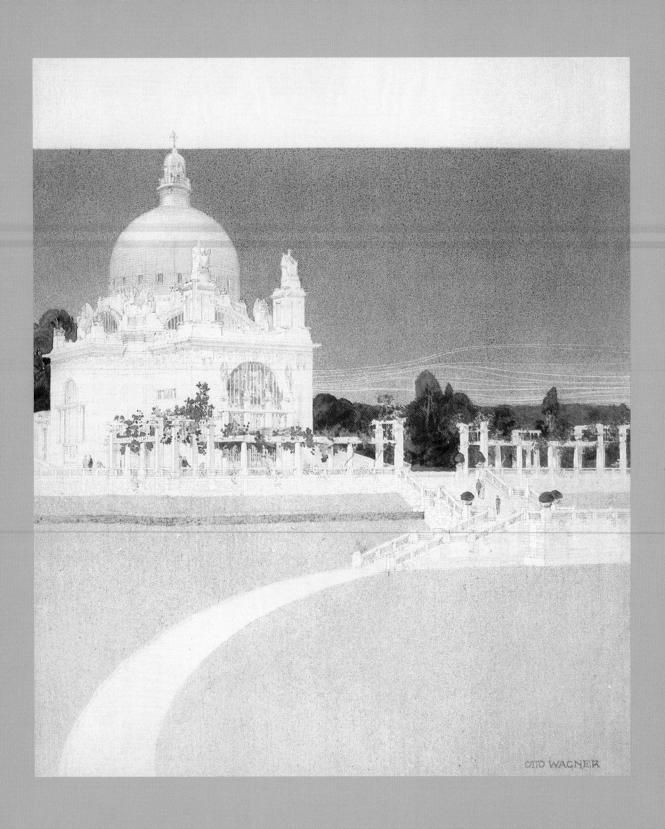

EQUILIBRIUM VIENNE: THE MODERN STYLE ARRIVES

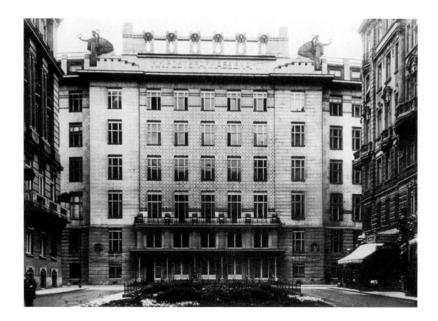

After all that has been said, there may be some doubt as to whether Vienna's contribution to the Modern Style around 1900 may still be classed as Art Nouveau. The lucid clarity so often found speaks against such an attribution, the continuing delight in rich ornamentation speaks for it. What emerges very clearly, however, is that Vienna was in many ways very different from the other European centres of Art Nouveau. The innovative dynamism found elsewhere was countered in Vienna by reflective maturity – the Dionysian element of sensuous functionalism by an Apollonian attitude of harmony and classicism. One who could not be relied on to conform – Joseph Maria Olbrich – took the consequences and left the city early on, for Darmstadt. No trouble was caused. That is, of course, too simple a reading of events, but it provides a useful introduction.

No one could maintain that Vienna was a provincial capital. Everything achieved in the city before, and particularly after, 1900 made it a great metropolis, almost on a par with the French capital, and perhaps more self-sufficient than Paris, in that it was in no way dependent on foreign – for instance Russian – resources. Value judgements shift so slowly that this possibility has only been acknowledged in recent years.

Yet the complexity of the highly differentiated culture of the metropolis, which achieved pinnacles of excellence not only in architecture and the fine arts, but also in literature, music, philosophy and medicine – no mention of Vienna at this time is complete without the name of Sigmund Freud – obscured a politically disparate situation. As in Brussels, intellectual forces seem to have formed a bond which was increasingly weakening at other levels. Since 1872 Vienna had no longer been the Empire's sole capital; it had to share the title with Budapest. This led to large-scale expansion in the Hungarian city, which proceeded to assume the role of dominant province within the Dual Monarchy, at least as far as self-

Title page: view of the church "am Steinhof" by Otto Wagner, Vienna 1902, watercolour. Historisches Museum der Stadt Wien, Vienna

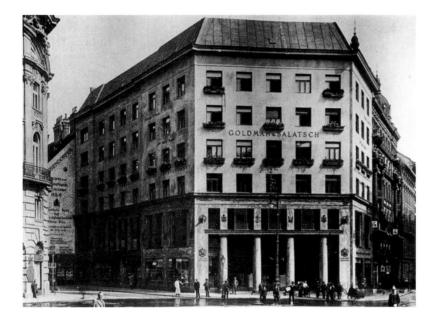

assurance and mannerisms were concerned. It, too, used the means of modern art to this end, but could not rival the brilliance of the true metropolis.

The division of power, the formation of the Austrian-Hungarian Dual Monarchy, was one of the most spectacular steps taken in order to ensure the stability of the multinational state, which in 1900 comprised several dozen nationalities. Various military defeats, above all by Prussia in 1866, and recurrent crises of government, accompanied by economic problems and the disastrous losses incurred by the World Exhibition of 1873, had damaged Austria's reputation and endangered internal solidarity. Growing nationalism amongst the individual ethnic groups and cultural rivalries forced the central administration to make greater and greater concessions, which in turn weakened the state.

Although the revolution of 1848 had failed, bourgeois Liberals had had a share in government since 1860. Their influence was felt most strongly in Vienna, where they remained the steering force in politics, economy and culture until late in the century. Their support was drawn from the relatively small but affluent middle and upper classes, who were able to control local government thanks to the restrictive class system of franchise based on tax returns. The Liberals' political goals were to diminish the power of the authoritarian state and to reduce the privileges of the aristocracy; they argued vehemently for constitutional rights and strict conformity with the rule of law. For the economy they demanded free competition without state intervention, and freedom of trade without social restrictions. Clericalism was to be replaced by faith in the value of rational educational methods and science. An optimistic belief in the upward trend of progress governed most of their thoughts and deeds. Their relatively cosmopolitan views ensured the rejection of blinkered nationalism and emphatically ethnic orientations. Liberalism therefore

Otto Wagner, Post Office Savings Bank in Vienna, 1903–1912. (p. 206)

Adolf Loos, house on Michaelerplatz in Vienna, 1909–1911.

<u>Otto Wagner,</u> view of the Stadtbahn station at Karlsplatz, Vienna 1898, watercolour. Historisches Museum der Stadt Wien, Vienna

Wagner began his training at the Technische Hochschule in Vienna in 1857. He also studied at the Berlin Bauakademie and, from 1861 to 1863, at the Vienna Akademie der Bildenden Künste, where he became a professor in 1894. He was a member of the Wiener Secession from 1899 to 1905. He was commissioned with the replanning of the City of Vienna in 1890, for which he realized the construction of the Stadtbahn rail network.

Major works: apartment buildings in the Linke Wienzeile, 1898/99; buildings for the city Stadtbahn, 1894–1897; church "am Steinhof"; Vienna Post Office Savings Bank, 1904–1906.

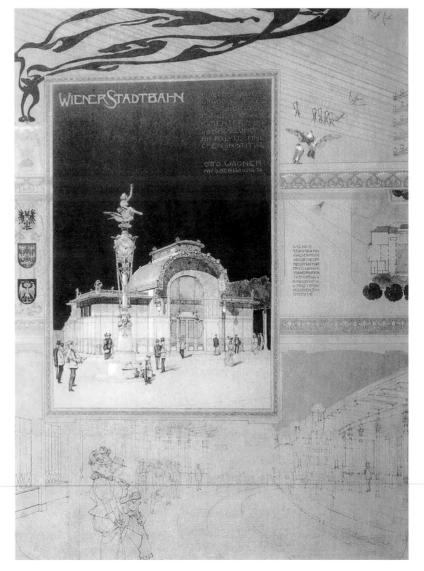

<u>Otto Wagner,</u> façade detail of No. 38, Linke Wienzeile, Vienna, 1898/99.

<u>Otto Wagner,</u> Majolika House in the Linke Wienzeile, 1898/99, from: Moderne Städtebilder, Neubauten in Wien, Berlin, 1900.

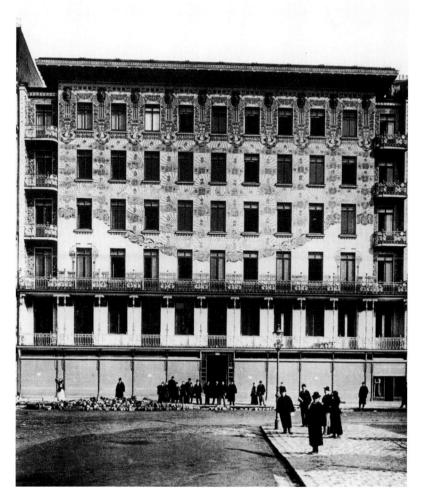

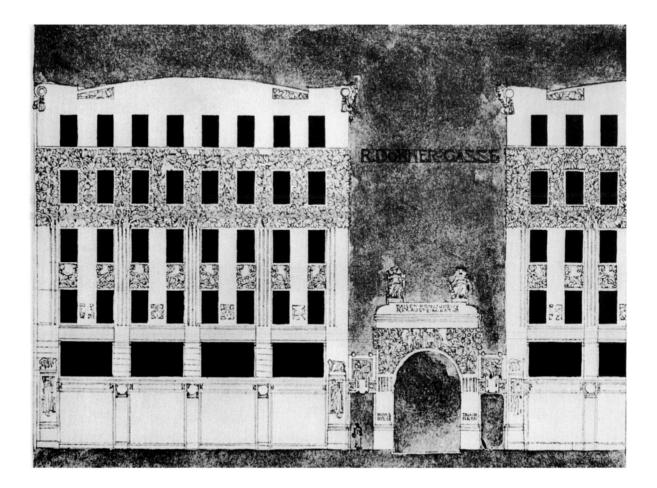

<u>Josef Hoffmann,</u> façade design, c. 1895, from: Dekorative Kunst II, 1898.

Josef Hoffmann, 1870–1956

Studied at the Brunn State Polytechnic and, from 1892 to 1895, at the Vienna Akademie der Bildenden Künste, under Karl von Hasenauer und Otto Wagner, in whose studio he later worked. From 1899 to 1936, he was professor at the Vienna Kunstgewerbeschule; in 1897, he was a cofounder of the Wiener Secession, which he left with the Klimt Group in 1905. Founded the Wiener Werkstätte (Vienna Workshops) with Koloman Moser in 1903, and remained their artistic director until 1932. From 1907 to 1912 he was chairman of the Austrian Werkbund. Major works: the Moser, Moll, Henneberg and Spitzer houses, Vienna, c. 1900; sanatorium in Purkersdorf near Vienna, 1903; Palais Stoclet in Brussels, 1905–1911; exhibition pavilion for the Biennale in Venice, 1934.

helped to provide stability for several decades for a Habsburg monarchy which was tending to drift apart. It was staunchly supported by a number of wealthy Jewish families, among others.

After more than thirty years of uncontested supremacy, the last years of the century brought a surprisingly rapid collapse, and the catastrophic defeat of the Liberals in the municipal elections of 1895 opened the way for the Christian-Socialist party founded in 1899 under Karl Lueger, who became Mayor of Vienna after an unusually hard-fought election campaign. He remained in this office until his death in 1910, but his memory lingered on for many years.

There were a number of different reasons for the change: the Liberals' economic policies had been discredited by various collapses and had led to a feeling of insecurity, especially among the lower middle classes. Moreover, it had not been possible to gain the confidence of the lower classes with regard to municipal policies. Growing social problems demanded more serious measures than those previously adopted. Some steps towards modernisation had been taken on behalf of the community: the level of the Danube had been lowered in 1871 and 1875, preventing the customary floods; in 1873 the first municipal non-denominational hospital had been opened. But there was still a certain indifference; too Joseph Maria Olbrich, salon for a luxury yacht, shown at the Paris World Exhibition in 1900.

Alois, Ludwig, frontispiece, c. 1900.

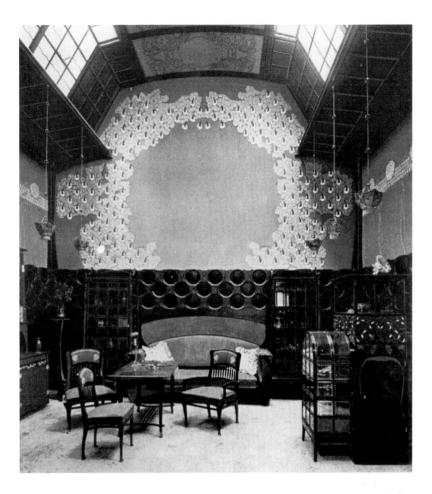

AUS DER WAGNER SCHULE MDCCCIC

0

little heed was paid to the fears of the small tradesmen and skilled workers who felt threatened by the principle of free competition, and to the growing proletariat's need for housing. It was not until later that municipal housing initiatives came to be a feature of the city.

Lueger's Christian-Socialist program contained some timely and appropriate demands, but also some points which revealed a distinctly anti-liberal frame of mind. Above all, it demanded greater clerical influence in schools and it stirred up cheap nationalist feeling against "international plutocrats". It was easy to see who he was aiming at, and no attempt was made to disguise it. Lueger's victory was based largely on anti-semitic broadsides aimed at powerful figures in the city's economy.

At the turn of the century Vienna had therefore only recently experienced considerable unpheaval, but was at the same time obliged to be the cohesive centre of a heterogeneous state. The increasing power and influence of Berlin may have been an additional annoyance. In matters of culture in particular, the city was losing ground. Vienna was also suffering the unusually rapid growth burdering so many cities at the time. Between 1870 and 1900 the population had doubled, to reach 1.6 million, making the city the fourth largest in Europe. The major factor in preserv-

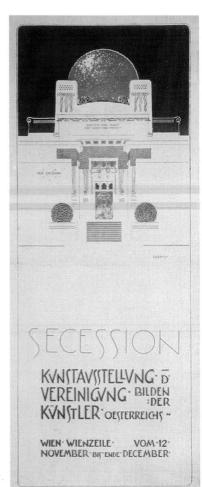

<u>Joseph Maria Olbrich,</u> poster for the Second and Third Secession Exhibitions, Vienna, 1898/99. Collection Mr. and Mrs. Leonard A. Lauder

<u>Joseph Maria Olbrich,</u> the cupola of bronze gilt over the Secession building in Vienna, 1897/98.

ing unity in this situation of painstakingly veiled weakness was the venerable figure of Emperor Franz Joseph; in 1900 he had already been on the throne for twenty-five years and was to remain there for another sixteen. His reign, overshadowed at times by human tragedy, was marked by jubilee celebrations which included specifically Austrian incarnations of the modern style in art. Nothing quite like this could have come about in Berlin.

Into Vienna's fin-de-siècle spirit there often crept an apocalyptic tone, which intensified emotion, introspection, aestheticism and psychologizing. Skins grew thinner, nerves were exposed. On the other hand, moments of decline and collapse could always be interpreted and utilised as potential new beginnings, as indeed happened in Vienna to an astonishing degree around 1900. This may explain the background to the new movement arose, but not its subsequent momentum. To a greater extent than in other leading cities, the new developments in Vienna were supported by a liberal bourgeoisie, whose longer and more harmouious traditions made them particularly open-minded and discerning. Communications between artists and their public – a small circle in Vienna, as elsewhere – were easy. The results were astoundingly assured.

Four architects determined the course of events around 1900, albeit not necessarily through building. In the exhibition building for the Wiener Secession, Joseph Maria Olbrich created a meeting-point for all the other forces of innovation, in particular young painters and sculptors. Adolf Loos added his polemics to the hotly-debated issues of the day. Otto Wagner and Josef Hoffmann were more pragmatic; they did not hesitate to take advantage of the golden opportunities that were offered to them.

As in Chicago, so in Vienna there was already a modernist tradition – it did not have to be invented. Its chief exponent was the architect Otto Wagner, in whose oeuvre it is possible to follow the linear transition, free

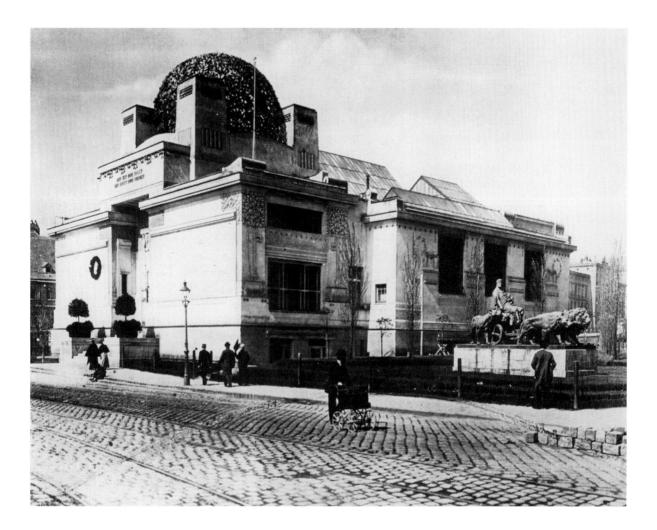

of interruption and uncertainty, from cultivated historicism to an uncompromising Modernism. He demonstrated innovation through change rather than rupture, and many in Vienna were to follow his example. Revolutionary blows were thus uncommon, and the new style developed fully at an early date.

Wagner was the oldest of the four architects by many years, and therefore something of a father-figure. This gave him, like Louis Sullivan in Chicago, a focal and binding strength which – in view of its results – proved more helpful in the long run than the freedom available elsewhere. Olbrich and Hoffmann were his pupils, and Olbrich must have been particularly close to him since he was chosen as his assistant. The classicism in Wagner's work was acquired early, during his studies of buildings by Friedrich Schinkel in Berlin, and it had a decisive influence on his entire oeuvre. It gradually acquired a certain timeless quality, pervading even his last, most modern designs of 1910. Around 1900 it was still combined with animated ornamentation, but this never obscured the unambiguous formal and constructional thinking behind his houses. Thus the purely two-dimesional decoration of the Majolia House in the Joseph Maria Olbrich, Secession building in Vienna, 1898/99; the figure of Mark Antony drawn by lions is by the sculptor Arthur Strasser and was first shown at the Paris World Exhibition in 1900.

<u>Max Klinger,</u> his Beethoven sculpture in the Wiener Secession building during the XIVth. exhibition, 1902.

<u>Adolf Böhm</u>, decoration of the main hall of the Wiener Secession building on the occasion of the XIVth exhibition, 1902.

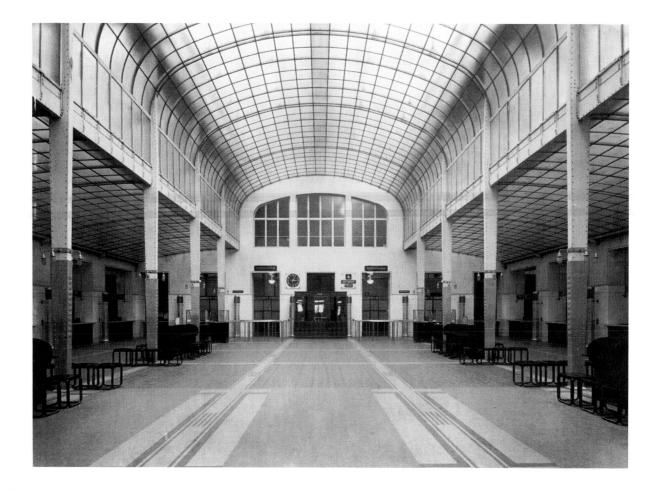

<u>Otto Wagner</u>, banking hall of the Post Office Savings Bank in Vienna, 1906. Wienzeile (p. 209) was clearly designed to animate what might have been too severe a façade.

The lower storeys of the Majolica House offer early evidence of Wagner the engineer, and it war this side of the architect which strongly Wagner's influenced one of rail most important undertakings – the stations for the city's Stadtbahn rail network. In Vienna as in Paris, the design of these great urban amenities was entrusted to architects who were not bound by tradition. The Karlsplatz location (p. 208), in the shadow of historic buildings of the most various kinds, provided a challenge similar to that encountered by Guimard in Paris. Wagner chose a less provocative solution, attaching more weight to architectonic design.

Quite outstanding was his design of the Vienna Post Office Savings Bank, whose interior is one of the Modern Style's key works. The façade is still tied to Art Nouveau, however, (p. 206), its superstructures illustrating the imperial manner that Wagner favoured in his more official buildings. The metropolis was not denied its rightful grandeur.

The ornamental elements in Wagner's work before 1900 probably stemmed from his assistant Olbrich, who was given early opportunities to display his perilously rich talents. The delight he took in making the secondary the primary, and in creating ambivalence in scale and significance, is alredy evident in his most important early work, the building for the secessionist artists' association, the Wiener Secession (pp. 212, 213). It is a cunning combination of studio-workshop and temple, hive of activity and monument. The original laurel dome ensures that the imperial-type motif so dear to the Viennese is not missing. There are similar elements in the very elegant Austrian room shown at the Paris World Exhibition (p. 211), hard to credit as the work of a beginner. Olbrich was subsequently active only in Germany, however.

It is the work of Adolf Loos which fits least happily under the heading of Art Nouveau. He himself never tired of pointing out the difference of his approach. Some of his earliest décors are pleasantly pragmatic in design, attuned to a rather English way of life, uncomplicated and yet sophisticated in a very unselfconscious way. He tried to fashion things to suit their function, and on a small scale he was often very successful. But as larger commissions came his way he, too, found himself compelled to

<u>Otto Wagner</u>, modern reconstruction of the façade of the telegraph office of the "Die Zeit" newspaper, Vienna 1902. Historisches Museum der Stadt Wien, Vienna

<u>Otto Wagner</u>, chair from the conference hall of the Vienna Post Office Savings Bank, 1906; beech with upholstery and aluminium fittings. Private collection

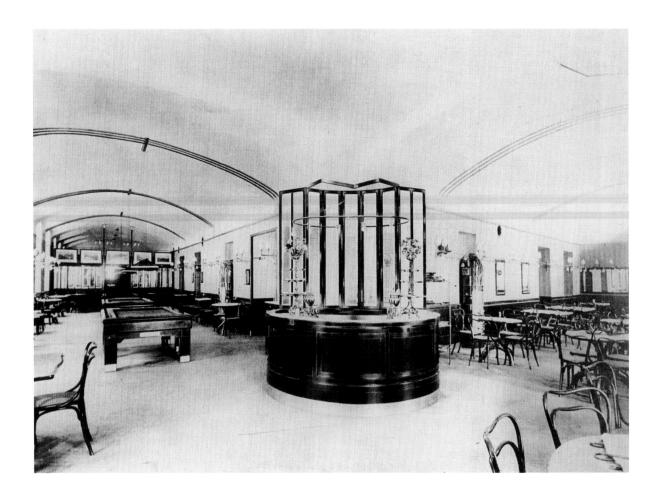

Adolf Loos, main room of the Café Museum in Vienna, 1898/99.

Adolf Loos, 1870-1933

After training at the Dresden Technische Hochschule he went to the United States for three years in 1893, where he survived on casual work. Afterwards he worked briefly for Carl Mayreder in Vienna, before turning freelance. Moved to Paris for a few years in 1923. He became known not only through his buildings and interior designs but as a writer and publicist. Major works: Café Museum, 1899; Kärntner Bar, 1908; the Steiner House, 1910; department store on Michaelerplatz 1911 (all in Vienna); his entry for the competition for the Chicago Tribune Tower in the shape of a gigantic Doric column, 1922; Tristan Tzara's house in Paris, 1926. fulfil expectations with conventional art forms. His robust criticism of colleagues in Vienna rebounded on him when he adorned a prominently-located business premises (p. 207) with Doric columns and marble cladding. Wagner had approached his Majolica House, with its very similar composition, with a much less academic attitude. There were other occasions when Loos's ostensible simplicity seemed forced rather than spontaneous. He was, however, an ardent polemicist of inimitable sharpness, as was amply demonstrated by his editorship of the short-lived "Zeitschrift zur Einführung abendländischer Kultur in Österreich". (Journal for the Introduction of Occidental Culture in Austria). He once remarked that a prison cell decorated by van de Velde would amount to an aggravation of the sentence. Of all the artists active at the turn of the century, he was the one who fought most persistently against being classed as one. Indeed he could more aptly have been described as a pioneer – he had spent decisive early years in America.

His most scathing aspersions were cast at a colleague born on the very same day as himself, who might well have been his twin brother in spirit, had not the antagonism between them been inscribed in tablets of stone. Like Loos, Josef Hoffmann looked back at English models and expressly claimed William Morris as his master, but he adapted Morris's now somewhat brittle ethos to Viennese elegance and culture. That, to Loos, must have seemed like treason. Be that as it may, Hoffmann's Viennese variation of Art Nouveau was the purest of them all.

He was lavish and convincing. Hoffmann rapidly made a name for himself as a confident designer of rooms and furniture, and indeed of objects of all sorts – like van de Velde, he turned his hand to almost everything. Whereas van de Velde was master of the line, Hoffmann favoured geometrical forms, in particular the square. Yet he did not take this to excess, however eager his critics may have been to level the charge at him. It was easy to see that many of his designs were drawn on graph paper, and had thereby acquired a certain schematic quality, but his partiality for strict forms also, created discipline; the appeal of Hoffmann's creations lies in their blend of elegance and slightly affected simplicity, of the precious with the sparing.

He rapidly developed a following; many other designers worked in the same manner, the most independent of them being Koloman Moser. This versatile artist, originally a painter, joined Hoffmann in determining,

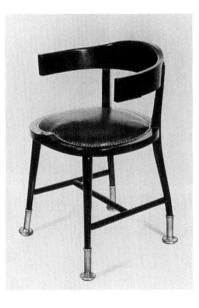

<u>Adolf Loos,</u> chair, Vienna, 1898/99, beech with leather and brass. Private collection

<u>Adolf Loos,</u> table clock, Vienna 1900, brass and glass, 48 cm high. Patrik Kovacs Kunsthandel, Vienna

<u>Wilhelm Schmid</u>, competition design for a livingroom, awarded third prize, Vienna 1902, from: Innendekoration XIV, 1903.

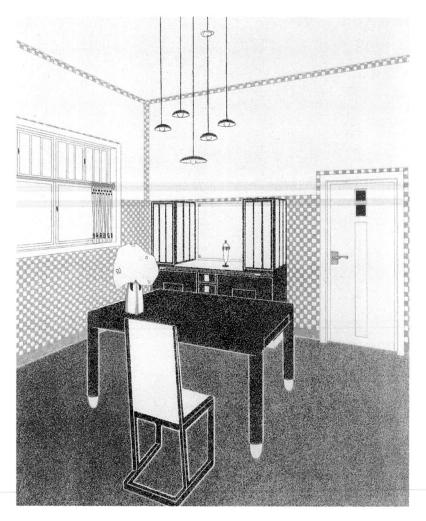

from 1903, the face of the Wiener Werkstätte, whose foundation was intended to allow artists' designs to be manufactured to a very high standard and introduced an interested public. In Vienna this was accomplished with great generosity, but with the result, however, that the highly regarded firm was never entirely self-financing. Patron Fritz Waerndorfer was obliged for many years to cover the losses. Later on, other financial arrangements were made, but by that time Hoffmann and Moser had little to do with the firm, as is evident from the artefacts produced.

The Wiener Werkstätte were far more versatile than the comparable workshops in Munich, Dresden and elsewhere. As well as furniture and entire décors, they produced jewellery, silver, ceramics, glass and leather goods, eventually even clothes. These were sold through their own shops, and it was possible to equip oneself there for every eventuality, even including a special form of entertainment in the shape of the "Fledermaus" cabaret. This rather irresponsible addition to the reper-

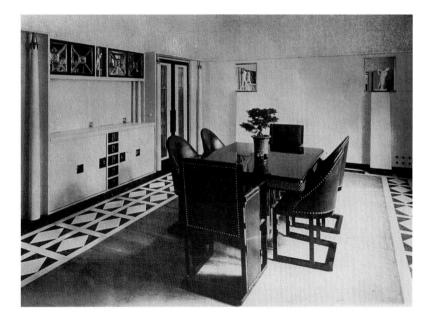

Josef Hoffmann, small desk with top, Vienna 1905, oak stained dark blue and polished, rubbed with chalk. Österreichisches Museum für Angewandte Kunst, Vienna

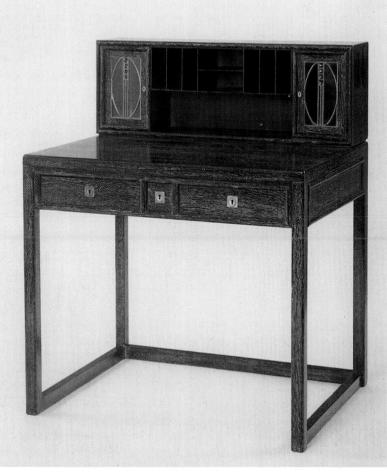

,

<u>Josef Hoffmann,</u> silver cutlery set, 1904, Wiener Werkstätte. Kenneth Barlow Ltd., London toire was in part financed through funds generously advanced by the artists' wealthiest client, as he soon became – Adolphe Stoclet.

A man of apparently unlimited means and excellent taste, he was the initiator of the house that may be regarded as the apotheosis of Art Nouveau: Palais Stoclet (pp. 230–237). It was remarkable in every way, not least because of its location and date. More than just an opulent town-house, it was built in the period 1905 to 1911, at a time when the new movement had passed its peak in Vienna. And it was somewhat strange that the most lavish example of Viennese Art Nouveau should be built in Brussels, a city which had given splendid testimony a few years earlier of its own artistic potential and did not stand in need of imported art. Yet Stoclet preferred Hoffmann to Horta or van de Velde, and it was thanks to him that Art Nouveau ended in the city where it had begun, albeit in a very different form. The most fleeting glance enables one to see that Hoffmann's ideas were very different from those of the Belgian artists.

The background to the Palais Stoclet was similar to those observed in earlier instances: wealthy artistic patronage coupled with knowledge and courage. Stoclet joined the illustrious ranks of Karl Ernst Osthaus, Fritz Waerndorfer, Count Harry Kessler and Grand-Duke Ernst Ludwig. Trust and generosity allowed the architect to develop his ideas unhindered, and the result was one of the greatest achievements of the early twentieth century. It represented a peak of achievement in Hoffmann's own work, too, superior in precision to anything he had done before, simple and yet a marvel of sophistication. Deferring to the basic cuboid shape, the slightly sloping roof is set back, although remaining visible. It dovetails cleverly with the projecting window surrounds. The complete absence of gables precludes the least hint of classicism, while the rightJosef Hoffmann, parts of a porcelain service, Vienna c. 1905.

<u>Josef Hoffmann,</u> samovar with warmer, Vienna 1909/10, silver and ivory, 29 cm high. Österreichisches Museum für Angewandte Kunst, Vienna

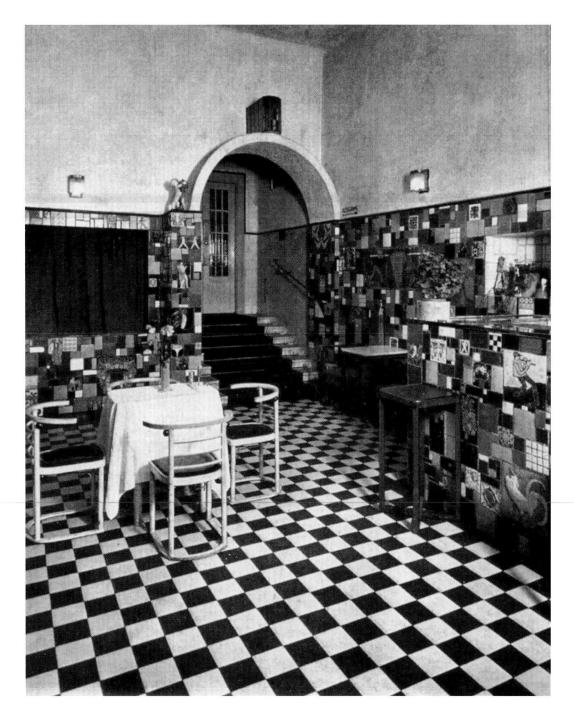

<u>Josef Hoffmann</u>, "Fledermaus" cabaret in Vienna, 1907, foyer and bar. Around the table are the characteristic Fledermaus chairs, which could be straddled by guests sitting with their back to the stage.

<u>Bertold Löffler,</u> fan for the "Fledermaus" cabaret, Vienna, 1907, printed paper. Historisches Museum der Stadt Wien, Vienna

9

<u>Otto Czeschka,</u> cover of the programme for the "Fledermaus" cabaret in Vienna, 1907. The Robert Gore Rifkind Center for German Expressionist Studies, Los Angeles County Museum of Art, purchased with the Anna Bing Arnolds Fund, Museum Acquisition Fund and Deaccession Fund. Fritz Zeymer and Otto Czeschka, a page from the programme for "Fledermaus" cabaret in Vienna, 1907. The Robert Gore Rifkind Center for German Expressionist Studies, Los Angeles County Museum of Art, purchased with the Anna Bing Arnolds Fund, Museum Acquisition Fund and Deaccession Fund.

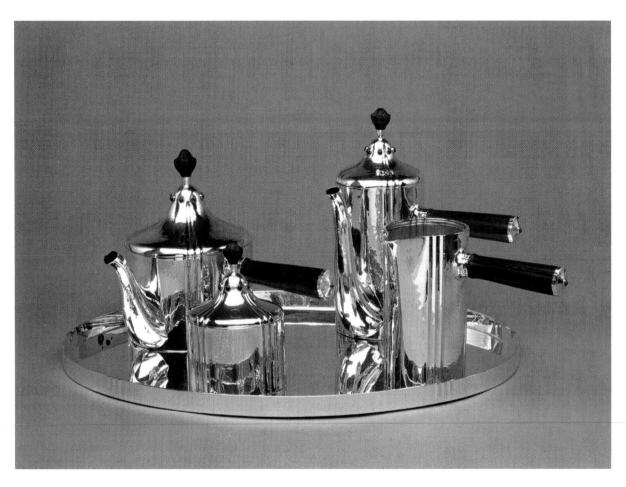

<u>Josef Hoffmann</u>, tea and coffee service, Vienna c. 1905, silver with handles of precious wood, from 13 to 22 cm high. Christa Zetter, Galerie bei der Albertina, Vienna

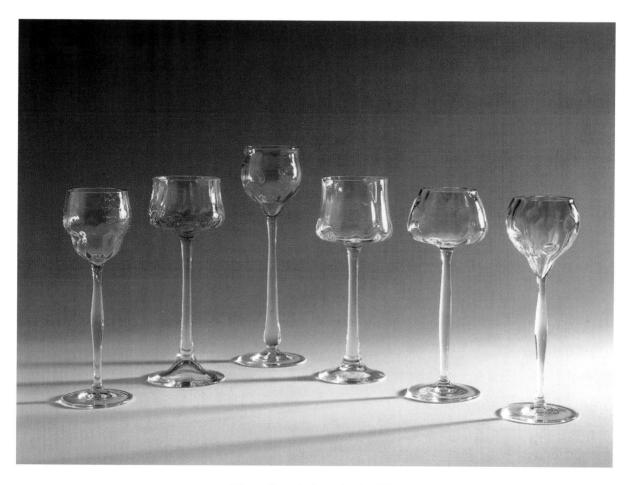

Koloman Moser, six glasses, Austria c. 1900. Private collection, Munich

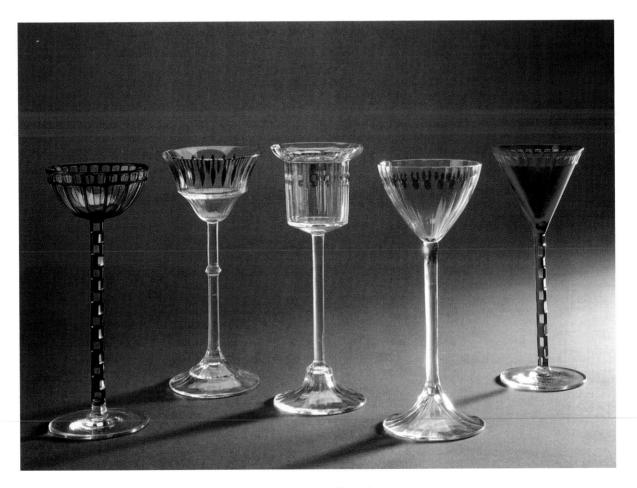

Otto Prutscher, five glasses, Vienna, between 1905 and 1907, crystal, coloured flash, ground and cut, all c. 21 cm high. Private collection, Munich

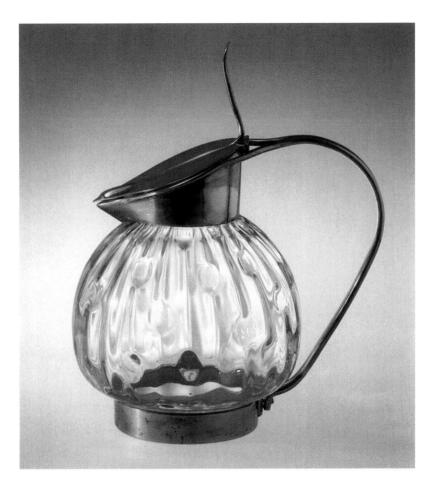

<u>Koloman Moser,</u> glass jug with silver-plate mount, Vienna 1900/01, 24 cm high. Private collection, Munich

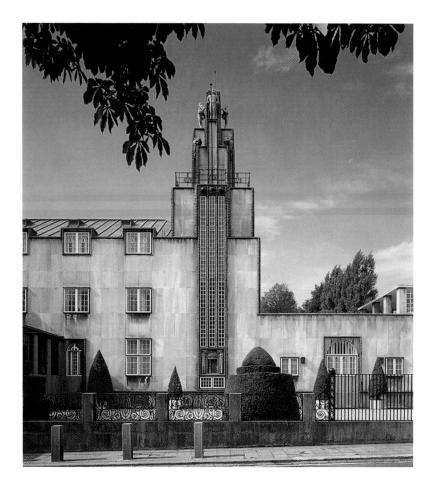

angled contours of the building are not tempered by diagonals. In the design of his Darmstadt house Behrens had used corner pilaster strips to emphasize the edges (p. 155); but while his aim war to create a sense of solidity and security, Hoffmann's bronze markings have more of a graphic function. They provide a slim and elegant frame for the large areas of grey Norwegian marble used in the outer walls, giving them independent worth. This impression is strengthened by the fact that the horizontal and vertical borders are equally narrow. Surfaces thus appear directionless, free of load and almost diaphanous. During the First World War, Osthaus exerted his considerable influence to prevent the bronze parts of the house being requisitioned and melted down by the German military.

The precision of the exterior, reduced to just a few clear components, is matched by an equally rigorous ground-plan inside. A two-storey central hall leads from the asymmetrical entrance side of the house to a symmetrical garden front. The tone of the exterior is taken up inside by the frequent use of marble, though now in warmer colours. The lavish use of marble in floors, walls and pillars emphasises the precisely calculated design of the rooms. The dining-room displays a subtle and sumptuous Josef Hoffmann, street façade of the Palais Stoclet in Brussels, 1905–1911.

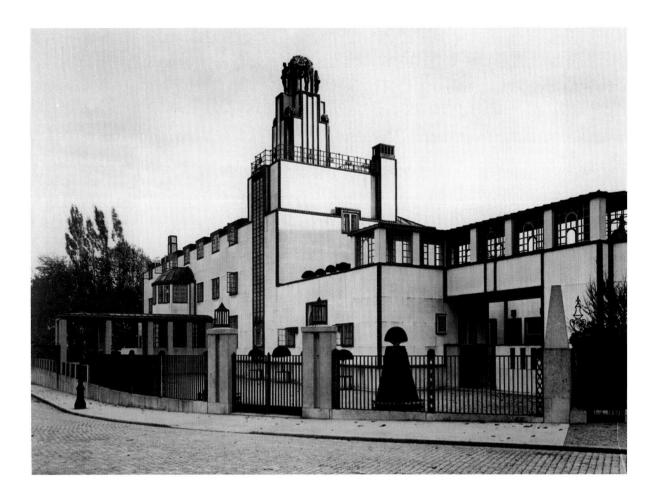

interplay of cool and costly materials, with golden yellow marble, dark ebony, coloured mosaics and silver tableware.

Of all the famous rooms, the dining-room is the most intellectual in conception. Emotion is subordinated to calculation, everything seems to have been thought out to the last degree. This applies above all to the relationship between architecture, furniture and artistic décor. The discipline which assigns each detail to its rightful place ensures unity in spite of the claims that individual elements may make on one's attention. This is true even of Gustav Klimt's mosaics, which form an integral part of the whole despite being in no way merely decorative. Within the intimite dimensions of this one room, Hoffmann achieved the same interplay of architecture and art as so often earlier in the changing interiors of the Secession exhibition building (pp. 214, 215). This was something almost without parallel in the entire movement; as a rule the two disciplines were mutually exclusive. But here, by means of ornament, colour and animated design, architecture took upon itself a higher all-embracing function that included art. Pictures and the like, indeed anything created by others, could only have been a distraction.

At first sight this self-confidence on the part of the artist might seem

Josef Hoffmann, street view of Palais Stoclet in Brussels, 1905–1911. astonishing; but it was the result of the greater value now accorded the applied arts, and thus architecture itself.

It was this very capacity for synthesis which distinguished Vienna from other centres of innovation. It expressed a maturity and mastery which made efforts elsewhere seem strained and excessively laboured. A compromise was struck between Utopian hopes and a sense of reality. An equilibrium had been reached. Josef Hoffmann was no doubt displaying sublime self-assurance when, in the garden of Palais Stoclet, he placed a slender Doric column with no function whatsoever in the middle of a pool. It is highly ironical that his most vehement opponent – Adolf Loos – showed the same mastery in handling traditional material (presumably in ignorance of Hoffmann's earlier example) when in 1923 he submitted plans for an office building in the shape of a Doric column. The unintended rapprochement rebounded most bitterly, causing him surprise and embarrassment.

Palais Stoclet marked the end of a development which collapsed even as it reached its height – a phenomenon which has been observed several times in the course of Art Nouveau. The lavishness of the object was justified by the consummate art it displayed. Beyond that, it remained an expensive exclusive. A summary of this house can thus be applied to almost everything that Art Nouveau brought forth: art of the highest degree, but with limited prospects of a future in society.

<u>Josef Hoffmann</u>, pergola in the garden of Palais Stoclet in Brussels, 1905–1911. In the backround a figure by the Austrian sculptor Richard Luksch, 1907.

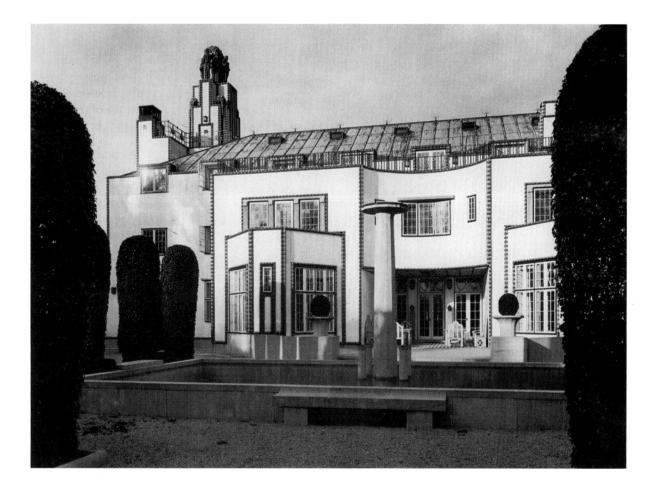

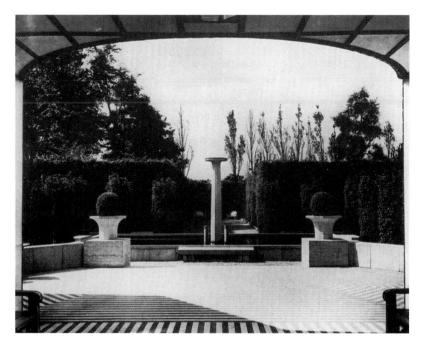

Josef Hoffmann, view of Palais Stoclet from the garden, Brussels, 1905–1911.

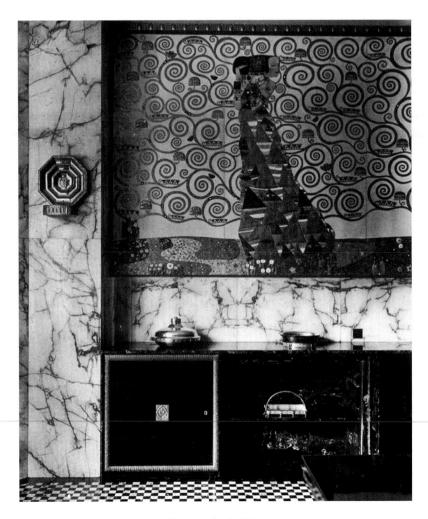

<u>Josef Hoffmann,</u> wall in the dining-room of Palais Stoclet, with mosaics by Gustav Klimt, c. 1910.

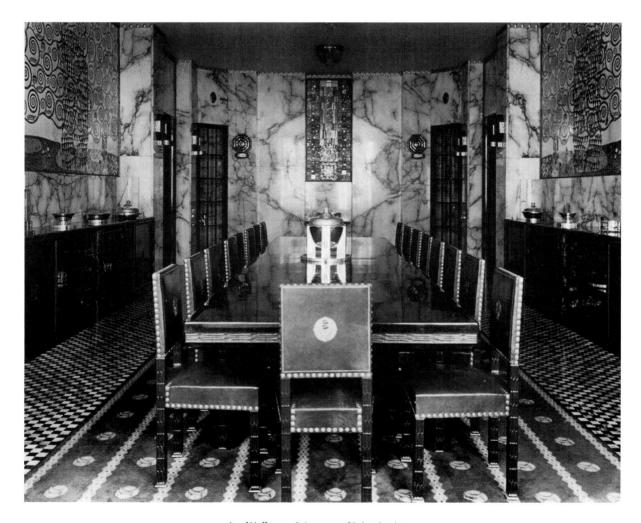

<u>Josef Hoffmann,</u> dining-room of Palais Stoclet in Brussels, 1905–1911.

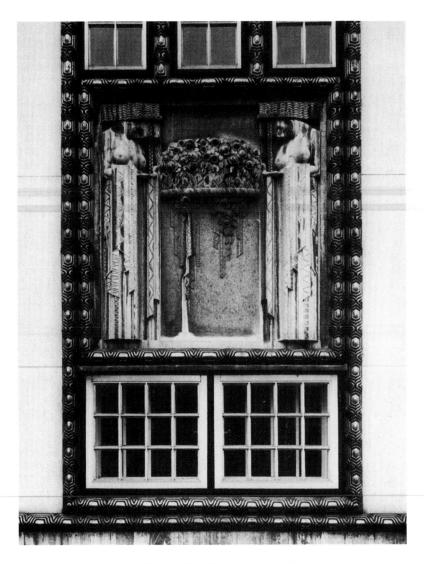

<u>Josef Hoffmann,</u> Palais Stoclet in Brussels, relief on the street front by Franz Metzner and (right) part of the garden front, 1905/1911.

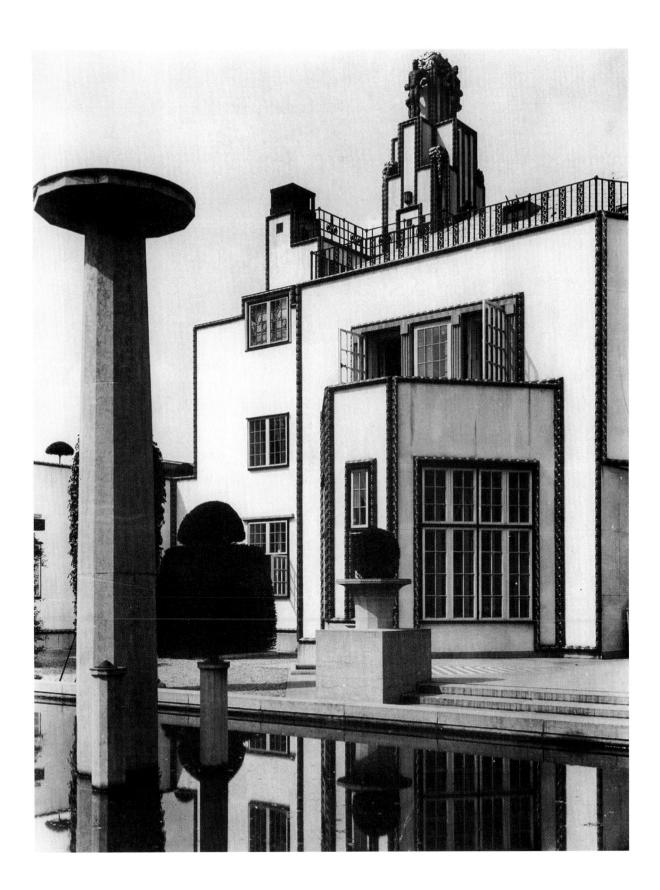

Bibliography

Books

Ahlers-Hestermann, Friedrich: Stilwende, Aufbruch der Jugend um 1900, Berlin 1956

Cassou, Jean, Emil Langui and Nikolaus Pevsner: Durchbruch zum 20. Jahrhundert, Kunst und Kultur der Jahrhundertwende, Munich 1962

Fischer, Wend: Bau, Raum, Gerät, Munich 1957 Frecot, Janos, Johannes Geidt and Diethart Kerbs: Fidus, zur ästhetischen Praxis bürger-

licher Fluchtbewegungen, Munich 1972 Garcias, Jean Claude: Charles Rennie Mackintosh, Basle 1989

Graf, Otto Antonia: Die vergessene Wagnerschule, Vienna 1969

Günther, Sonja: Interieurs um 1900, Bernhard Pankok, Bruno Paul und Richard Riemerschmid als Mitarbeiter der Vereinigten Werkstätten für Kunst im Handwerk, Munich 1971

Hamann, Richard, and Jost Hermand: Stilkunst um 1900, Berlin 1967

Hesse-Frielinghaus, Hertha, August Hoff et al.: Karl Ernst Osthaus, Leben und Werk, Recklinghausen 1971

Howarth, Thomas: Charles Rennie Mackintosh and the Modern Movement, Glasgow 1954

Hüter, Karl-Heinz: Henry van de Velde, sein Werk bis zum Ende seiner Tätigkeit in Deutschland, Berlin 1967

Just, Johannes: Meissener Jugendstilporzellan, Gütersloh 1983

Kreisel, Heinrich, and Georg Himmelheber: Die Kunst des deutschen Möbels, vol. 3, Klassizismus, Historismus, Jugendstil, Munich 1983

Lenning, Henry F.: The Art Nouveau, The Hague 1951

Madsen, Stephan Tschudi: Sources of Art Nouveau, Oslo 1956

Olbrich, Joseph Maria: Architektur (complete reprint of the original volumes from 1901–1914), Tübingen 1985

Pevsner, Nikolaus: Wegbereiter moderner Formgebung von Morris bis Gropius, Cologne 1983

Prinz, Friedrich, and Marita Krauss: Munich, Musenstadt mit Hinterhöfen, Munich 1988

Russell, Frank (ed.): Architektur des Jugendstiles, Überwindung des Historismus in Europa und Nordamerika, Stuttgart 1981

Schmutzler, Robert: Jugendstil, Stuttgart 1962 Schorske, Carl E.: Wien, Geist und Gesellschaft

im Fin de siècle, Frankfurt am Main 1982 Seling, Helmut (ed.): Jugendstil, der Weg ins 20.

Jahrhundert, Heidelberg 1959 Sembach, Klaus-Jürgen: Henry van de Velde,

Stuttgart 1989 Sternberger, Dolf: Über den Jugendstil und an-

dere Essays, Hamburg 1956 Varnedoe, Kirk: Vienna 1900, Art, Architecture & Design, New York 1986 Weisberg, Gabriel P.: Art Nouveau Bing, Paris Style 1900, New York 1986

Ausgeführte Bauten und Entwürfe von Frank Lloyd Wright, Nachdruck der 1910 bei Ernst Wasmuth A.G., Berlin, erschienenen Portfolioausgabe, Tübingen 1986

Zerbst, Rainer: Antoni Gaudí, Cologne 1988

Catalogues

Art Nouveau. Art and Design at the Turn of the Century, The Museum of Modern Art, New York 1959

Art Nouveau. Belgium/France, Catalogue of an exhibition organized by the Institute for the Arts, Rice University and the Art Institute of Chicago, Houston 1976

Sammlung Bröhan. Bestandskatalog Jugendstil, Werkbund, Art Deco, vol. II, Berlin 1976

Darmstadt 1901–1976. Ein Dokument deutscher Kunst, 5 vols., Darmstadt 1977

Museum Künstlerkolonie Darmstadt, compiled by Renate Ulmer, Darmstadt undated (1990)

August Endell. Der Architekt des Photoateliers Elvira, Museum Villa Stuck, Munich 1977

Europäische Keramik des Jugendstils, Hetjens Museum, Düsseldorf 1974

Theodor Fischer. Architekt und Städtebauer 1862–1938, exhibition by the Architektursammlug der Technischen Universität München and the Münchner Stadtmuseum in collaboration with the Württembergischer Kunstverein, compiled by Winfried Nerdinger, Berlin 1988

Gallé, Musée du Luxembourg, Paris 1986

Das Glas des Jugendstils, Katalog der Sammlung Hentrich im Kunstmuseum Düsseldorf, compiled by Helga Hilschenz, Munich 1973

Das Glas des Jugendstils, Sammlung des Österreichischen Museums für angewandte Kunst, Vienna, compiled by Waltraut Neuwirth, Munich 1973

Josef Hoffmann. Wien, Museum Bellerive, Zurich 1983

Jugendstil Bestandskatalog, Badisches Landesmuseum Karlsruhe, compiled by Irmela Franzke, 1987

Jugendstil. Kunsthandwerk um 1900, Katalog des Hessischen Landesmuseum Darmstadt, compiled by Gerhard Bott, 1973

Jugendstil, Palais des Beaux Arts, Brussels 1979

Jugendstil, Katalog der Möbelsammlung des Münchner Stadtmuseums, compiled by Hans Ottomeyer, Munich 1988

Die Meister des Münchner Jugendstils, Münchner Stadtmuseum, edited by Kathryn Bloom Hiesinger, Munich 1988

Franz Metzner. Ein Bildhauer der Jahrhundertwende in Berlin, Wien, Prag, Leipzig, Museum Villa Stuck, Munich 1977 Möbel des Jugendstils, Sammlung des Österreichischen Museums für angewandte Kunst, Vienna, compiled by Vera J. Behal, Munich 1981

München 1869–1958. Aufbruch zur Modernen Kunst, Haus der Kunst, Munich 1958

Objekte des Jugendstils aus der Sammlung des Kunstgewerbemuseums Zürich, Museum Bellerive Zurich, compiled by Erika Cysling-Billeter, 1975

Hermann Obrist. Wegbereiter der Moderne, Museum Villa Stuck, Munich 1968

Joseph Maria Olbrich 1867–1908, Katalog der Ausstellung auf der Mathildenhöhe in Darmstadt, 1983

Bernhard Pankok 1872–1943. Kunsthandwerk, Malerei, Graphik, Architektur, Bühnenausstattungen, exhibition by the Württembergisches Landesmuseum, Stuttgart 1975

Bernhard Pankok. Malerei, Graphik, Design im Prisma des Jugendstils, Westfälisches Landesmuseum für Kunst und Kulturgeschichte, Münster 1986

Das frühe Plakat in Europa und den USA, vol. 1, Großbritannien und die Vereinigten Staaten von Nordamerika, vol. 2, Frankreich und Belgien, vol. 3, Deutschland, Berlin 1973–1980

Richard Riemerschmid. Vom Jugendstil zum Werkbund, exhibition by the Architektursammlung der Technischen Universität München, the Münchner Stadtmuseum and the Germanisches Nationalmuseum Nürnberg, compiled by Winfried Nerdinger, Munich 1982

Traum und Wirklichkeit. Wien 1870–1930, Historisches Museum der Stadt Wien, 1985

Werke um 1900, Katalog des Kunstgewerbemuseums Berlin, compiled by Wolfgang Scheffler, 1966

Wien um 1900, exhibition held by the Kulturamt der Stadt Wien, 1964

Die Wiener Werkstätte. Modernes Kunsthandwerk von 1903–1932, Österreichisches Museum für angewandte Kunst, Vienna 1967

Index of names

The numbers refer to pages; numbers in italics refer to pages with illustrations.

Adler, Dankmar 199 Adler, Friedrich 107 AEG 38, 113, 155 Alexander | 187 Arnold, Galerie in Dresden 132, 136, 137 Baillie Scott, M.H. 158 Bakalowits, G. 160 Beardsley, Aubrey 174 Behrens, Christian 28 Behrens, Peter 26, 35, 38, 53, 85, 92, 109, 113, 114, 115, 141, 150, 153, 154-159, 181, 192, 199 202 230 Bernhardt, Sarah 196 Billing, Hermann 192 Bismarck, Otto von 38, 83, 196 Böcklin, Arnold 121 Böhm, Adolf 215 Bruckmann, P. 88, 160 Bugatti, Carlos 181 Bürck, Paul 143 Burnham, Daniel H. 197 Busoni, Ferruccio 138 Chedanne, Georges 23 Christiansen, Hans 148 Coonley, Avery 200, 201 Craig, Edward Gordon 138 Czeschka, Otto 225 Daum, Antonin 15 Daum (Nancy) 67 Denis, Maurice 124, 126 Deutscher Künstlerbund 137 Deutscher Werkbund 111 Dresdner Werkstätten für Handwerkskunst 102.

103, 105, 109, 111 Dumont, Louise 137 Duncan, Isadora 43 Dresser, Christopher 172

Eckmann, Otto 53, 111, 113 École de Nancy 67, 68, 69 Eetvelde van 58, *61, 63* Endell, August 11, 13, 86–88, 94–97 Engel, Carl Ludwig 189 Engelhardt, Christian Valdemar 16, 29 Engels, Friedrich 74 Ernst Ludwig, Grand Duke 37, 121, 122, 141–143, 159, 230

Fischer, Theodor *82*, 83, 86, 87, *108*, *109* Förster-Nietzsche, Elisabeth *122*, *123* France, Anatole 188 Franz Joseph 212 Frosterus, Sigurd 193 Fuchs, Georg 143, 156 Fuller, Loie *8*, 10, 11

Gaillard, Eugène 18, 26

Gaillard Lucien 18 26 Gallé, Emile 15, 65-69 Gallén-Kallela Akseli 190 Gärtner, Friedrich von 82 Gaudí, Antoni 27, 36, 74-79 Gesellius Herman 188 190 191 192 Gide, André 138 Glückert 148, 151-153 Goethe, Johann Wolfgang von 121 Goethe-Schiller Archive 122 Goah, Vincent van 52 Goncourt, Edmond de 66 Gorky, Maxim 187 Gradl, Hermann 115 Grand Bazar Anspach 49, 50 Gropius, Walter 155 Gruber, Jacques 66, 70 Güell, Eusebio 75, 76 Guimard, Hector 11, 20-22, 26, 75, 216 Gulbransson, Olaf 91 Habich, Ludwig 145, 148, 150 Haby, Francois 55, 57

Haeckel, Ernst 188 Hankar, Paul 44, 45 Harnack, Otto 188 Hauptmann, Gerhart 107, 138 Hebbel, Friedrich 121 Heine, Thomas Theodor 8, 88 Held, Louis 123 Hentschel, Konrad 131, 132 Hentschel, Rudolf 130 Herder, Johann Gottfried 121 Heymel, Alfred Walter 85 Hirschwald, Wilhelm 55 Hoffmann, Josef 109, 199, 210, 212, 213, 218. 219, 221-224, 226, 230-236 Hofmann, Ludwig von 135 Hofmannsthal, Hugo von 138 Hoosemans, Frans 46 Horta, Victor 11, 26, 30, 31, 43, 45, 47-51, 52, 54, 56, 57, 58-63, 199, 222 Huysmans, Joris K. 126

lbsen, Henrik 107 Joan of Arc 66 Jugend (illustrated Munich magazine) *110, 111,* 114

Karl Alexander, Grand Duke 121, 122 Karl August, Duke 121 Kaulbach, Wilhelm von 121 Kessler, Harry Count 122–127, 129, 137–139, 222 Kipling, Rudyard 196 Klenze, Leo von 82 Klimt, Gustav 12, 231, 234 Klinger, Max 121, 214 Koch, Alexander 158, 178 Kok, Juriaan 17, 29 Kovacs, Patrik 219 Kreis, Wilhelm 38

Lange, Konrad 116 Larche, Raoul François *11* Lauweriks, J.L.M. 38 Leczinski, Stanislas 65

Lenin VI 187 Leopold II 42 Leopold of Saxe-Cobura 41 Liebermann, Max 56, 121 Lindaren Armas 188, 190, 191, 192 Liszt, Franz 121 Löffler, Bertold 225 Loos, Adolf 207, 212, 218, 219, 232 Ludwig | 82, 83 Ludwig II 83 Lueger, Karl 210, 211 Luitpold, Prince Regent 83 Lumière, Auguste and Louis Jean 9 Macdonald, Margaret 173, 174, 176 Macdonald, Frances 173, 174 Mack, Lajos 17 Mackintosh, Charles Rennie 27, 158, 172–185, 199 MacNair, Herbert 173 Magnussen, W. 106 Maillol, Aristide 124, 126 Majorelle, Louis 69, 70, 71 Maximilian II 82 Méliès, Georges 8 Mérode, Cléo de 42,43 Messel, Alfred 143, 168 Metzner, Franz 28, 29, 38, 39, 237 Mies van der Rohe, Ludwig 155 Mommsen, Theodor 188 Monet, Claude 52 Morave, Ferdinand 110 Morris, William 16, 17, 53, 54, 100, 218 Moser, Koloman 219, 227, 229 Müller, Theodor 129 Munch, Edvard 12, 120 Muthesius, Hermann 178

Leino, Eino 190

Napoleon III 65 Neumann, Ernst 80 Newbery, Francis 173 Nicholas II 141, 187 Nietzsche, Friedrich 139 Nietzsche Archive 122, 133, 139 Nightingale, Florence 188

Obrist, Hermann 10, 11, 12, 90, 91, 93, 94, 100 Olbrich, Joseph Maria 32, 37, 110, 141, 142–153, 159, 160–166, 167, 168, 169, 175, 177, 178, 192, 199, 202, 206, 211–213, 216, 217 Osthaus, Karl Ernst 38, 39, 139, 230

Pankok, Bernhard 53, *85, 86, 87, 90, 91*, 100, *114*, 115, *116–119* Paul, Bruno 27, *42, 84, 87, 89,* 90, 91, 100, 106, *112, 113,* 114, 115 Perscheid, Nicola *122* Philipp V 73 Plumet, Charles *19* Poelart, Joseph 42 Prouvé, Victor *64* Prutscher, Otto *228* Pützer, Friedrich *167*

Reinhardt, Max 138

Renoir, Auguste 52 Riemerschmid, Richard 11, 27, 38, 53, 81, 85, 86, 87, 97, 98-106, 107, 109, 110, 113, 114. 115-117 154 Riesbroek, Jules van 43 Rilke, Rainer Maria 138 Rode, Gotfred 27 Rodin, Auguste 81, 138 Root, John W. 197 Ruskin, John 15-17 Saarinen, Eliel 188–191, 192, 193 Scharvogel, J.J. 106 Schaumann, Eugen 188 Scheffler, Karl 150 Schiller, Friedrich 121 Schiller Foundation 122 Schinkel, Friedrich 213 Schmid, Wilhelm 220 Schmitz, Bruno 28 Schröder, Rudolf Alexander 85 Seidl. Gabriel von 83 Selmersheim, Tony 19 Serrurier-Bovy, Gustave 44, 45 Seurat, Georges 52 Shakespeare Society 122 Sibelius, Jean 190 Simplizissimus 81, 84, 88-90, 114 Skladanowski, Max 9 Solvay 60, 62 Sparre, Louis 192 Stoclet, Adolphe 222, 231-233, 235, 236 Strasser, Arthur 213 Stuck, Franz von 82, 83, 84, 86, 140, 141 Sullivan, Louis H. 196, 199, 213 Tiffany, Louis Comfort 14,68 Toorop, Jan 12 Toulouse-Lautrec, Henri de 8, 12 Troost, Paul Ludwig 85 Truchet, Abel 9 van de Velde, Henry 8, 11, 17, 22, 24, 25, 26-28, 36, 37, 38, 39, 40, 43, 45, 51-57, 85, 98, 99, 106, 107, 109, 113, 120, 121, 123-129, 132, 133-139, 150, 154, 177, 191, 193, 199, 202, 218, 219, 222 Vavaseur, M.E. 9 Verne, Jules 8 Villeroy & Boch 26, 86 Virchow, Rudolf 188 Waerndorfer, Fritz 178, 222 Wagner, Otto 199, 206, 208, 209, 212, 213, 216, 217.218 Wagner, Richard 86 Walton, George 173 Wedekind, Frank 86 Whistler, James Mc Neill 173 Wieland, Christoph Martin 121 Wiener Secession 147, 212-215 Wiener Werkstätte 18, 222 Wilde, Oscar 126 Wilhelm II 104, 143, 156 Wilhelm Ernst, Grand Duke 122, 138

Wolzogen, Ernst von 97 Wright, Frank Lloyd 8, 28, 183, *194, 198–203*

Zeymer, Fritz 225 Zola, Emile 188 Zsolnay, Vilmos 17 Zumbusch, Ludwig von 110

List of illustrations

Annan, Glasgow: 173 r. / 174 / 177 / 184 / 185 Architektursammlung der Technischen Universität München: 98 / 102 a. / 108 a. / 109 Archiv La Cambre, Brussels: 122 r. / 126 / 131 / $134 \, \text{a} / 138$ Paul Asenbaum, Vienna: 2171. Ch. Bastin & I. Evrard, Brussels: 30/31/461/ 58/59/63 Bayerisches Nationalmuseum, Munich: 141. / 14r./97l. Bibliothek der Landesgewerbeanstalt, Nuremberg: 180 Bildarchiv Foto Marburg: 101. / 13 / 25 a. / 28 r. / 34 / 35 / 36 l. / 36 r. / 37 l. / 37 m. / 37 r. / 38b / 43l / 44g / 47 / 48 / 49l / 50 / 51 / 55 / 56 / 60 / 61 / 85 / 97 r. / 103 / 104 l. / 105 a. / 117 / 119 / 124 a. / 125 / 129 / 135 / 136 / 139 r. / 156 / 158 / 172 r. / 196 l./196 r. / 1971. / 197 r. / 198 b. / 206 / 207 / 221 a. / 223 a. / 231-237 Bildarchiv der Österreichischen Nationalbibliothek, Vienna 213-216 Bildarchiv Preußischer Kulturbesitz, Berlin: 421. / 42 m. / 42 r. / 72 Bildarchiv Hans Wiesenhofer, Vienna: 209 a. Chris Burke, New York: 212 a. Chicago Architectural Photographing Company: 201 / 202 Danz, Halle (Bild und Heimat Reichenbach i. V.): 38 a. / 39 Decorative Arts, K. Barlow Ltd., London: 99 r. / 222 Dekorative Kunstvol, 3 (1898/99): 40 Robert L. Delevoy, Victor Horta, Brussels 1958: 62 Deutsche Kunst und Dekoration vol. 3 (1898/99): 224; vol. 10 (1902): 170 © Direktion der Museen der Stadt Wien: 225 a. The Domino's Center for Architecture and Design: 200 Fine Art Society, London: 173

Klaus Frahm, Hamburg: 22 / 23 Frehn & Baldacchino, Hambura: 19 Retoria Futagawa & Associated Photographers. Tokvo: 183 Mario Gastinger, Munich: 151, / 15 r. / 69 / 881, / 88r / 991 / 2191 / 226-228 Sigrid Geske, Weimar: 133 g. Germanisches Nationalmuseum, Nuremberg: 157 Sophie Renate Gnamm, Munich: 10r. / 111. / 16/ 171, / 17 r. / 25 b. / 26 / 27 / 561, / 861, / 90 / 102b./105b./106l./106r./107/110l./ 110 r. / 111 l. / 111 r. / 113 l. / 113 r. / 114 l. / 128 b. / 130 / 131 / 132 / 133 b. / 137 l. / 160 a. l. / 160 b. / 175 / 229 Louis Held, Weimar: 120b. / 1231. / 123r. Helsinafors Stadtmuseum: 186 a. / 186 b. Historisches Museum der Stadt Wien: 204 / 208 / 217 r. Hoch Drei, Berlin: 29 / 115 Klaus Kinold, Munich: 108 b. Roland Koch, Darmstadt: 32 Kunstaewerbemuseum Köln: 181. Kunstgewerbemuseum Zurich: 54 l. / 128 a. l. / 128 a.r. Kunsthalle zu Kiel, Kiel: 11 r. Henry F. Lenning, The Art Nouveau, The Hague 1951 . 64 Loos-Archiv, Vienna: 218 Foto Archivo Mas, Barcelona: 78 / 79 The Metropolitan Museum of Art. New York: 194 1202 Georg Meyer, Vienna: 223 g. Münchner Stadtmuseum, Munich: 12 / 66 a.r. / 68b. / 70 / 104 r. / 112 Musée de la Publicite, Paris: 9 © Museum Associates, Los Angeles County Museum of Art: 225 b. 1 / 225 b. r. Museum für Kunsthandwerk, Frankfurt: 127 / 139h Museum of Finnish Architecture, Helsinki: 189 Rudolf Nagel, Frankfurt: 18 r. Die Neue Sammlung, Munich: 80 a. Österreichisches Museum für Angewandte Kunst, Vienna: 68 / 178 / 221 b. / 223 b. Oslo Kommunes Kunstsamlinger, Munch Museet: 120 a. Nicola Perscheid: 1221. © Photo: R.M.N., Paris: 176 Roger-Viollet, Paris: 21 François René Roland: 76 / 77 Royal Commission of the Ancient and Historical Monuments of Scotland, Edinburgh: 182 Rühl & Bormann, Darmstadt: 140 a. / 1421. / 143 r. / 159 / 160 g. r. SMPK Kunstbibliothek, Berlin: 39 SMPK Kunstgewerbemuseum, Berlin: 40 r. © Sotheby's, Inc. 1991: 66 a.l. © Sotheby's, Inc. 1990: 67 a.r. Hildegard Steinmetz Archiv im Theatermuseum München: 100 / 101 a. / 101 b. Westfälisches Landesmuseum für Kunst und Kulturgeschichte, Münster: 114 r. L. Sully-Jaumes, Paris: 201. Württembergisches Landesmuseum, Stuttgart: 86 r.

Wolfers, Philippe 46